FORMS
IN MODERNISM
A VISUAL SET

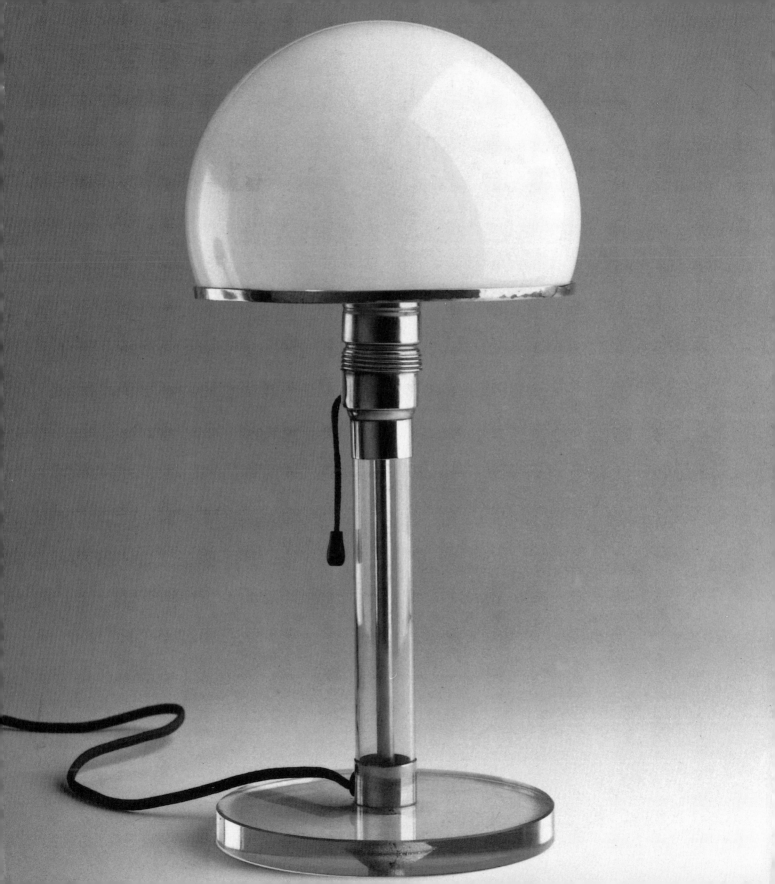

FORMS
IN MODERNISM
A VISUAL SET

THE UNITY OF TYPOGRAPHY, ARCHITECTURE & THE DESIGN ARTS

VIRGINIA SMITH

Watson-Guptill Publications
New York

Note from the Author:
The use of typefaces and any other graphic work in this book is intended as historic documentation for an editorial purpose. It is not intended in any way to infringe on the rights and owners of these names. Its use is intended, rather, to promote knowledge of their historic contribution to the design of the modern movement.

Page ii: Wagenfeld table lamp of 1924, designed by Bauhaus students Karl Jucker and Wilhelm Wagenfeld.

First published in 2005 by Watson-Guptill Publications
a division of VNU Business Media, Inc.
770 Broadway, New York, New York 10003
www.wgpub.com

Executive Editor: Candace Raney
Editor: Holly Jennings
Copy Editor: Meryl Greenblatt
Design: Designthing: Mark Von Ulrich
Production Manager: Ellen Greene
Project assistance: Katherine Happ

Library of Congress Control Number: 2005925159

Text set in Futura

ISBN: 0-8230-5624-4

Printed in the United States

First printing, 2005
1 2 3 4 5 6 7 8 9/13 12 11 10 09 08 07 06 05

CONTENTS

Letters act as practical and useful signs, but also as pure form and inner melody.

WASSILY KANDINSKY

PREFACE
TYPOGRAPHY'S ROLE IN MODERNISM

Type is one of the most eloquent means of expression in every epoch of style. Next to architecture, it gives the most characteristic portrait of a period and the most severe testimony of a nation's intellectual status.[1]

Peter Behrens, architect

Forms in Modernism: A Visual Set is a book that uses typography as the unifying discipline through which to understand, analyze, and compare forms. It studies form—its varieties and permutations—in other design arts, especially architecture, but with examples from couture fashion and furnishings. This book identifies some actions on form appearing in Modernism—the culmination of earlier experiments in architecture and type that had found conscious and committed practitioners by the 1920s.

Typography throughout most of the twentieth century can be seen as a lengthy response to principles stated by early European Modernists such as JaKob Erbar, Rudolf Koch, and Paul Renner, whose type-faces set the direction in the 1920s. In his book *Die neue Typographie* of 1928, typographer Jan Tschichold set out design practices for an audience of printers, mentioning the experiments of Herbert Bayer, László Moholy-Nagy, and other contemporary designers. A century-long variation on those early principles of typography followed, with designers on both sides of the Atlantic imitating, elaborating, attacking, and, finally, ignoring them.

The century started with the search for universal pure form and perfection and ended with an awareness of the interesting possibilities to be found in violating that perfection. That is the narrative thread I follow in this book. The 1920s through the 1960s is the primary period I investigate, where the principles of Modernism were first launched and fully realized, and where the seeds of tendencies that marked the last three decades of the century were sown. The final chapter covers the period when the principles of Modernism were finally abandoned, yielding an eruption of anti-Modern impulses and diverse forms. In the Afterword I present examples from an earlier century that indicate the visual set connection before the Modernist period, suggesting that typography manifests the design principles of its age, often sharing tendencies elaborated by architecture and other design arts, whether unconsciously or not.

This narrative is based on the premise that there is a "visual landscape" of periods in design, where we can detect a pervasive tendency in all the design arts to treat form in similar ways. This tendency I have called a "visual set," similar to the idea of a mindset. A principle underlying theories of early modern design was a belief in the oneness of all fields of creativity. This view—that all the arts were similar expressions of the same spirit—was clearly expressed by early theorists. In 1923 Le Corbusier wrote in *Towards a New Architecture:* "Style is a unity of principle animating *all the work of an epoch*, the result of a state of mind that has its own special character. Our own epoch is determining, day by day, its own style."[2]

His publication *L'Esprit Nouveau* covered architecture, cinema, sport, and (only twice) typography. Walter Gropius wrote of the Bauhaus: "What we preached in practice was *the common citizenship of all forms of creative work*, and their logical interdependence on one another in the modern world." In mid-century America, Alvin Lustig, anticipating a will to form in the United States, wrote of his hope that ..."the kind of relationship that existed [in earlier periods] between objects—the great symbolic spark that jumped between a candlestick, a Gothic cathedral, or a tapestry—will be rediscovered, the same vital meaning broadcast and received by a series of objects, which were in themselves separate, but *related by this larger meaning*." [3]

Of course, it is typography that benefits from its inclusion with a "major" art such as architecture. Form characteristics appear in architecture on a monumental scale, in type on a miniature scale. The architectural profession, with its long history, draws on a larger body of professional literature and theory. The complex job of designing a building, compared with designing an alphabet, takes more time, people, and money. Publicity helps: The public reads about celebrity architects and their buildings in the media, bringing an already public art closer to the public's attention. But now computers and the Internet enable a wider public to be involved with typography.

While considering the form characteristics appearing in architecture on a monumental scale, in type on a miniature scale, and in couture on a physical, human scale, I have not attempted any causal connection between the designers included here. I am making no claim that Chanel knew Le Corbusier or Le Corbusier read Renner. Though it is very likely that fashion designers such as Jeanne Lanvin, Madeleine Vionnet, and Coco Chanel dressed the same clients who inhabited villas designed by great architects—certainly both fashion designers and architects needed rich clients—rather, what I demonstrate is that certain tendencies existed in a "climate of opinion"[4] that was felt by most design practitioners.

The early Modern European typefaces discussed in this book were imitated and directly copied by many typefounders, both in Europe and the United States. Often changes were made in name and to the original design. Futura could become "Airport" or "Spartan," and Kabel, or Cable, was generically called "Sans Serif." Other typefaces, especially Goudy's types, have been copied, altered, and reissued with varying names. American Type Founders, Monotype, Linotype, Intertype, and Ludlow have issued typefaces over decades with changes. With phototypesetting, and now digital type, there are countless variations in names and design among typefaces known and used by graphic designers. The typefaces in this book are identified based on the authorities listed in the bibliography, chiefly, Mac McGrew's *American Metal Typefaces of the Twentieth Century* (1993); Jaspert, Berry, and Johnson's *Encyclopedia of Type Faces* (4th ed., 1970); Sebastian Carter's *Twentieth-Century Type Designers* (1995); and private and public collections.

Forms in Modernism identifies some actions on form—stripping, fragmenting, compressing, elongating, and more—that appeared in the Modern period. The typeface I use to illustrate those actions is usually display type, not text type. The large type used for announcements, posters, advertising, book jackets, and other display makes deviations in form more obvious than in text type, which is read in small sizes. These actions on form were, of course, not universally practiced. Although the desire for purity and clarity of form was prominent in Modernist thinking, a persistent second current was Expressionism—the assertion of an individually driven creativity working outside the dominant style. It is present in the graphic design

of Rudolf Koch and Paul Rand, and in the architecture of Eero Saarinen and Paul Rudolph. Where Modernism had rejected "meaning" in form in favor of principles of form, this alternate, other Modernism communicated meaning through form. These two approaches coexisted. For example, corporate art departments in the 1950s and 1960s understood Helvetica to be the neutral, lucid counterpart of their glass buildings. Yet, at the same time, decorative faces and exuberant revivals—Cooper Black and Push Pin Studio, for example—enjoyed popularity. Wild typefaces from fringe areas, such as the drug culture, the underground, and the comics, appeared alongside corporate annual reports.

Forms in Modernism omits some periods of design that offer abundant examples of similarities of form. Art Nouveau and the Vienna workshops are two of these. Art Nouveau is today seen as a limited style of a limited period, one that looked back to the eighteenth century as a decorative source; the Art Nouveau style is historicist, and left few descendants.[5] It was over by World War I. Wiener Werkstätte had its own sources and history, and was ended, with other crafts movements by the war.[6] The movements of Futurism, Dadaism, and other permutations are not covered, although they provide pertinent examples, and I touch on Russian Constructivism only because examples of it from the 1925 Paris Exposition influenced later typefaces. It is not possible to be all-inclusive. There could be another volume with more examples, and perhaps readers will become aware of form similarities I have ignored. Here I am offering a few observations on periods chosen because they impressed me with striking similarities between formal properties found in type, architecture, and artifacts—similarities I haven't seen noted. In the text I suggest resemblances in forms and imply they come from the same impulse—the same spirit and climate of a period—and I illustrate them through "creative documentation" (a term borrowed from a sociologist)— that is, abundant visual examples.

Today we understand the global spread and variations of the Modern movement. This book focuses on the dominant Central European examples that, as Americans, we received through powerful institutions and émigrés from those regions. But Modernism took root in Latin America, notably in Mexico, Scandinavia, and other places; China in the 1920s had its avant-garde Modernists, even in graphic design. There are thousands of examples to see, study, and understand.

By the end of the twentieth century, the relationship of typography to architecture and other design had become subtler than in past years. Instead of an obvious likeness of appearance in forms, there was a similarity in intellectual activity. For example, the inherent instability Philip Johnson describes in architecture, first explored by Russian Constructivists, erupts into the complex, deconstructed "follies" of Bernard Tschumi and in the Deconstructivist architecture of Zaha Hadid, Frank Gehry, and Daniel Libeskind, among others whom Philip Johnson and Mark Wigley presented in their 1988 exhibition at The Museum of Modern Art (MoMA).[7] In type the possibilities of encoding commands into digitized faces introduced desta-bilization into what was previously solid as lead, precise as film. This impulse to explore the possibilities of instability and explosion, even egotism, appeared. Today the possibilities of finding similarities in creation and treatment of form seem unbounded.

Virginia Smith
New York City, 2005

Numerous people and institutions helped with this book and deserve my thanks.

First, I want to thank the University Committee on Research Awards of the City University of New York. Their continuing support, through successive PSC-CUNY Research Awards, enabled me to secure permissions to reproduce most of the images in the book. The perceptive comments of the panelists who reviewed proposals in art encouraged me, and their funding permitted me to travel to archives where rare and important photographs could be found.

The director of the William and Anita Newman Library of Baruch College, Arthur Downing, and his staff, especially Louisa Moy, Ester Ramos, and Eric Neubacher, found many books essential to my study and facilitated my work in countless ways. To all the librarians and staff of Interlibrary Loan, Reference, and Circulation Divisions at Baruch College I express my admiration and gratitude.

In France I benefited from the collections in the Musée des Arts Décoratifs and the Musée de la Publicité of the Louvre, where I appreciated the assistance of Rachel Brishoual and Michèle Jasnin; from the Fondation Le Corbusier, and its Director Evelyn Trehin; from the Director of the Imprimerie Nationale, Paul-Marie Grinevald, and his colleagues Yvette Vibert and Christian Paput. In Berlin I was assisted by the staff of the Bauhaus-Archiv when using its collections and after, especially Sabine Hartmann.

Here in the United States I used the resources of The Museum of Modern Art where Pierre Adler helped me greatly with the Architecture and Design collection; I worked also in the Lily Auchincloss Study Center for Architecture and Design at MoMA. I also worked with the resources of The Metropolitan Museum of Art, where I appreciated the help of the late Richard Martin, Curator of the Costume Institute; with the archival photographs and curators of the Museum of the City of New York; the Rochester Institute of Technology Archives of Editorial Design, where APHA member David Pankow supplied many images, and Roger Remington his graphic design expertise; the Columbia University Rare Book and Manuscript Library, with the assistance of APHA members Jane Siegel and Jennifer Lee; as well as the Yale University Library and the Avery Architectural Library of Columbia. I am grateful to David Garrard Lowe for his generous assistance and, for hard-to-find images and material, my thanks go to Christine Cordazzo of Esto Photographics, Jennifer Belt of Art Resource, the Artists Rights Society, the Archives of American Art, the Wellesley College Archives, the Albers Foundation, and Fritz Hansen of Denmark.

I am grateful for the cooperation of the architects Michael Graves, Bernard Tschumi, James Wines, Frank Gehry, and their offices, who readily cooperated with me; to typographers Bill of Waltzer Digital Services for film type; to Woodside Press for their rare metal types; and to Joe Treacy, P22 type foundry, and especially to Milton Glaser and Matthew Carter for supplying their typefaces, more than finally could appear in the book. I am grateful to Ed Benguiat, Irene Tichenor, and Lowell Bodger for looking at the manuscript, and especially to Paul Shaw for his exhaustive comments about the manuscript and his answers to many questions on typefaces; to Henrietta Condak, April Greiman, and Wolfgang Weingart for their artwork; to Elaine Lustig Cohen for her historical insights and photos; to Massimo Vignelli, helpful as always; to my colleague Cynthia Whittaker for Russian translations; to my research assistants Skip Dietrich, Loretta Lorance, and Onur Oz; and to Michael Gross of the Authors Guild.

Most of all thanks to my acquiring editor Candace Raney for her unparalleled good judgment and to my developmental editor Holly Jennings for her perceptive questions and expert guidance, and for helping to improve the manuscript in numerous ways—from overhauling the organization to attending to the smallest details, including tracking down elusive artwork. One couldn't wish for a better design collaborator than Mark Von Ulrich, whose beautiful design created a unified and elegant home for a daunting number and variety of images and typographic elements. And production manager Ellen Greene also deserves a word of thanks for helping to make this book come together.

V.G.S.
April, 2005

1 EARLY EUROPEAN MODERNISM

The tattooed who are not in prison are latent criminals or degenerate aristocrats. If someone who is tattooed dies at liberty, it means he has died a few years before committing a murder.[1]

Adolf Loos "Ornament and Crime," 1908

With this provocative statement Adolf Loos opened Modernism's attack on past periods of design. He wanted no decoration added to buildings, but a search for forms stripped to essential, functioning parts. Loos was an Austrian architect who stated these principles in his 1908 essay "Ornament and Crime" and demonstrated them in his Viennese architecture. His Looshaus, built for a men's clothiers, so offended the emperor by its lack of ornamental window pediments that he refused to ride by it, referring to it as "the building without eyebrows." Loos had "stripped" the building of its conventional window finishes.

Was Loos's statement and its acceptance by Modernists a reaction to the falseness of ornament, or was it an abandonment of forms that had reached their utmost elaboration? Did artists feel that existing forms were exhausted, and that they had no more potential? Probably both. The force that began with early-twentieth-century manifestos would be potent enough to energize European designers for the rest of the century.

Looshaus building by Adolf Loos, Michaelerplatz, Vienna, 1910–12

STRIPPING

Architects after Loos, as well as designers in other professions, shared his spirit. The great Modern architect Le Corbusier reprinted Loos's 1908 essay in L'Esprit Nouveau (The New Spirit), the French publication he edited that was devoted to Modernism in the arts. In the print professions, typographers—rejecting fantasy worlds and elaborate flourishes—aimed for the creation of unadorned letterforms and logical pages. In their realm, it was the sans serif typefaces that were stripped of superfluous ornament. Sans serif typefaces carried no finishing strokes; they were as stripped of "eyebrows" as were the architect's windows.

Detail of Looshaus building by Adolf Loos, Michaelerplatz, Vienna, 1910–12. Upon the building's completion, city authorities demanded that flower boxes be placed in the windows to soften their stripped-down appearance, a tradition that has carried through to today.

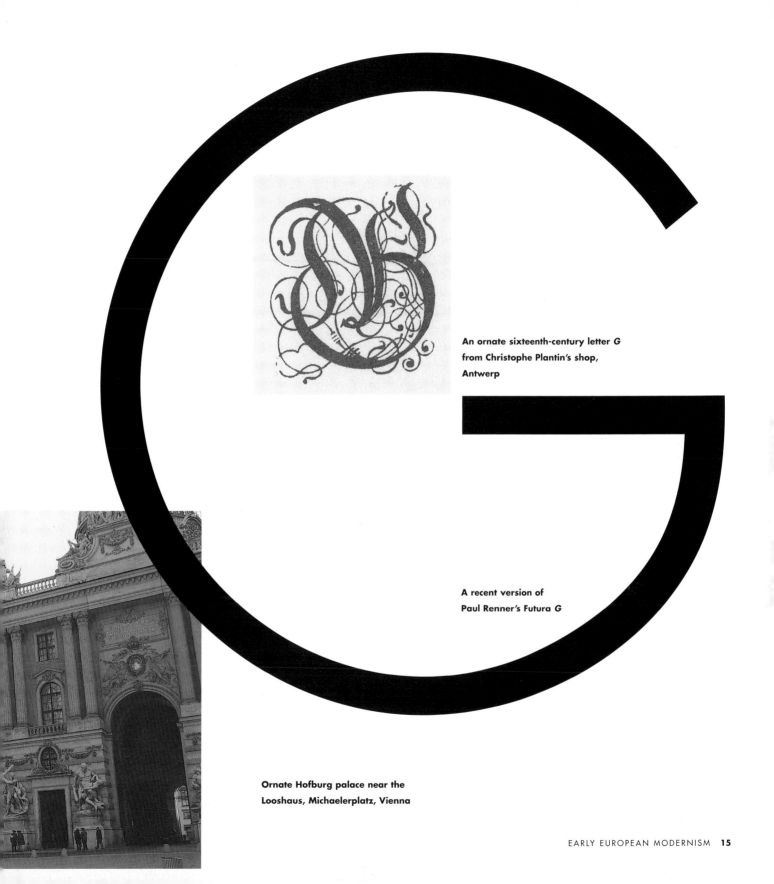

An ornate sixteenth-century letter *G*
from Christophe Plantin's shop,
Antwerp

A recent version of
Paul Renner's Futura *G*

Ornate Hofburg palace near the
Looshaus, Michaelerplatz, Vienna

REJECTION OF THE PAST

How will the day break? No one knows. But we can feel the Morning. We are no longer Moonstruck wanderers roaming dreamily in the pale light of history.[2]

Bruno Taut, "Daybreak," 1921

Survivors of World War I such as Jan Tschichold, Walter Gropius, and Bruno Taut—along with many other designers and architects in Central Europe—emerged in 1919 as converts with a near-religious mission to change the world for the better. They would change it through art, rejecting ornament and decoration as expressions of past centuries that had tolerated war, disease, and poverty. To continue using these idioms was illogical; it was escapism and romantic rubbish, they claimed.

Tschichold, a letterer and layout artist in the German book city of Leipzig, excelled in specifying type for printers in the traditional manner. After his exposure as a young man to Modern designers, however, he considered new ways of using type. He accepted a position as a teacher at the Master School for Printers in Munich—led by Paul Renner, designer of the Futura typeface[3]—where he developed Modern principles for working printers, resulting in direct, practical instructions.

Setting aside everything dating from 1450 to 1914 as "the old typography," Tschichold claimed the sans serif typefaces to be the only ones in spiritual accordance with modern times.[4] He presented his fully formed ideas in his book *Die neue Typographie* (*The New Typography*), published in Berlin in 1928, which had as influential an impact on the design and typography professions as Loos's and Le Corbusier's ideas had on architecture. *Die neue Typographie* was the manifesto of the Modern spirit in typography, imbued with the same spirit found in the architecture of Loos, Ludwig Mies van der Rohe, and Le Corbusier; the furniture of Marcel Breuer and Mart Stam; the theater of Bertholt Brecht; and the films of Joris Ivens and Dziga Vertov—all of whom Tschichold cited in his book as practitioners exemplifying the new spirit.[5] Tschichold also incorporated what he had seen in the work of the Bauhaus Weimar exhibition of 1923, and the work of László Moholy-Nagy, El Lissitzky, and the Russian Constructivists. He illustrated his manifesto with their works, as well as with his own.

Tschichold clearly claimed the new typography as part of the changing Central European Modernist culture.[6] He explained the goal of design and typography in "the new era" in his book, which was directed toward German printers. Tschichold felt the new principles could be commercially implemented adequately with the typefaces already stocking printers' cases, by using what he called "the old anonymous sans serifs." In particular, he mentioned Venus as an existing typeface that could work with the new typography.

But, rather than use acceptable old typefaces, designers in German foundries (and later in America) created many faces they felt better displayed the new spirit. Soon to come were the extensive Futura family and Rudolf Koch's Kabel. Tschichold's book remained an influential manifesto of graphic design practice for the twentieth century.

Venus Light type specimen, a monoline typeface widely available in prewar Germany, from Wagner & Schmidt typefounders

ABCDEFGHIJKLM
NOPQRSTUVWXYZ
abcdefghijklmnopqr
stuvwxyz0123456789
!?&,.:;@¤⁺([{¢£ ,

Clarity was the chief goal of the new typographic design. Speed of contemporary living made it impossible, Tschichold claimed, to linger over decorative printed material. Instead, the city dweller, swamped by newspapers, posters, and periodicals, needed to scan and extract essential information when reading on the run. Design must help reading and comprehension. So the arrangement of material must follow the movement of the eye. This "syntax," or arrangement of the printed material, became the determining factor in typographic design. Another way of saying this was "form follows function."

The rules taught by Tschichold resulted in a new style of design, first seen in announcements and posters. In *The New Typography*, he reproduced an announcement by Willi Baumeister as a successful example of new typographic design, while dismissing others as poor imitations. As startling, spare works, with bold sans serif typefaces, empty spaces, unusual angles and placements, and sometimes grainy photographs, they differed markedly from previous styles of printed matter. A new graphic design came about based on[7] logical reading order, fewer typeface sizes and weights, arrangements of lines and rules, use of photos, use of heavy typefaces, and bold contrasts.[8] Asymmetrical arrangement of printed matter became a major identifying characteristic of the new typography. The edges of the usable space could be extended (as in architecture) to accommodate the needs of the reader. Tschichold's design for a poster announcing one of his lectures demonstrated many of the new typography principles.

Willi Baumeister's 1924 invitation, an example of logical reading order resulting in an asymmetrical layout

The Essence of the New Typography is clarity.[9]

Jan Tschichold

TSCHICHOLD'S NEW TYPOGRAPHY

Arrange text in logical reading order

Logical order results in asymmetric design of printed page

Form of text will result from function (which is reading)

Therefore, no preconceived shape. No standard solutions

No centered type

No central axis

Weight and size of type in accordance with importance

No typographic ornaments. No decorated rules or fleurons

Use photography, never illustration

Use contrast: size, position, direction, style

Use blank spaces of white paper as part of design

Use no more than five type sizes; preferably three

Use no ethnic types, only Roman alphabet

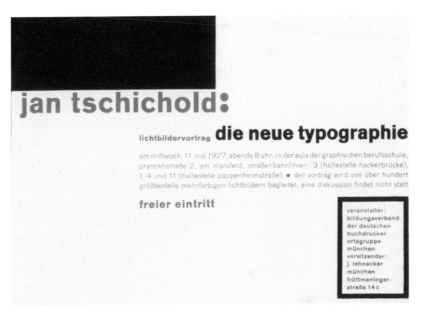

Poster designed by Jan Tschichold
announcing his lecture, 1927

GEOMETRY IN TYPE AND ARCHITECTURE

Architects and type designers analyzing the spirit of the new age discovered the engineer. New shapes of airplanes, automobiles, telephones, motorcycles—all mass-produced objects in the new visual environment—resulted from industrial technology. Machines had created beauty. Typographers like Jan Tschichold thought of these new shapes when formulating his treatise on the New Typography: "car–airplane–telephone–factory–neon advertising–New York!" Writing about airplanes in 1920, French architect and theorist Le Corbusier called the airplane beautiful because it responded to a need for "utility, comfort, and practical arrangement."[11] This belief in functionalism affected the work of Modern designers for years, in furniture, couture, interiors, and small objects. Geometric shapes, wrought by engineers for the requirements of machine production, produced honest form, free from applied ornamentation, fulfilling a need. The machine produced clarity and functionalism; the machine rejected attempts at beauty or "charm."

TWENTIETH-CENTURY SANS SERIFS

The New Typography acknowledged the type experiments of the Futurists and the Dadaists who had discarded typographic traditions. But neither Futurist typography nor that of Dada foreshadowed true Modern typography. Futurist pages visually expressed the emotional content, and attempted to communicate its sounds—soft, loud, pauses—while Dadaists, cynical and desperate, rejected the past while giving no practical solutions for the future. Tschichold and his peers preferred clear and logical solutions. Their theories and their typefaces evolved from contact with the rational—though impassioned—artists of the Bauhaus and the Constructivist movements. Geometry, knowledge of the history of letterform and book design, and practical requirements of actual commercial printing resulted in a new typography for the new age.

Although their origins reach to fifteenth-century Florence, and even to Greek inscriptions, sans serif letters were, from the start, the defining typefaces of Modernism. Although the Germans called them Grotesk, the French Antique, and the Americans Gothic, all refer to typefaces stripped of finishing strokes and reduced to essential form.

Modernism's pervasive characteristic was the drive toward abstraction. For type designers, that meant a return to geometric forms; these were pure, universally understood shapes. When designing new alphabets, they reduced each letterform to basic geometric elements—circle, square, triangle—with arcs and lines. German typographers Jakob Erbar, Paul Renner, and Rudolf Koch, who invented the first modern sans serifs—Erbar, Futura, and Kabel—consciously returned to geometric shapes as spines on which to construct their letterforms.

ÄBCDEFGHIJKLMNÖ
PRSTÜVWXYZ
abcdefghijklmnöpqrst
úvwxyz +!?".; * &
1234567890 ß

Erbar specimen of 1922

Erbar, An Early New Sans Serif. Erbar was the first of the German sans serifs, appearing in 1926. Jakob Erbar was a compositor and type designer from Düsseldorf, and for many years a teacher. He designed Erbar in several variations: Lux, Lumina, and Phosphor, all in the 1920s. This early specimen of Erbar shows the advanced state of his sans serif at this early date. The geometric basis of his letters is evident throughout; the cut-off capital C shows him to be in love with the pure form of the arc, the section of a circle. The circle is evident in the cap *O* and *Q*, *C* and *G* and the lowercase *o*, as well as in the bowls of the lowercase *b*, *d*, and *g*.

Futura, A Landmark Typeface. Paul Renner, however, believed that Erbar relied on the design of his own Futura, which he had been developing since 1924–25.[12] Renner had shown his versions freely to others, but did not issue the final typeface until 1927. Over time, his Futura alphabet became more pointed in the cap *A* and *N*, while retaining the severity of its geometric grid base—the *S* was derived from two circles placed atop each other, and some early thoughts on the lowercase *g* reduce the letter to an unimaginable collection of a triangle, circle, and rectangle at one point. The entire face was said to have been designed with a T square, compass, and triangle.

Futura was soon copied by American Type Founders (see page 82), under the name "Spartan," and later by Intertype with the name Futura. Futura has been widely copied and adapted for all typesetting, including now for computers in digitized form. Since 1927 Futura has been one of the most popular typefaces in the world.

The origin of the typeface Futura was linked to a proposed actual use. Renner started his sketches on Futura as an alphabet for public signage for the City of Frankfurt's enlightened architectural projects directed by Ernst May, an architect cited by Tschichold in his 1928 book as sharing the spirit of the new typography.[13] Did Renner begin his different style, geometric, modern, because of his associations with May and Tschichold? Being older than Tschichold (he was fifty) when the younger man wrote the manifesto, yet having hired him as a teacher at the master school for German book printers in Munich, he evidently found his ideas convincing.

Renner also brought type designer Georg Trump to the school in 1929, where Trump designed City type, a square serif type used by some new typographers.[14] Renner, Trump, and Tschichold were in the German book industry, which was totally separate from the well-known German school called the Bauhaus (see next chapter); Renner's Bauhaus contacts were confined to later acquaintance with Gropius and Mies. Tschichold had been developing his own views when he visited the Bauhaus exhibition of 1923 and incorporated them into his own. The Bauhaus name and influence are great in part due to their instructors who immigrated to the United States and proselytized those views. Renner and Tschichold, on the other hand, directed their 'rules' mainly to Germans.

Kabel and Neuland. Kabel was designed in 1927 by Rudolf Koch.[15] He worked in Offenbach, Germany, as a craftsman, and the Klingspor foundry cut his typefaces in metal for commercial use. Koch produced many typefaces over a long career but Kabel is unique. Usually his typefaces were traditional, German blackletter typefaces and scripts. With Kabel, he dipped into Modernism for a moment and created a winner.

Early geometric sketches of the letter g for Futura typeface by Paul Renner. These extreme forms for the lowercase letters were abandoned in favor of more readable letterforms, not abstract signs.

Letters g through s of Futura Light, a contemporary version of Futura

G H I J K L M N O P Q R S

Before Kabel, and in a different mood, he designed Neuland, a type reflecting his experience with woodcutting tools—slashing, crudely angled, cut directly on the metal as if on wood. Though it can be called sans serif, Neuland differs from Futura and Erbar in two important respects: it does not have a lowercase, and it is not based on a pure, rational, geometric base. Instead, its rough wood-cut force allies it to another strain of German Modernism, that of Expressionism. Neuland's popularity, paralleling that of the geometric faces, indicates how a personal, expressive voice could be compatible with the early rational Modernism of leading thinkers.

VISUAL SET IS THE EYE'S MINDSET

VISUAL SET IS THE EYE'S MINDSET

Two weights of Kabel by Rudolf Koch, 1927

OCGQS

PBRKD

EFLNH

X Y Z

Constructive grid of Kabel. Rudolf Koch analyzed the construction of letters and grouped them according to their width and geometric shapes on a four-square grid.

VISUAL SET

Visual Set in Neuland type. Rudolf Koch designed Neuland in 1923 out of his craft experience with wood-cutting and calligraphy.

Other Important Sans Serifs. In England, Edward Johnston, a calligrapher, designed a signage alphabet for the London subway system in 1916. In this early sans serif Johnston abandoned the thicks and thins of the broad-pen letter and designed "London Transport Johnston's Railroad Type" not only without serifs, but with a uniform weight of stroke. The typeface is typical of English lettering in its insistence on wide cross strokes in the *E* and *F*, and in strict adherence to a rectangular base. This geometric, monoline face for the Underground proved so appealing that in both 1988 and 1999 English type designers revised it for computers, adding new weights.[16]

It had an immediate effect on his student Eric Gill, whose Gill Sans and Gill Sans Bold remain among the most popular sans serifs used today. One of the religious, monastic brotherhood of graphic designers (akin to Johannes Itten in Germany at the Bauhaus; see pages 33–35), Gill united his spiritual life with his art.[17] His ascetic costume of a monk's habit concealed a randy temperament.

G H I J K L M N O P Q R S
G H I J K L M N O P Q R S

Gill Sans compared with Futura

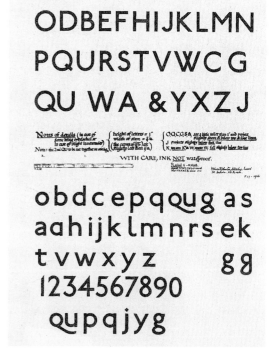

**Johnston Railroad Type
specimen, 1916**

ARCHITECTURAL GEOMETRY IN THE 1920S

Swiss-born architect Le Corbusier declared cubes, cones, spheres, cylinders, and pyramids to be the great primary forms revealed by light.[18] His revolutionary designs of the 1920s demonstrated how to work with these forms to produce "architectural sensations."[19] Throughout that decade Le Corbusier developed his "white villas," culminating in the Villa Savoye of 1929, and including such masterpieces of early Modern architectural design as his Atelier Ozenfant, a workshop studio for Amedée Ozenfant, in 1922 and the Villa Stein at Garches of 1927.

The "rigid, clean-cut envelope" of the villa at Garches is composed of a large white cube, with one façade (the entrance side) divided into horizontal strips, that progress in widths, a numerical analysis based on the Golden Section. The openings of the doors, garage, and windows were arrived at through his *tracés regulateur*, regulating lines or diagrams. Projections from the façade supplied the in-and-out third dimension, and raising the ground at the bottom of the stairs by a few centimeters permitted his governing diagonal lines to remain parallel. Le Corbusier explained his theories in books and articles, paintings and built structures, and in the 1920s was emerging as one of French Modernism's geniuses.

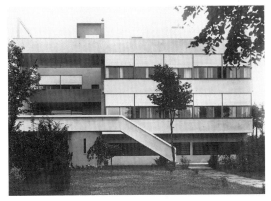

Villa Stein at Garches, view of rear façade, 1927

Villa Stein at Garches, view of front façade

ASYMMETRY ACROSS THE DESIGN ARTS

In Modernism, according to these two grand theoreticians, Le Corbusier and Tschichold, neither building design nor page design were to be forced into a traditional form; rather, the form would result from the activity of the person, whether moving within the building or reading the page. The severely geometric elements of Le Corbusier's Atelier Ozenfant, especially the corners admitting light through the daring oversize window, are made possible by the architect's free plan, or non–load bearing walls. The grand window is off to one side, with a disregard to symmetry, in favor of light and the linear convergence of the panes.

Mies van der Rohe set out his beliefs in 1923 in an early issue of *G*, a journal of forward-looking architects in Berlin. Rejecting past doctrines, he believed that only architecture creates the form of its day. Mies believed architecture to be a "will of the age conceived in spatial terms."[20] He designed one of the icons of Modernism, the German Pavillion at Barcelona in 1929. Its asymmetric plan, defined by walls as freestanding planes, permitted a fluid space.

In the private, small-scale world of personal dress, designers followed principles of asymmetry, as couture expressed the spirit of modern thought. Jeanne Lanvin's black cotton velveteen evening coat of 1927 draws the white wool embroidered stripes to a cluster above the right hip.

Title page of Andrea Palladio's _Second Book on Architecture_ (1570) and a plan and elevation for a Palladian villa. The axial symmetry seen in Palladio's plan and elevation, echoed in the typographic treatment of the title page, was rejected by early Modernists in all the design arts in favor of asymmetry.

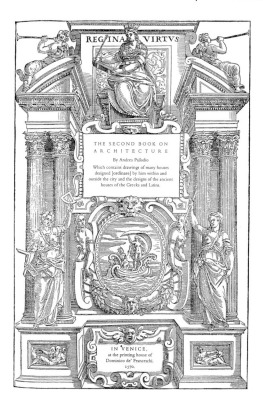

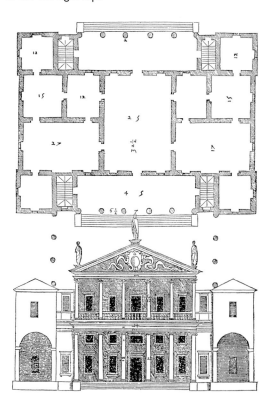

An asymmetrically designed film poster, based on logical reading order, by Jan Tschichold, 1927

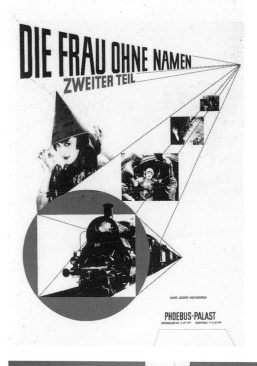

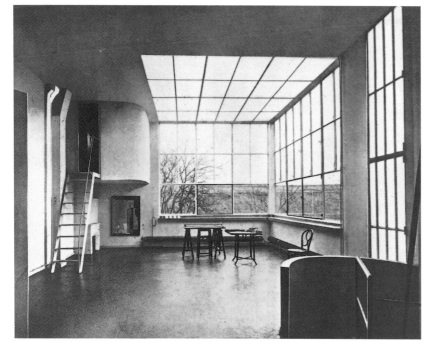

Le Corbusier's Atelier Ozenfant, 1923

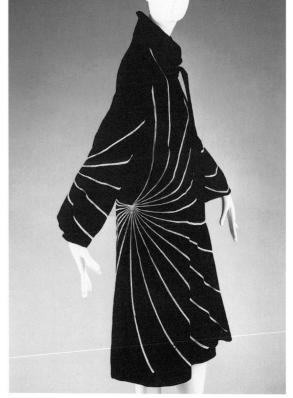

Jeanne Lanvin evening coat, 1927
The Metropolitan Museum of Art,
Isabel Shults Fund, 1986

Another French designer, Madeleine Vionnet, designed asymmetrical garments. Her couture wedding dress of 1929 shows exquisite use of gentle lines. The entire dress focuses asymmetrically on the left hip. The sleeves simply follow the shape of the arm loosely. It is only coincidence that this dress was from the same year—1929—as the Barcelona Pavillion; yet, both incorporate rich, luxurious materials and create elegance through simplicity.

The metallic cording defines the construction of the dress, and those lines curve around the body. There is no added ornament; instead, the construction material itself is the ornament—traditional ivory silk panne velvet which beautifully reflects the light. This contemporary of Vionnet's could have been describing this gown, not architecture, when he wrote, "Hurray and again hurray for the fluid, the graceful…the sparkling, the flashing, the light."[21]

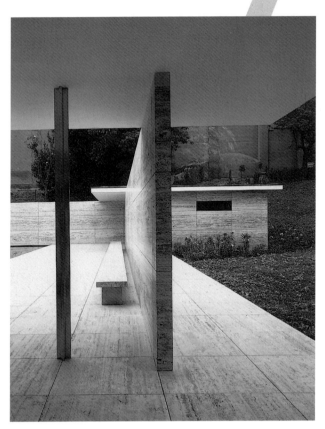

Photograph of the reconstructed Barcelona Pavilion, originally built in 1929. The temporary pavilion, designed by Ludwig Mies van der Rohe, stunned visitors with its long planes of glass and precious materials, defining space instead of solid walls.

**Back of Madeleine Vionnet
wedding dress, 1929**

The Metropolitan Museum of Art,
Gift of Mrs. van Heukelom Winn,
1974

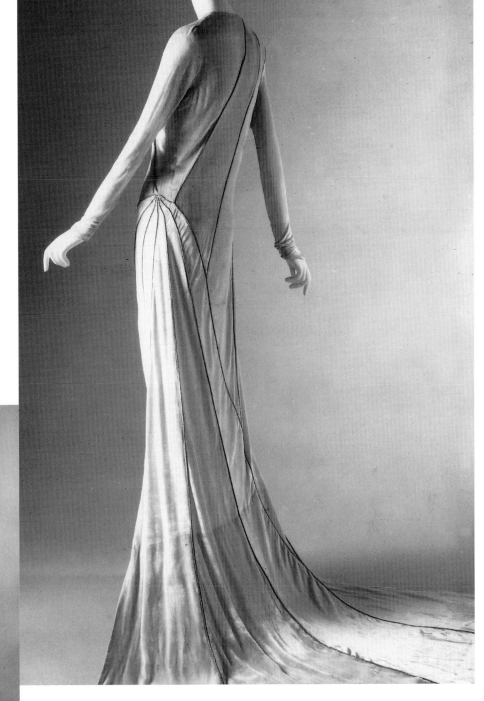

**Front of Madeleine Vionnet wedding
dress, 1929**

The Metropolitan Museum of Art, Gift of
Mrs. van Heukelom Winn, 1974

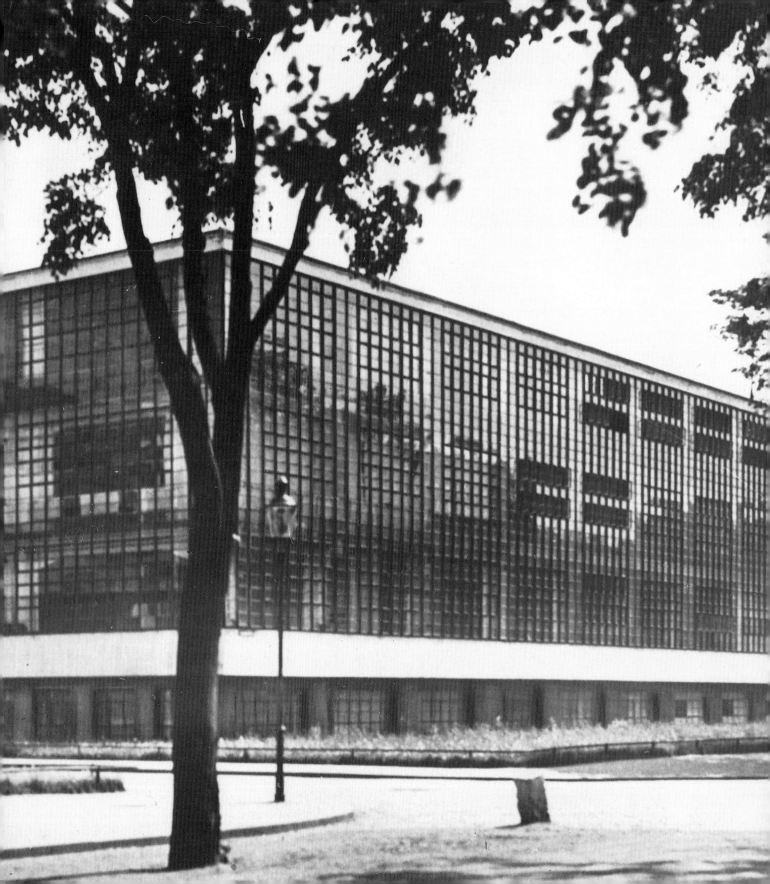

2 THE BAUHAUS

The object of the Bauhaus was not to propagate any
"style," system, dogma, formula, or vogue, but simply to
exert a revitalizing influence on design.[1]

Walter Gropius, from *The New Architecture and the Bauhaus*, 1937

The Bauhaus approach to type design was the same as its approach to all art and design—experimental. Walter Gropius, the founder and first director of the German art school, which operated from 1919 to 1933, said that all forms created at the Bauhaus emerged from an intensive, creative process of exploring form—with some thought for economic concerns.[2]

Gropius, a practicing architect and theorist and contemporary of Le Corbusier in France, believed, along with Le Corbusier, in the "common citizenship" of all creative work.[3] He aimed at eliminating the separation of fine artist and craftsman; rather, a person would be educated to be both. Craft training and fine art training would be united through a carefully planned course of study, which began with a required foundation course, or *Vorkurs*, that developed artistic talent. After completing their foundation studies, students entered a workshop—for example, wood, glass, or metal—and prepared to design for mass-production. Each class was to have two teachers, one for fine art (form master) and one for the technical training (craft master).

**The Bauhaus building at
Dessau of 1925–26**

Lithograph invitation to the Bauhaus opening ceremony, March 19, 1921, designed by student Karl-Peter Röhl

Radically altered through his military experiences in World War I (he had been buried alive during a bombardment),[4] Gropius saw architecture as the fundamental unity under which all the other arts flourished to improve the human condition, and, in 1923, he declared architecture and "design in a general sense" to be matters of national importance.[5] By the word design he meant all man-made visible surroundings, from "simple everyday goods to the complex pattern of a whole town."[6] The concept of the total work of art, the Gesamtkunstwerk, where a building, furniture, fabrics, clothing, and silverware were in the same style and spirit, usually designed by one person, was not new; the synthesis of all the arts had been attempted since the late nineteenth century.[7] But Gropius founded his entire art school on that concept. In Gropius's plan for the Bauhaus, architecture was the unifying art that all other design, from murals to ashtrays, supported.

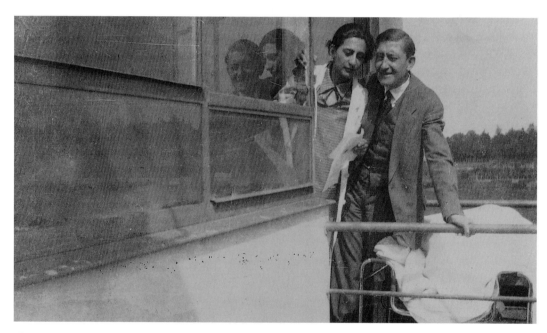

Photograph of Josef and Anni Albers taken by Marianne Brandt, c. 1927

THE EARLY EXPRESSIONIST BAUHAUS

Sharing with all Modernists the rejection of past period styles, Gropius invited instructors to the school who would pioneer design discoveries. Instructors Johannes Itten and Lyonel Feininger, described as "individual, expressive, and spiritual,"[8] dominated the Bauhaus at its beginning in 1919. For the first four years of the Bauhaus, Itten and Feininger strongly influenced Gropius, encouraging personal and subjective student work. The mystic, Expressionist nature of the early Bauhaus is often overlooked in concentrating on its later rational and geometric style or its technical and commercial achievements.

Wassily Kandinsky, *Three Geometric Shapes*, 1923. Kandinsky, a teacher at the Bauhaus from 1922 to 1931, issued a questionnaire asking foundation students to match the three primary colors to the three primary geometric shapes, to prove his theory that there was a corroboration between shape and color.

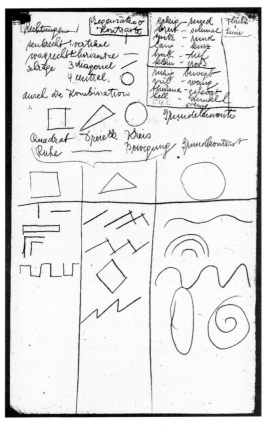

Page of a student notebook from Johannes Itten's *Vorkurs*, or foundation course, c. 1921

Student life drawing from Johannes Itten's class emphasizing lines of rhythm, c. 1921

Feininger, a painter and later a photographer, briefly supervised the print shop, but remained as a master without classes, and lost influence because he neither taught nor developed artistic theories.[9] Itten, a painter, introduced the highly influential *Vorkurs*, the famous required preliminary course at the Bauhaus. Itten gathered around him disciples of his Mazdaznan way of life, an ancient philosophy he had adopted that included religious meetings, vegetarian diets, and rooftop exercises before class. Itten's monklike appearance, reinforced by his ascetic program of living, exemplified the religious/spiritual nature of the early Bauhaus. But Itten's ideas did not prevail, and he left in 1923. The new tendency, carried forward by instructors such as László Moholy-Nagy, Josef Albers, Joost Schmidt, and Gropius himself, would be toward analytical, universalizing objective form.

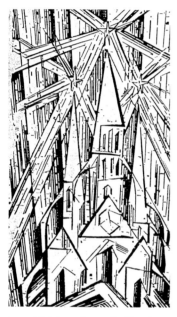

Lyonel Feininger's woodcut for the cover of the Bauhaus Manifesto of 1919, in which Walter Gropius stated his program for the school. Feininger's Expressionist woodcut for this cover reveals in form and subject matter—a cathedral crowned with stars—the spiritual aspirations of the new art school.

Lyonel Feininger's woodcut letterforms for the title page of the album *New European Graphic Art*, its style would soon be replaced. Printed and bound at the Bauhaus, 1921.

A hand-drawn and hand-lettered page by Johannes Itten for an early Bauhaus portfolio, 1921

Photograph of Lyonel Feininger
taken by Josef Albers in 1929

Lithograph invitation to the Bauhaus opening ceremony,
March 19, 1921, designed by student Karl-Peter Röhl.

Johannes Itten photographed at
the Bauhaus in a Mazdaznan
costume of his own design, 1920

DE STIJL AND THE BAUHAUS

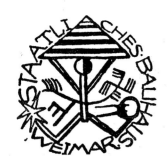

First Bauhaus seal, 1919–22. Initially, the Bauhaus used a seal with symbolic elements indicating its life-reforming ideals; they used this seal designed by Karl-Peter Röhl from 1919 to 1922.

Current historians of the Bauhaus claim that the person most responsible for the final suppression of the Expressionist Bauhaus was Dutch artist Theo van Doesburg.[10] De Stijl, a group of Dutch artists led by van Doesburg, formed in Leyden in 1917. Others sharing his views were painters Piet Mondrian and Vilmos Huszar, poet Antony Kok, sculptor Georges Vantongerloo, architect J. J. P. Oud, and designer Gerrit Rietveld. The preeminence of the rectangle, the exclusion of colors (except for the primaries red, yellow, and blue), and carefully composed asymmetry characterized De Stijl and reflected its aesthetic convictions. Committed acolytes applied its principles to architecture, typography, and furniture. Through the magazine *De Stijl*, they promoted "lucid, elemental, and unsentimental" art. In 1918 Mondrian pronounced De Stijl's principles to be a recognition of the unity of life, art, and culture.

Theo van Doesburg arrived in Weimar in 1921[11] and established himself in a student's studio. In the next year he began offering courses taken independently by Bauhaus students. He encouraged criticism of the Bauhaus. In *Mécano*, a publication that he edited, he published a drawing of a foolish-looking student holding a thistle (an object often drawn in Itten's classes) facing a constructed man, the rational student of De Stijl. De Stijl adherents referred to the pre-1923 Bauhaus as "Expressionist jam"; in other words, a mess: "Everyone does what they feel like at the time, with no discipline."[12] Van Doesburg attracted about twenty-five students to his classes, which supported the direction toward abstraction at the Bauhaus.

As Gropius would later write in his authoritative book of 1938, obviously referring to van Doesburg, "several other artists…attracted by the endeavors of the Bauhaus"[13] came to visit Weimar, giving lectures and attracting Bauhaus students—in effect, setting up an opposition camp. Van Doesburg waited for the invitation to join the masters' faculty, but it never came. Gropius wrote that van Doesburg's preoccupations were "not in harmony" with the Bauhaus ideal of education.[14] Van Doesburg's complex philosophy of art bordered on religion. Earlier, he had called Wassily Kandinsky "The Redeemer"; later, he rejected his early spirituality and detested the Itten–Feininger aspect of it at the Bauhaus. De Stijl advocated purging art of sentimentality, emotion, and individuality; banishing picture painting; and allowing color only in an architectural setting.

The change wrought by De Stijl is apparent by comparing the first Bauhaus seal with the official seal by Oskar Schlemmer adopted in 1922. Feininger's combination of symbols, crosses, a figure, and hand lettering showing the motifs allowed at the outset were now expunged and replaced by the geometric composition of the human head by Schlemmer.

De Stijl publication, 1923

A 1922 cartoon, by Bauhaus student Karl-Peter Röhl, ridiculing the foolish practices of Johannes Itten as compared with De Stijl's rigorous abstraction

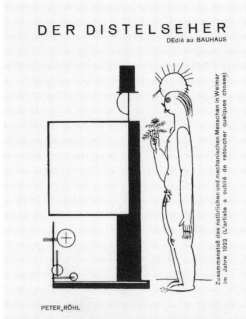

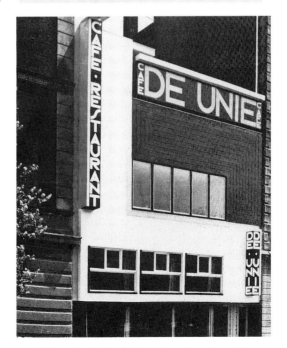

De Stijl façade of Café de Unie, Rotterdam, by architect
J. J. P. Oud, 1925

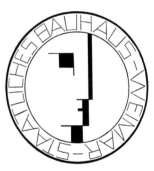

Second Bauhaus seal, designed by
Oskar Schlemmer, used after 1922

CONFLICTING DIRECTIONS
AT THE BAUHAUS

In May 1929, Alfred H. Barr, Jr., professor of art at Wellesley College, and later the first director of The Museum of Modern Art (MoMA) in New York, gave a series of lectures on European Modernism at the college.[15] Barr, recognizing the divisions at the Bauhaus, presented the school as a "paradox," posing Gropius as the visionary architect/executive in contrast with artists Kandinsky, Feininger, and Paul Klee—his "Expressionist counterpoints." When discussing typography, Barr showed the now iconic Hans Poelzig announcement and the Kandinsky exhibition poster, both by Herbert Bayer. By this time, Bayer's interest in typography had become identified with Bauhaus graphics.

The complex curriculum, changing faculty, and conflicts of personalities and theories meant that no single approach or style dominated the Bauhaus during its fourteen years of existence. The three architects who served as director—Gropius, Hannes Meyer, and Mies—had different ideological convictions, and led the school in different directions. Gropius conceived the union of fine art and craft, and the possibility of working with industry; Meyer, a Communist, emphasized social obligations such as housing; Mies, ambitious and enterprising, actually bought the Bauhaus and ran it as a private school in Berlin that made a profit until it closed after Nazi harassment.

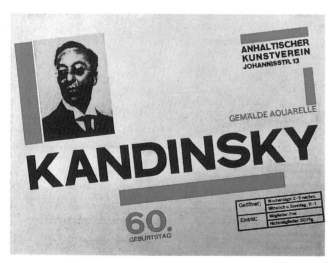

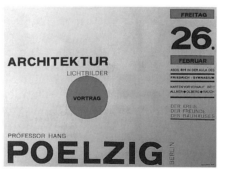

Poster by Herbert Bayer for a lecture by the architect Hans Poelzig at the Bauhaus, 1926

Poster by Herbert Bayer, printed in the Bauhaus printing shop, 1926. Bayer's use of sans serif types, bold rules, photography, and free composition relfect the new Bauhaus style.

Walter Gropius, c. 1920 Hannes Meyer, c. 1928 Ludwig Mies van der Rohe, c. 1933

TYPOGRAPHY AT THE BAUHAUS

At the outset, in Gropius's own plan, the Bauhaus workshops were to be stone (sculpture), wood (carpentry), metal (which became heavily involved in lighting), textiles, color (wall-painting workshop), glass, and clay (ceramics). The goal of all the Bauhaus workshops, such as weaving, furniture, or wall painting, was to furnish and enhance buildings designed in the spirit of the new architecture.

Typography was not initially a workshop at the Bauhaus. However, during the early years, publicity was needed for school projects: posters, exhibition invitations, announcements, calls for parties, etc. These printed pieces—lithographs, woodcuts, and engravings—were printed in a workshop equipped with hand presses left over from the crafts school preceding the Bauhaus. Until the experiments of Albers, Bayer, and Schmidt demonstrated that it conveyed the same spirit as other Bauhaus arts, typography was viewed as a lesser craft.

EMERGENCE OF TYPOGRAPHY, HERBERT BAYER

Gropius interviewed Bayer and accepted him to the Bauhaus in 1921. As a student, Bayer designed much of the school's publicity and advertising, and when the Bauhaus officially designated a typography and advertising workshop in 1925, Bayer—by then a Bauhaus master—became its director. Bayer wished to eliminate uppercase letters, a problem for text written in German since nouns are capitalized. As German architects rejected the peaked roofs of the German cottage as remnants of feudal, aristocratic domination of the worker, graphic designers saw the capitalized nouns as relics of the old world. Bauhaus efficiency entered here, since Bayer also had the novel notion that the shift key on the typewriter would become unnecessary if capital letters were eliminated. In addition, font and type cases could be smaller, so, he maintained, printers would spend less rent for space. After 1925 the Bauhaus banned the use of capitals on all printed matter: no poster, book, catalog, or card should use them. They broke this rule, however, constantly.

In his own type design, Bayer reduced every letter to the basic elements upon which he constructed his "Universal" type, which consisted of circles and arcs, three angles, and horizontal and vertical lines. His letterforms were sans serif, stripped to conform to a strict geometric model. His expressed wish was to design a type that could be used universally. His lowercase Universal alphabet moved, he thought, in the direction of "machines, architecture, and cinema" as an expression of its age.

Herbert Bayer, c. 1922

In 1923 the Bauhaus began to print a series of books on what Gropius called "the integration of cultural problems."[16] Faculty and contemporary design theorists such as Mondrian contributed to the series, but the first book was a record of the school itself, titled *Staatliches Bauhaus in Weimar 1919–1923*, or *State School for Building in Weimar*. The first book was printed in time for an exhibition showcasing the design achievements of the Bauhaus during its first four years of existence, as seen by Gropius and Moholy-Nagy.

Bayer, still a student, was chosen to design the cover, although Moholy-Nagy exerted control over the series, being the Bauhaus theorist of typography at the time. By the eighth Bauhaus book (1925), Moholy-Nagy called for "a new typographic language."[17] He wrote, "Letters should never be squeezed into an arbitrary shape like a square"—putting himself at odds with Albers, who was designing a typeface on a square grid.

TYPE AND THEORIES OF HERBERT BAYER AT THE BAUHAUS

Aim for legibility and clarity

Eliminate serifs and typographic ornaments

Use a geometric base

Use the same letterform for both lower- and uppercase

Use only lowercase whenever possible

Use fewer weights

Use the typewriter as an model for type design: regular, uniform size of letters

First Bauhaus book by Herbert Bayer, 1923. The letters extend to the edges of the square cover, filling the space with large capitals; the central symmetry of past periods is gone. The sans serif letters are a powerful early statement of the Bauhaus look.

Herbert Bayer's Universal Alphabet of 1928, showing proposed bold, medium, and light weights on the last line.

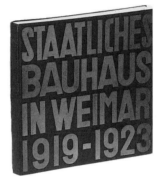

A contemporary interpretation of Herbert Bayer's Universal Alphabet from P22, a foundry that has copied some of the early Modern types for the computer

abcdefghijklmnopqrstuvwxyz

ELEMENTS OF A TYPEFACE, JOSEF ALBERS

Bauhaus type designers explored what letters could look like as a visually unified set of characters based on a premise. Albers's premise was to use segments from a geometric base. As a color theorist and painter, he organized his alphabet of 1925 on a square, triangle, and segment of a circle.[18] Later, in the United States, he would steadfastly focus on the square, developing a series of color studies that he called "Homage to the Square."

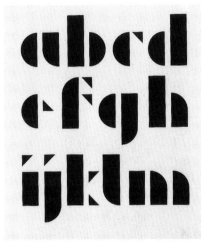

Letters from Josef Albers's Stencil Alphabet of 1925. For this alphabet Albers developed characters based on segments.

Josef Albers, c. 1931

During his Bauhaus years, Albers worked in glass, ceramic, and stained glass, and he carried knowledge of that medium into his letterform work, designing an alphabet in 1925 in white glass. His studies for the alphabet show an analysis of the ten foundational forms underlying letters. He then constructed each letter with these elements, with four heights. All letters met these criteria. The top line of the milk glass set shows the ten foundational forms.

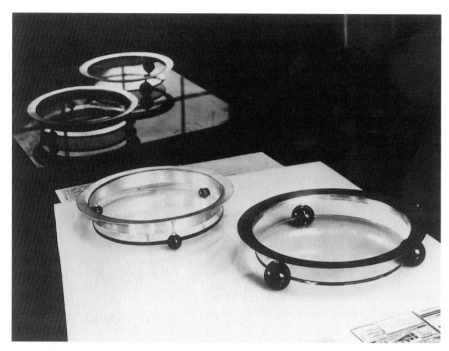

Josef Albers's circular fruit bowl, 1924. Albers combined basic geometric forms in a variety of media; here he rendered circles and spheres in glass and metal.

Josef Albers's lettering set made of milk glass on painted wood, 1926–31
The Museum of Modern Art, New York, Gift of the designer

ABCDEFGHIJKL
MNOPQRSTUVW
XYZ
1234567890

Revivals of Bauhaus typefaces today copy the look of Josef Albers's experiments, including this one by P22 Type Foundry.

STUDENT TYPOGRAPHER, JOOST SCHMIDT

Typical of the nonhierarchical structure of the school, the poster for the 1923 exhibition was designed by a Bauhaus student, Joost Schmidt. A painter and sculptor, he later became a master of the advertising and sculpture workshops at the school and continued to work with Gropius after it closed in 1933.[19]

Joost Schmidt's now famous poster for the Bauhasu exhibition of 1923

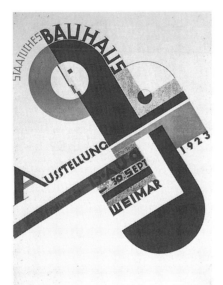

Joost Schmidt's analysis of the letter _a_

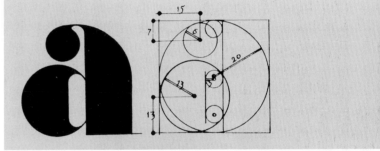

aocqeghknbpdsü
auxyegzfijlrtmwz

A portion of an alphabet designed by Joost Schmidt

Joost Schmidt

ARCHITECTURE AT THE BAUHAUS

When the Bauhaus moved to Dessau, Germany, in 1925, Gropius designed the new building for the school. He avoided axial symmetry, interpreting it as an architectural remnant of past periods,[20] and deliberately restricted himself to using certain basic forms—cubes, slabs, and rectangles—in concrete, and simple pipe railings.[21] The studies had enormous glass windows for studios, open roofs, and balconies. By this time, the Bauhaus commitment to geometric forms pervaded all the workshops, and subjective expression diminished.

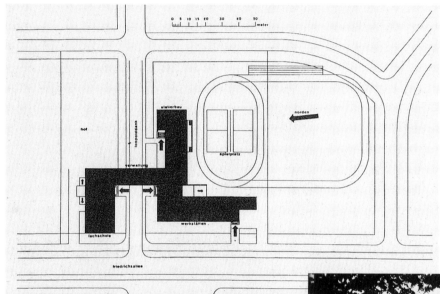

The asymmetry seen in plan of the main Bauhaus building of 1925 in Dessau reflects Natter Gropius's conviction that "the old obsession for the hollow sham of axial symmetry is giving place to the vital rhythmic equilibrium of free asymmetrical grouping."

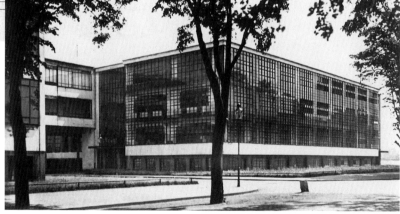

The Bauhaus building at Dessau of 1925–26, designed by Gropius and still standing today, is an architectural icon of the Modern movement. In post–World War II Germany, the school, then in East Germany, became solely an architectural training ground for public projects. No other art besides architecture was taught at the Bauhaus under the Communist administration.

Masters' Houses and the Director's House,1925–6. At Dessau Walter Gropius planned and built houses for the form masters, or fine artists, as well as his own house; all are based on cubelike forms in different combinations.

Walter Gropius's house

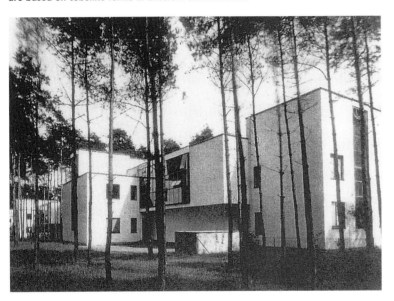

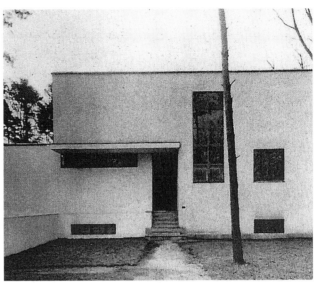

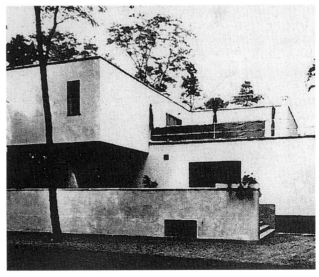

Side view of Gropius's house

NEW SOLUTIONS, NEW FORMS

**Marcel Breuer at the Bauhaus,
1925–30**

Gropius credited Marcel Breuer, a Master at the Bauhaus from 1925 to 1928, with the invention of tubular steel furniture. An early Breuer chair, from 1923–24, resembles an American executioner's chair, so rigid is it in its right angles, slabs, and unadorned wood and canvas parts. For this chair, Breuer seems to have relied on the "Red and Blue" chair of 1918 designed by the De Stijl artist Gerrit Rietveld. Later in the 1920s, Breuer devised a chair made from tubular steel. It became known as the Wassily chair—named after Wassily Kandinsky, another master at the Bauhaus—whose large size apparently seemed to fit the space-consuming chair. The Wassily chair advanced from the strict squareness of Breuer's earlier chair, whose rough straight lines were unrelieved by any curve.

In 1929, Josef Albers constructed a chair with only two pieces of wood, one piece of laminated beech wood for the legs and arms and another for the back. He claimed to have been the first to accomplish this structural feat.

**Marcel Breuer's early
experimental chair,
1923**

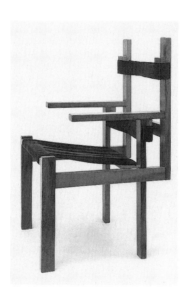

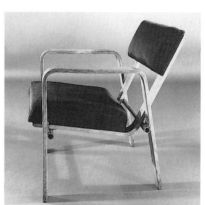

**Josef Albers's "Model ti 244"
armchair of laminated beech
wood and tubular steel with
canvas upholstery, 1929**

The Museum of Modern Art, New York, Gift of the designer

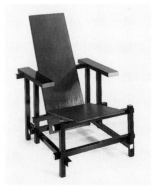

**Gerrit Rietveld's "Red and Blue" chair
of painted wood, 1918**

The Museum of Modern Art, New York,
Gift of Philip Johnson

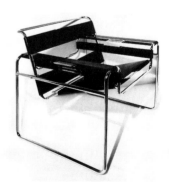

Marcel Breuer's "Wassily" chair, 1925

Photograph courtesy of the Marcel Breuer papers,
1920–1986, Archives of American Art,
Smithsonian Institution

Energetic Oskar Schlemmer directed the Bauhaus stage from 1923 to 1929. He designed experimental costumes with stiff padding, concealing the body and transforming human arms and legs into nongendered shapes in motion. Masks furthered the nonpersonal, objectifying quality of the actors. Schlemmer placed these padded forms on stage with precision, achieving abstract patterns. To dehumanize the figures and further emphasize the pure geometric forms, he painted the costumes with metallic paint.

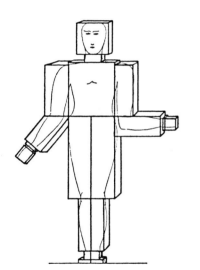 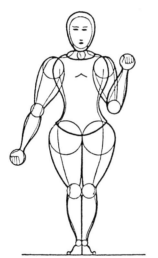

Figures for stage, c. 1927

TEXTILES AND WOMEN WEAVERS

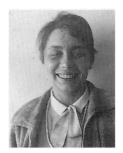

Gunta Stölzl was at the Bauhaus from 1919 to 1925, and an influential teacher of weaving from 1925 to 1931.

Gunta Stölzl and student weavers, 1927

Under the Weimar government's constitution, women in Germany could study anywhere. Many entered the Bauhaus. Although Gropius announced there would be "absolute equality" at the school, in reality women were routed into the weaving workshop, with pottery and bookbinding as second choices. And by 1923, Gropius prohibited women from the pottery workshop "for the good of the workshop."[22]

Discrepancies between proclamations and reality were typical of the Bauhaus. Gropius, as architect and autocrat, permitted only certain masters to advise him on policy. The crafts masters, though much lauded, were reduced to teaching assistants for students.[23] Prejudices against women were common among all the influential masters. They discouraged female students from performing "the very hard work of stone sculpture, carpentry…art printing."[24] Women were never involved in type design.

Gropius and the masters advised female applicants and students to work with wool and thread, a kind of elevated needlework. Gunta Stölzl surmounted these obstacles to develop a real Weaving Workshop with borrowed looms, and eventually was named a junior master, guiding large numbers of Bauhaus female students to careers in textile design. Tapestries, curtains, and carpets from the workshop and offices found their way into buildings designed by architects, as Gropius intended.

Yet, the prodigious output of wall hangings, rugs, blankets, curtains, and various fabrics from the weaving workshop are some of the most important indicators of changing aesthetics of the entire Bauhaus project. Early textiles reflect Expressionist tendencies of Itten and Georg Muche, the masters closest to the workshop. Their emphasis on creativity, with its component of play, showed in woven landscapes, rivers and clouds, faces, animals, and Christmas scenes. When Klee became a form master after 1923, he directed the women, who were anxious to be a real part of the Bauhaus, in overcoming the "playful elements."[25] Thus later textiles became abstract, with experiments in materials, technical proficiency, and a strong direction toward commercial production.

Early textile by Gunta Stolzl. Gunta Stölzl's tapestry abstracts forms from nature into pictorial landscape composition.

A later manufactured fabric designed by Gunta Stölzl, using synthetic materials in linear abstraction.

FINDING FORMS FOR FABRICATION

It was Johannes Itten, again, who was given the assignment of form master for the metal workshop. He supervised the design of objects for daily use, such as teapots, candlesticks, and boxes. When he resigned in 1922, it was influential Moholy-Nagy who became Form Master over the workshop; he encouraged the use of new materials such as Plexiglas, as well as new objects, not all in metal. He, unlike Itten, aimed to make prototypes for industry—one of Gropius's aims. Under Moholy-Nagy, the metal workshop produced many lamps, not previously encouraged in the workshop.

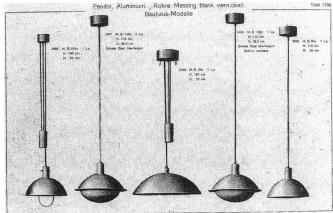

The Bauhaus provided many models of lamps for industry, shown in this 1929 catalog from Berlin.

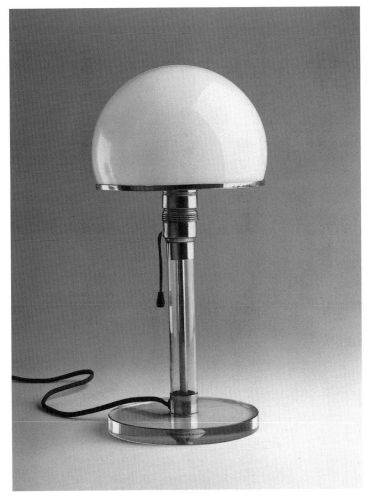

Wagenfeld table lamp of 1924, designed by students Karl Jucker and Wilhelm Wagenfeld. The model was supplied by Bauhaus Ltd. and typified the wish to work with industry, most fully realized by the lamps from the metal workshop. This successfully-manufactured design, which achieved harmony from simple forms and showed its functions with its transparent shaft, base, and pull, used industrial materials of metal and glass.

At the time when the school aimed to unite with industry for contracts, one strong-minded woman managed to get into the metal workshop. After a period of ridicule from male students, Marianne Brandt excelled, both as an artist and as a commercial success. She absorbed the circular and spherical aesthetic, and her brass and nickel ashtrays, tea services, and lamps are among the clearest examples of the elementary geometric form inspiring the school in its middle period. It was believed that basic geometric forms could be most easily mass-produced, and influential masters promoted the functionalism of simple geometric shapes. Her silver tea services with ebony handles reach a level of luxury incongruous with the social aims held by the school, but she was not alone in this paradox. Many models proposed for mass-production required laborious handcrafting.

Marianne Brandt, 1926

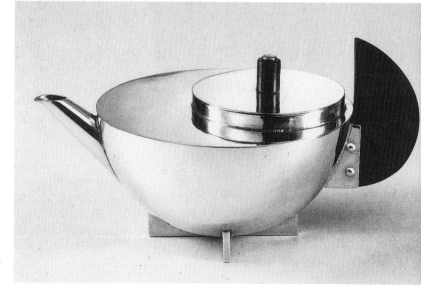

**Teapot in brass and ebony by
Marianne Brandt, 1924**

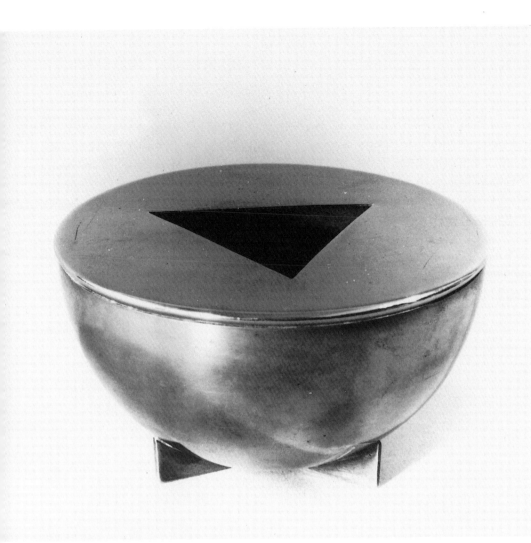

Brass ashtray, expressed in the reduced forms of sphere and triangle, by Marianne Brandt, 1924

Marianne Brandt lamp, 1926

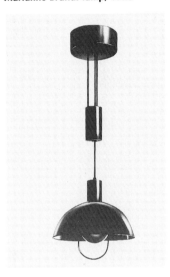

Inkstand in copper and nickeled brass by Marianne Brandt, 1924

THE LEGACY OF THE BAUHAUS

The paths of Tschichold and the Bauhaus masters Schmidt, Albers, and Bayer crossed at the 1923 Bauhaus exhibition at Weimar, mutually affecting each other's theories about type. Yet Tschichold had started from a different point than the Bauhaus masters—the former in commercial book printing, the latter in a progressive radical school environment that encouraged free experimentation. Certainly the example of Bauhaus colleagues—such as Schlemmer, Klee, Stölzl, and Gropius—creating new forms ranging from weavings to costumes for the Bauhaus theater and Modern buildings with matching furniture, along with the dialogue among them (which often occurred at the frequent costume parties that masters and students attended), must have reinforced bold ventures in type and graphic design at the school. Commercial printers, who needed to answer practical questions for a host of clients, based their typographic philosophy foremost on utility.

Today, the Bauhaus can be understood as a major, but not the only, source of Modernism. Its popularity, as one cynic remarked, is based on its name; the best thing Gropius thought of was the name "Bauhaus." It surfaced in the United States as the New Bauhaus of Chicago, while its émigré masters brought its teaching methods to the Department of Architecture at Harvard via Gropius and Breuer, to Illinois Institute of Technology via Mies, to Black Mountain College in North Carolina, and later to Yale via Albers.

The Modernism of the Bauhaus was established as the pinnacle of achieved Modernism, validated by MoMA in New York—an American advocate of Modernism—in its Bauhaus exhibition of 1938, which was supervised by Gropius. It is interesting now to recall the reception in the New York press of what became dogma. The book accompanying the exhibition, *Bauhaus 1919–1928*, edited by Walter and Ise Gropius with Herbert Bayer, became the classic and accepted understanding of European Modernism. Previously, MoMA had presented an influential architectural exhibition in 1932, "The International Style: Architecture since 1922," with its accompanying catalogue, affirming the "International Style" of Le Corbusier, Oud, and Mies (as well as Gropius) as dominant architectural Modernism. In 1934, MoMA's "Machine Age" exhibition showed objects exemplifying a Modernist engineering aesthetic of clean, functional lines. Today, with distance allowing criticism of the Modernist period and acceptance of its limitations, along with the possibilities of wider contexts and other narratives of design, these accounts have been supplanted by studies that introduce the possibilities of looking at design from other perspectives— from the viewpoint of feminism, sociology, philosophy, for example—of form creation or from any other discipline or approach. And later publications from the Bauhaus itself and others have thrown new light on different aspects of that important Modernist project.[26]

RECEPTION OF THE BAUHAUS IN AMERICA

At the 1938 opening of the Bauhaus exhibition, held for members of The Museum of Modern Art, interest was intense and attendance record-breaking. The show, held in the Museum's temporary quarters in Rockefeller Center, met with strong reviews in the New York press. They ranged from praise to scorn:

"An epitaph to the Bauhaus"—*Art News*
"A living idea"—*New York Times*
"A forlorn gesture"—*New York Sun*
"Clarity, emphasis, drama in the arrangement"—*World Telegram*
"Clumsily installed"—*New York Sun*
"Excellent character of the presentation"—*Retailing*
"The survey is chaotic…disorganized…cheap"—*New York Times*
"Magnificent textiles"—*Art News*
"Unfortunate textiles"—*New York Sun*

Readers wrote letters with opinions calling the show:

"A final *danse macabre*"
"Finest thing in existence"

The Bulletin of the Museum of Modern Art,
December 6, 1938

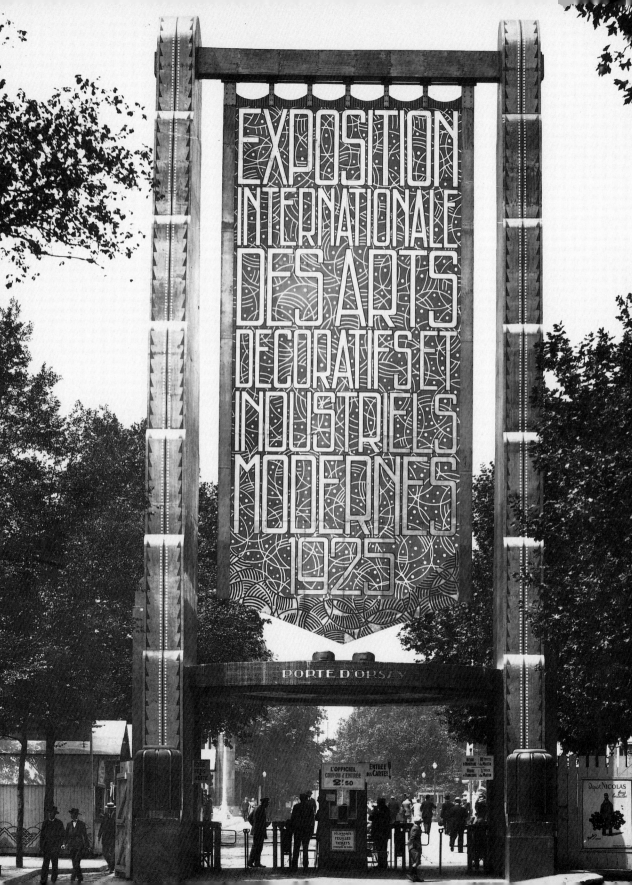

3 DUELING MODERNISMS

There is no reason for decorative art to exist; there is architecture.[1]

Le Corbusier, *L'Art Décoratif d'Aujourd'hui*, 1925

Confrontation describes the styles that came together in Paris in April 1925 at the famous *Exposition Internationale des Arts Décoratifs et Industriels Modernes*. While Paris department stores displayed luxury goods by the Seine on Pont Alexandre III, the De Stijl architecture of Theo van Doesburg and his Dutch colleagues was banned from the exposition,[2] and Le Corbusier's Pavillon de l'Esprit Nouveau (Pavilion of the New Spirit) was partially hidden by a screen. France had invited designers from other countries to the Expo with the knowledge that French decorative arts would not suffer by comparison. Design, industry, and retail had worked successfully together in Paris for years, producing fashion, interiors, books, fabrics, silver, and more to enhance urban life for sophisticated customers, making the French leaders in the decorative arts. What Walter Gropius laboriously attempted in Germany—collaboration between art and industry—the French tossed off in an abundant production of objects for the body, home, and voyage. Pavilions at the Expo were built to display French proficiency in the decorative arts with all the fantasy, novelty, and opulence that Americans would later experience in Art Deco–style movie theaters.

Gates to entrance of the 1925 *Exposition Internationale des Arts Décoratifs et Industriels Modernes* at the Porte d'Orsay

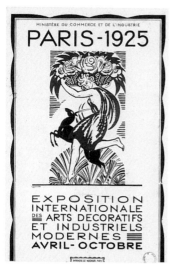

A poster for the Exposition by
Robert Bonfils, 1925

A double row of boutiques lined
the Pont Alexandre III, and other
pavilions spread around the river-
side and gardens at the 1925
Exposition.

Art Deco was an eclectic style, a mixture of sources that included Sergei Diaghilev's Russian ballets, Modern art (Cubism and Constructivism), and earlier exhibits of French decorative arts. Added to the Orientalism of Léon Bakst's ballet—with its luxe décor and costumes for the sensational Scheherazade— was the exoticism of ancient Egypt.[3] After archaeologists opened Tutankhamen's tomb in 1922, lotus and papyrus motifs, pharaoh's wigs, mummy motifs, scarab jewelry, and hieroglyphs appeared on French furniture.[4] From Mexico came the Aztec stepped-temple motif, and from contemporary artists, abstract curves, rainbows, and sun rays.[5] Designers chose motifs from many such sources, isolated them from their original, meaningful contexts, exaggerated their forms, and rearranged and reapplied them to objects both precious and mundane. Rendered in ballet's vivid colors, especially orange and jade, and luxe materials—gold, silver, and lacquer—all framed within the geometry of Modernism, the new style of Art Deco arrived.

This style became ubiquitous in the following years, appearing on everything from the smallest items, such as earrings and compacts, to the largest auditoriums all over the world. It adapted easily to typography. Its exaggerations and deviations, bulges, and overlaps all altered type's basic linear structure into planar surfaces on which to draw patterns. Art Deco, in its ornament and exaggerations, represented an opposing Modernism to the rationality and geometry of German commercial printers like Paul Renner and Jan Tschichold and Bauhaus theorists such as Lázló Moholy-Nagy and Herbert Bayer.

THE 1925 EXPOSITION INTERNATIONALE

Temporary pavilions occupied the area around the Grand Palais, and still more bordered along the Seine. The monumental entrance gates led to architectural fantasies erected by large French department stores such as Galeries Lafayette and Au Printemps. Pavilions promoting French furniture, accessories, textiles, publishing, perfume, silver, glass, and porcelain attracted crowds of visitors. Decorator René Lalique's glass fountain, illuminated at night, shot jets of water that inspired later Art Deco motifs of cascades, waves, and fountains.

ART DECO ARCHITECTURE

The pavilion designed for Galeries Lafayette combined fluted columns with figurative sculpted capitals and a gilded sunburst entrance portal, and exemplified the eclectic Art Deco architectural style created by French architects especially for this moment, presented to the international community, and launched to other countries. The pavilions were not of the spirit of Modern architecture as it was being defined by Le Corbusier, Gropius, or Ludwig Mies van der Rohe; instead, they were aggressively reactionary in their squat centrality, axial symmetry, and use of historical elements—columns, pillars, rooftop sculptures, and flights of stairs that rivaled the altar at Pergamum, but led only to display cases of kid gloves. Certainly their stubby proportions must have been partially determined by the site. But such exaggeration of form, along with the balanced plan and central entrance, ignored the achievements of Modern architects. From contemporary photographs of the pavilions such as those of Baccarat/Christofle (destroyed after the Exposition), we can see that one characteristic action of form was to pack abstracted nature motifs so densely into geometric shapes that they contorted and bulged within their limits; the adjoining walls were left totally bare, unencumbered, to provide a surprising, uneventful blank counterpart. Bas-reliefs with symbolic human figures, or varieties of deerlike creatures, sylphs, and fountains, were compressed into bands around the structures. The lotus bud column and the pylon from Egypt joined the abstract bas-relief.

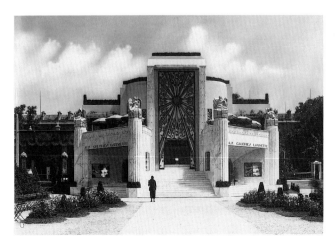

La Maîtrise, the pavilion of Galeries Lafayette

The irrational form of the pavilions is striking. Columns everywhere were thick and massive—supporting nothing, and used only for effect. The monstrous dome of Primavera, the studio workshop of the department store Au Printemps, dwarfed visitors; its size could have topped a palace. Everything was designed to attract the eye, and the great entrances were meant to draw people in to one-story merchandise displays in vitrines. Extravagance in materials, excess in amounts, and irrationality in proportions—these characterized the temporary structures that housed the displays.

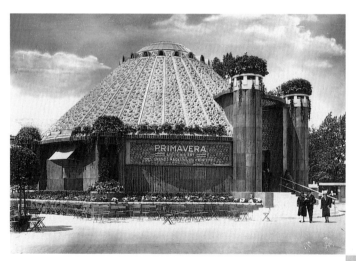

Primavera, the studio workshops of the department store and Au Printemps, 1925

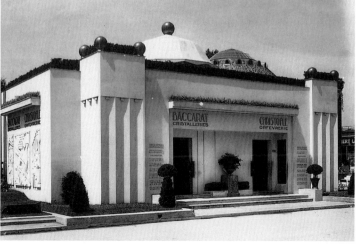

The Baccarat/Christofle pavilion with massive piers supporting only greenery exemplifies the irrationality of the pavilions, architect Georges Chevalier's design. Its packed decorative panel crowds all forms into a rectangle, leaving blank walls elsewhere. The pebbly lump of the Primavera dome looms in back of it.

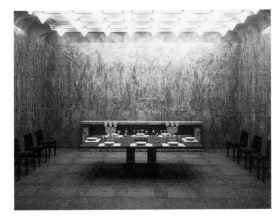

Lalique pavilion, Salle à Manger, designed by René Lalique. Art Deco's characteristic love of visually stunning effects is epitomized in the shimmering walls of the Lalique pavilion, constructed of etched glass in faceted glass triangles contained by ironwork, both of which became motifs for future designers.

Pomone pavilion designed by L. H. Boileau. The studio workshop of the department store Au Bon Marché presented an illuminated façade of metal and glass, and a surface riot of papyrus patterns, chevrons, arcs, and disks. Such elaboration of the surface on a squat, low support became characteristic of Art Deco–influenced forms, including typefaces.

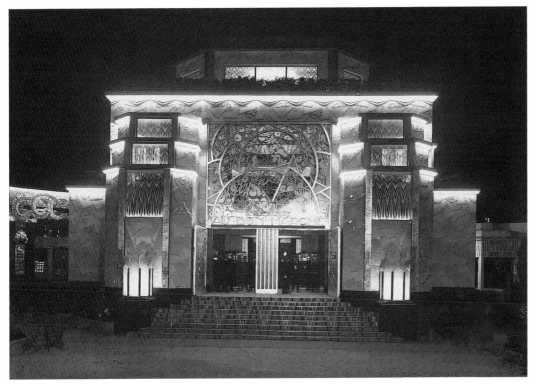

THE INFLUENCE OF RUSSIAN CONSTRUCTIVISM

Twenty-two international pavilions were included in the Expo. Some pavilions showed classical origins, some folk; some, like Czechoslovakia's pavilion, used symbolic slender nymphs. The Russian pavilion differed significantly from others. The architect Konstantin Melnikov built a Constructivist tower next to a glass-box exhibition building. Melnikov designed the pavilion in the manner of progressive architecture in the Soviet Union at the time. The stairway was angled to one side; its roof was an arcade of jagged beams. The timber slabs over the angled staircase and the open construction recall Vladimir Tatlin's tower and other experiments of the early Socialist state. Though the Art Deco style was more popular at the time, the Russian pavilion is closer to the look Modernism would eventually take. A glimpse of the future, this building had a big impact on Modernists.

RUSSIAN TYPOGRAPHY

In two Russian posters shown at the Exposition, a new typography is clearly evident. Here, letters are squat, overlapping, and widened into planes; diamonds appear as crossbars, exaggerated tiny counters, and stepped forms, triangles, and abstract shapes make these posters among the first Art Deco–looking typefaces.

Constructivist art was characterized by a new geometry: forms were analyzed, taken apart, and reused as separate elements, always with a daring visual sense of impact on the audience. Angled and overlapping forms appeared in Russian architecture, in paintings by Kasimir Malevich, in ads by Aleksandr Rodchenko and Vladimir Mayakovsky in the Soviet Union, and here at the Exposition in posters. Tschichold had mentioned the influence of Russian fine art and design in his essay in the October 1925 issue of *Typographische Mitteilungen* on "elementary typography." In that issue the manifesto of Russian Constructivism from 1920 was reproduced.

Leningrad poster at the 1925 Exposition: "A Heroic Poem in Ten Cantos, Red Partisans"

Russian pavilion

Russian poster for a new resort at Peterhof shown at the 1925 Exposition

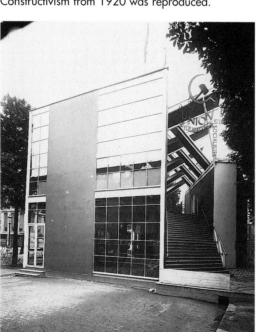

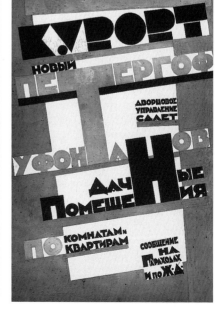

FRENCH TYPOGRAPHY BEFORE AND AFTER THE EXPOSITION

An entrance sign at the Porte d'Orsay (see page 54) indicates the state of French contemporary letterform at the time. Their Expo sign is only moderately tortured, with its elongated and condensed forms: the exaggerated and arbitrary lowering and raising of letterform parts. Letters that are usually round—such as an *s*—are here squared, the horizontals of the capital *E* are pushed near the top, and the horizontal of the capital *A* is pushed to the bottom.

The Exposition commissioned several artists to make publicity posters. René Prou's two posters for the Exposition show a letterform that was drawn, not typeset. It is an extended letter, flat and wide. The letters deviate from their usual widths, *N* being wider than *O*, and *E* wider than *C*.

In fine printed books, special editions, art books, and periodicals shown at the Exposition and dating from 1923, 1924, and 1925, wood engraving for illustration was favored over typographic design. Motifs from nature—nymphs, does, and woodlands—were prominent on title pages and magazine covers. Centered type arrangements were everywhere. Ironwork, a prominent French craft, was worked into cover illustrations. Hand-drawn letters on French posters became wide or cubelike, with a general extended feeling that was later carried into type.

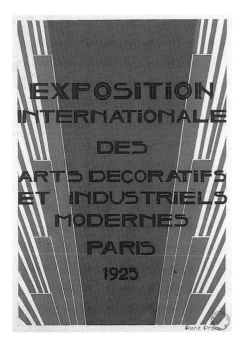

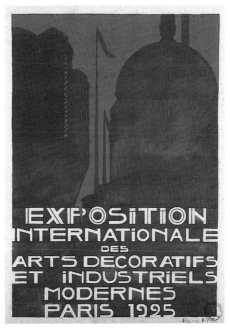

Two posters for the Exposition by René Prou. In the poster to the left, Prou has placed radiating sunrays in bright orange, red, and blue behind hand-lettered type, indicating an Art Deco–like feeling for form in his work.

Vignettes, drawn by Eugène Grasset, from the prewar offerings of the foundry Deberny & Peignot

Original Sphinx type specimen

Vignettes of Alfred Latour. These decorative type ornaments in a sharp geometric style were offered by Deberny & Peignot to be used with the new Sphinx typeface.

VIGNETTES

Official reports on the book section of the Exposition summarized the history of publishing design and placed current work in that tradition. They praised typographic ornaments, inspired by "French vegetation."[6] Wood engravings of borders, fleurons, and swags, and nymphs cut in wood by such French artists as Eugène Grasset to accompany existing typefaces such as Della Robbia, figured extensively in printing as a library of "vignettes" that were essential to the book design of the day.[7] In this tradition, Art Deco typographers designed typographic ornaments to go with their new typefaces.

DEBERNY & PEIGNOT: A FRENCH TYPE FOUNDRY

Deberny & Peignot had been a prominent type foundry in Paris since the nineteenth century. It created original type designs, and responded to the Expo style with another new typeface called Sphinx, which it issued in 1926. Whatever the specific source—Russian posters, Art Deco pavilions, or "Cubist" fine art—the resulting typeface was wide and black, compressed, short, and squat. The foundry offered Sphinx with the words that "its qualities respond not to a fashion but to a necessity."[8] Vignettes by Alfred Latour were made to accompany Sphinx; these kept the wide black planes of the type, the strong contrast between black and white, and the use of triangles, circle arcs, and sections, used in the traditional format of borders. Deberny & Peignot also issued Banjo, a font of capitals with two choices: extremely narrow or extremely wide. This 1930 typeface distorts letterform as a "modern" practice, and its name refers to jazz—trendy music for the French.

CARACTÈRE A DEUX CHASSES

AA B C(DD
EE FF G HH
I J K LL M
NN O PP Q
RR SS TT UU
V W X Y Z
Æ Œ Ç & C^(IE)
() . , ; : ' - «•» ! ?
1 2 3 4 5 6 7 8 9 0

Banjo type specimen, 1930. Characters with wide bodies became available as alternate characters, showing the preference for extended, short type as more in the "modern" manner. The word *modern* was sometimes used to appear up-to-date, and in this sense doesn't reflect the Modernism of Jan Tschichold, Le Corbusier, Walter Gropius, and others. Art Deco was thought "modern" because it was new.

CASSANDRE: A SPECIAL CASE

The Bifur[9] typeface is exceptional, as was its designer A. M. Cassandre. Cassandre was a painter named Adolphe Mouron who assumed the name Cassandre to keep his identity as a serious painter a thing apart from his typographic work. He designed posters, stage sets, and ballet backgrounds. Through his friendship with Charles Peignot of the Deberny & Peignot foundry, he designed type occasionally. He wrote that Bifur was conceived as "a vacuum cleaner or an internal combustion engine…not something ornamental." He shares here with Le Corbusier and other Modernists an admiration for machines, but Bifur appears to other eyes as an extremely eccentric typeface. Cassandre wrote of Bifur that "it was worked out as a precise problem…I want to stress the fact that Bifur is not an ornamental letter…. It is meant to answer a specific need, not to be decorative."[10] His Bifur seemed odd only because it was, in his words, "completely nude in a crazily dressed mob." A total departure from normality, this face takes linearity to the extreme. Half the strokes are omitted, and shaded shapes fill the counters or substitute for the missing strokes. Paradoxically, Bifur is all capitals, whereas Bayer and colleagues advocated lowercase only a few years before.

In 1937, Peignot, another type designed by Cassandre for the Deberny & Peignot foundry,[11] became popular. A sans serif letter with eccentric mannerisms, Peignot's lowercase letters are actually small capitals, except for a few—*b*, *d*, and *f*. This strange but popular typeface elongated certain strokes, such as the stem of the *h* and the *k*. And it pushes the main stroke to be overthick. In this it exaggerates like Art Deco, so Peignot continued the Art Deco style into the late 1930s and beyond.

Specimens of Bifur from Deberny & Peignot (above and top)

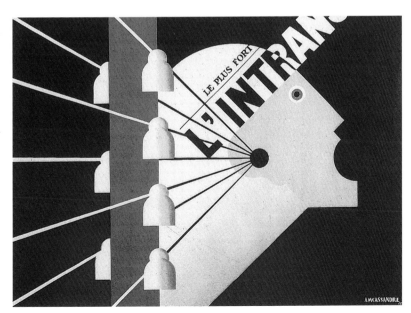

L'Intransegeant. Le Corbusier set out his theory of tracés regulateur, regulating lines or regulating diagrams, and it was adopted by Cassandre in designing posters for Paris walls. As an "architectural" poster maker, Cassandre considered how a poster related to the walls where it was posted.

Bifur type ornaments

Peignot typeface, 1937

THE NEW SPIRIT

Le Corbusier declared his thoughts on the design of objects—furniture, equipment, and all fabricated objects—in the pages of his journal *L'Esprit Nouveau* (The New Spirit). He questioned the need for decoration of any kind, praising work that served, not mastered, human needs—work that had the "character of a good servant that effaced itself to let its master be free."[12] Admiring machine-made utensils, he deplored the arbitrary superficiality of Art Deco objects. His journal carried pictures of turbines, automobiles, ship cabins, filing cases, and dentists' work tables[13] as designs to emulate. But radical Modernism lost to commerce at the Expo. Fashionable luxury appealed to a public largely unaware of the zealous, reforming Modernists like Adolf Loos, Le Corbusier, or Gropius and their demanding and austere forms.

In the pages of *L'Esprit Nouveau*, the new spirit manifested itself in cinema, sports, architecture, music, the "esthetic of the engineer," costume, furniture, and modern life. The journal's editors aimed to demonstrate that the current epoch equaled in beauty any period in the past. Largely due to Le Corbusier's passionate convictions, the journal spread the principles of Modernism, its pages advocating the idealism and hope inherent in this movement. Since the design profession he knew best was architecture, design such as typography received little attention, and the journal itself was undistinguished in type and appearance, using Didot and other existing French fonts, and carrying only two articles on typography during its entire run.

In an article called "Les Types," its author, "Christian,"[14] defines letters as the "exterior sign of the spirit." Le Corbusier's publication looked for evidences of the new spirit, but found it more often in works of the engineer than the typographer. Again, as in the *Report of the Section of the Book* at the Expo,[15] the writer recapitulates the history of letters and the alphabet to propose that they reached their highest point in French achievements of the recent past. Christian cites Mayan ideograms and the theories of the poet Arthur Rimbaud about the colors of vowels to explain the symbolism—the "mécanisme cérébral" or mental process—by which we understand letters and words. The alphabet is "a gift of the gods," but it is not perfect, and the writer ponders the usefulness of a new set of characters, of eliminating accents, and of simplifying the printers' type case, removing useless characters, reducing them to about 150 from 250. According to the writer, type design since Johannes Gutenberg's time reaches its fruition in Didot, one of the great eighteenth-century Parisian type founders who cut the first "modern" typeface in 1784. Type and book printing has been a continual progress toward "clarity" (the watchword of Modernism), even if that clarity is not seen or mentioned in any current model by this author. Deberny and Peignot's typefaces from the French past are mentioned: Garamond, Plantin, and Cochin, in addition to Didot.

Étude de Henri
A LOUER
21 BAINS

Type from L'Esprit Nouveau. This type shows there was no adoption of Tschichold's principles of new typography or those of the Bauhaus by Le Corbusier for his own publication.

> A great epoch has begun. There exists a new spirit.
> There exists a mass of work conceived in the new spirit.[16]
>
> Le Corbusier, *Vers Une Architecture*, 1923

The author considers the keyboard of the typewriter, and the telegraph operator's code. He concludes that the condensed code of the telegraph operator is correct, because of its acceptance by the world. One cannot argue with success. At times inconsistent, mourning the sacrifice of ornament to readability and the folly of designing new characters,[17] the article seems to conclude reluctantly that the will of the machine must be obeyed. That there will be little fantasy, fewer letters, no flowers, humanity, or sentiment—just a "march to the rules of the machine and geometry, everyone applauding the machine," even those who "would die rather than bruise a rose petal"—is *L'Esprit Nouveau's* last word on typography.[18]

THE NEW SPIRIT IN ARCHITECTURE AND FURNISHINGS

Le Corbusier designed the Pavilion of the New Spirit at the 1925 Expo midway through construction of his series of villas in and around Paris, begun in 1922 and culminating in the Villa Savoye of 1928–31. These white boxes present a sharp, pure profile, stripped of cornices, volutes, thick pillars, and shimmering surfaces. Their geometric forms—cubes and cylinders—define living spaces. Their spirit seems an architectural expression of principles similar to those of his Purist paintings, begun in 1918, where ordinary objects were presented in the manner of classical nudes: dishes and bottles caught in time, calm, devoid of color and movement, suffused in pale and pearly light. His principles of clarity and order, logic, and simplicity, explored in his paintings, appeared in his buildings.

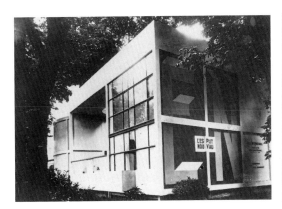

Pavilion of the New Spirit at the 1925 Expo, exterior

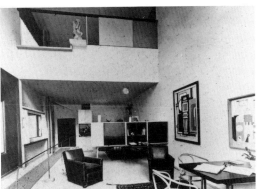

Pavilion of the New Spirit, interior

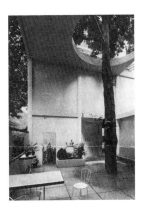

Pavilion of the New Spirit, courtyard with tree

Le Corbusier had been approached by the architect Robert Mallet-Stevens, a relative of a high official at the Exposition and an architect in the Modern spirit who admired Le Corbusier. Mallet-Stevens proposed that "it would be a big attraction if we could have some houses built natural size."[19] Le Corbusier took this opportunity to construct one unit for an ideal city. The Pavilion of the New Spirit was a two-storied cube of unadorned concrete construction, with windows letting in light on two floors, and a terrace for outdoor living. Thonet chairs and Purist paintings, all functional and simple, adorned his "machine forliving." Most startling was the circle cut in the terrace ceiling for the existing tree to continue its growth toward the sky, demonstrating Le Corbusier's aim to embrace nature, always, within his concrete steel and glass houses.

Le Corbusier's Purist period corresponds to the aim for pure form pursued by type designers like Renner, Rudolf Koch, and Jakab Erbar, and to pared-down and functional clothing of fashion designers such as Gabrielle "Coco" Chanel. Le Corbusier's Purist rooms were inspired by the simplicity of an Italian monastery he had seen years before. The suggestion that a homeowner should sleep in a cell is not as odd as it seems, when one becomes aware of the sensuality of forms as treated by Le Corbusier. Pure

LE CORBUSIER'S FIVE POINTS OF ARCHITECTURE (1926)[20]

Le Corbusier saw his principles permitting a completely new aesthetic—lighter, freer. They had no relation to the building of previous epochs, he stated. His white box houses of the 1920s exemplify his principles.

1. Replace foundations by individual supports, or posts. Placed at equal intervals, calculated exactly to bear their load, they raise the structure above the ground, increase airflow, and permit entrance to the ground floor garage by automobile.

2. Roof gardens. A flat roof provides a place for a livable terrace and a roof garden, and can be used for sun, air, and exercise.

3. Free ground plan. Because the supports carry the weight of the building at specific points, the interior walls can be placed at will.

4. Horizontal windows. Since there is no heavy masonry support, there is no need for windows to be cut into it. There can be long horizontal ribbon windows extending from support to support. More light flows into the interior of the building.

5. Free design of the façade. The supports actually support the weight of the building while allowing the floors to project beyond the supporting posts. The façade of the building can thus be designed in any way desired.

form, played against other forms, elaborated with invention and variations, produced delights—his goal. "Simplicity is not equivalent to poverty," he said. "It is a synthesis, an intellectual act that achieves 'crystallization,' or, as in other design, achieves perfect forms in complicated interactions."

Le Corbusier's white box constructions of the 1920s culminated in the Villa Savoye (1928–31). Here he saw his five principles of the new architecture realized: *pilotis*, or slim steel columns that raised the box above its site; the open plan; the free (nonsupporting) façade; horizontal windows; and roof gardens. Set in a squarish meadow, the purity of the villa's white envelope is stunning, as is its interior, with its fantasy of forms: ramps and the spiral staircase; striated light slanting through large windowpanes; changing views of the meadow seen through long bands of windows; the interplay of up and down and of outside

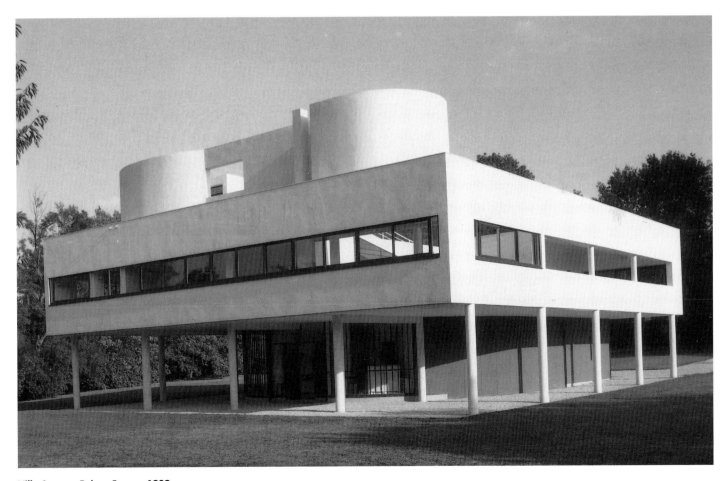

Villa Savoye, Poissy, France, 1929

and inside; and curves of glass and curves of concrete—all managed with contemporary functional materials such as tubular railings, rubber carpeting, and steel doors. A few chunky armoires and ceramic tiles in the architect's preferred colors of the period, royal blue and emerald green, add color to the interior. Le Corbusier's architecture epitomized the spirit as a treatment of form dedicated to a new way of living. He named the Villa Savoye *Les Heures claires* (The Light-filled Hours), reflecting the bright, free life for which Modern architecture yearned—and here achieved.

Villa Savoye, exterior corner showing supporting pilotis, which permit the free plan and continuous window bands

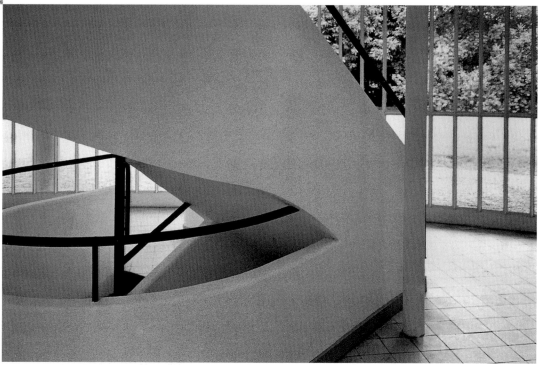

Villa Savoye, interior with spiral staircase and light-admitting glass walls on entrance side

The French admitted women—for example, Eileen Gray and Charlotte Perriand—to the practice of architecture, differing from the brotherhood of Gropius and Mies in Germnay. In 1927, Le Corbusier employed in his atelier a talented twenty-four-year-old woman, Charlotte Perriand, who designed furniture later signed by Le Corbusier, Pierre Jeanneret, and herself.[21] Their leather and steel chairs were radically different from furniture on exhibit at the 1925 Exposition. Perriand disparaged furniture by craftsmen such as Émile-Jacques Ruhlmann as the continuance of an old, dead tradition. For her own work she used the word "equipment" instead of furniture and committed her talent to the Modern aesthetic, which she called the "world of steel and glass."[22]

Architect and designer Eileen Gray mastered the lacquering process, and her screens, lamps, and interiors popularized her name. Her work started in the tradition of French decorative crafts, but she moved to an original style in her furniture and architecture. Using her own houses as a laboratory, she worked with tubular chromed steel and other modern materials. Her treatment of surface—layering ornamental lines and shapes for dazzling effect—is an Art Deco trait. While her "Bibendum" chair has the bulging rigidity of squat Art Deco carried to massiveness, her linear and more ergonomically functional Transaat chair is as much in the spirit as Marcel Breuer's or Josef Albers's designs.

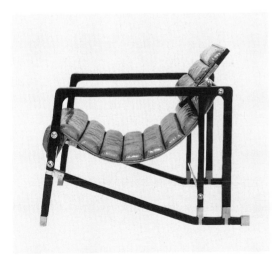

Transaat chair, designed by
Eileen Gray, 1924

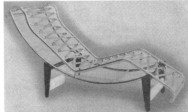

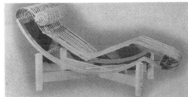

Experimental lounge chairs
designed by Charlotte Perriand

Cover of a book about
Charlotte Perriand's work, showing
her in a chair of her own design

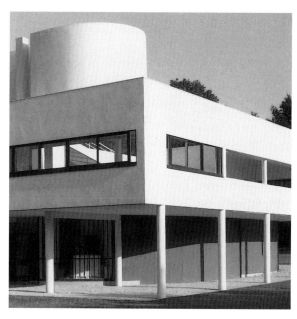

Detail of Villa Savoye. Its unadorned structural honesty made it an icon of early Modern architecture

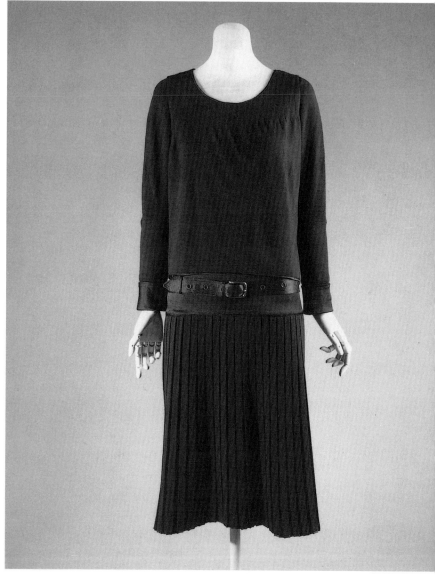

"The Dress of the Century" in black wool jersey and silk satin, designed by Coco Chanel, c. 1926

The Metropolitan Museum of Art, Gift of New York Historical Society, by exchange, 1984

Quote by Le Corbusier set in Futura (top) and Kabel (bottom)

Lack of truth is intolerable, we perish in untruth.

Lack of truth is intolerable, we perish in untruth.

THE NEW SPIRIT IN COUTURE

Coco Chanel's revolution in fashion was as revolutionary as her contemporary Le Corbusier's was in architecture, though she issued no manifestos. In the less monumental and less complex field of couture, nonetheless, Chanel worked in the new spirit, shown here (see opposite page) in her dress from 1926, called "The Dress of the Century."[23] In one black dress it incorporates many principles of Modernism: the exclusion of ornament (stripping), freedom from tradition, and geometric simplicity and utility. The dress does not conceal how it was made: it shows how the belt works, what it is for, and where a natural waist falls. It relates to human functions: you can walk in this skirt, since the pleats expand to make striding possible. The neck is free, allowing the wearer to turn and look around the street as she walks (function). The grommets that close the belt holes are as industrial as the pipe rails on Le Corbusier's villas of the same years. Chanel ignores traditional French decorative embroidery, a treasured national craft. She rejects lace and appliqué in favor of wool jersey, formerly used for men's underwear. Le Corbusier in a similar innovation made his villas for the rich out of concrete and pipe railings, not marble or stone. Chanel's talent constructed this original costume in the spirit of the new age. Le Corbusier, who extolled the aesthetic of the engineer, might have recognized Chanel as an engineer in couture. She stands with Le Corbusier, Perriand, Adolf Loos, Renner, Bayer, and Albers opposing Art Deco, not with Bakst, Gray, Lalique or the pavilion of Galeries Lafayette.

Villa Stein at Garches, rooftop with spiral staircase and rail. Le Corbusier's "shipboard aesthetic" is apparent in his 1927 villa at Garches, where spiral staircases lead to a rooftop lookout. Guided by industrial pipe railings—their arcs forming part of the overall linear and geometric exactness of the large house—visitors climbed to the top to explore the surroundings.

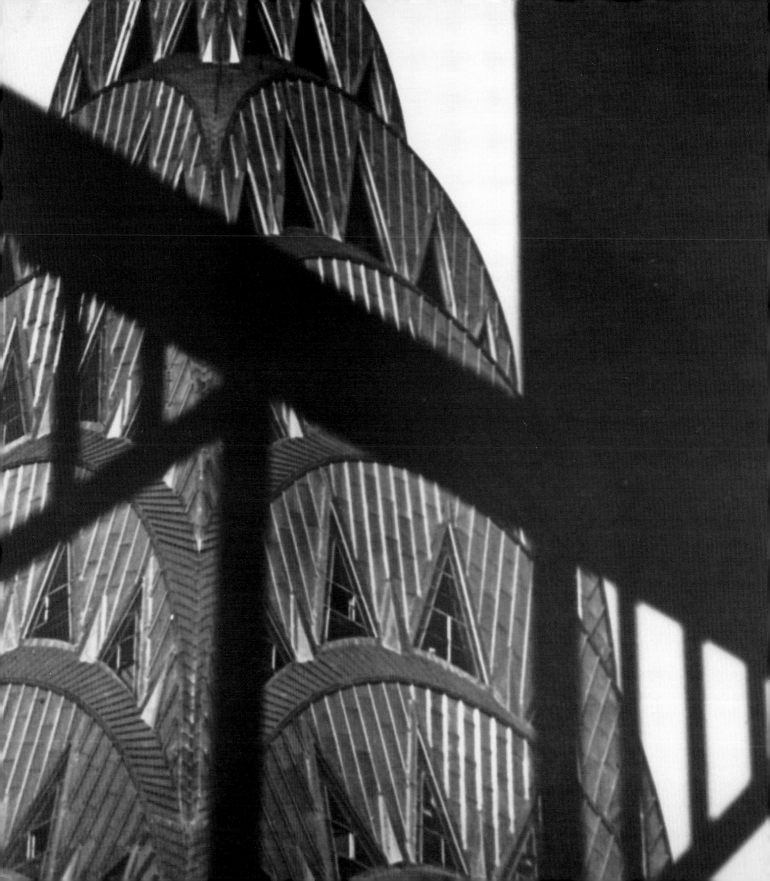

4 NATIVE AND IMPORTED FORMS

The soul of twentieth-century America, daring, inventive, susceptible to size, eager for novelty, spurred on by a conquering quasi-Elizabethan vitality and groping for expression, found it in the skyscraper.[1]

Alfred C. Bossom, *Building to the Skies*, 1934

A complex reaction to European Modernism uniting Art Deco elements with American engineering achievements resulted in the great American skyscrapers of the 1930s. Art Deco motifs were applied to skyscraper façades and the interiors of movie palaces. Romanced by this new American form, British architect Alfred C. Bossom proposed that the clear North American light that inspired the stepped form of the Mayan temple was also at work in the form of the modern skyscraper, though more rational explanations can be found in public policy (see "The Skyscraper's Stepped Form," page 76). With steel framework, elevators, and skilled labor, "building to the skies" introduced a verticality that was caught in type. The attenuated lines of typefaces like Huxley Vertical, Empire, and Slimline caught the feeling of fantasized 35-story buildings and of the actual 102-story Empire State Building of 1931.

Spire of the Chrysler Building, 1928–30

A prominent element of Art Deco ornament was the triangle, often found in ironwork, title pages, and façades in Paris, and repeated in arcs in the Chrysler Building spire (see page 72), on a couture black net dress of the period, and in an Art Deco typeface, replacing a stroke. The dazzling effect of the triangle form, especially in stainless steel on the building , reflected light and gave the desired Art Deco shimmer.

The 1930s later saw a relaxing of the pure geometry of the 1920s. Some European designers, like Marcel Breuer and Josef Albers, were already on the way to softening their early rigid geometric shapes, mastering materials that made new lines possible. In America a slinkiness and slimness, with drooping and sloping lines, appeared fashionable. Limp curves and attenuated forms coexisted with harder, jagged elements from Parisian Art Deco—its zigzags, faceted surfaces, rainbows and sun rays, shiny metallic surfaces, gemstones, and gazelles. Exotic influences entered American architecture and design from the Paris Exposition, though not all exoticism cherished in Paris traveled well (the "turbaned blackamoors" who delighted French audiences were not popular in the United States).

Letters A–F from an Art Deco alphabet

The Oasis screen, one of the most admired objects in the 1925 Paris Exposition, was designed by the French iron smith Edgar Brandt with the architect-designer Henri Fabier. Its fronds and fountains became popular Art Deco motifs. Brandt exported his very successful Art Deco designs to America by establishing a New York branch of his ironworking business in the 1920s.

Private Collection

Detail of black net dress, heavily embroidered with silver and black beads, c. 1928

The Metropolitan Museum of Art, Gift of Madame Lilliana Teruzzi, 1981

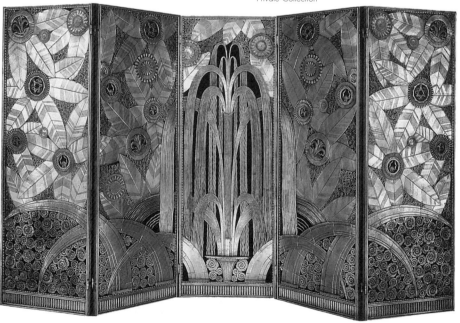

THE AMERICAN RESPONSE TO THE PARIS EXPOSITION

The United States had been invited to participate in the Paris Exposition of 1925, but had declined to show American decorative arts on the grounds that American craftsmen only produced "imitations and reproductions of ancient styles."[2] However, the Secretary of Commerce, Herbert Hoover, responding to pressure from American manufacturers, appointed three commissioners who invited more than a hundred manufacturers to visit the Expo.

The Americans were enthusiastic over the pavilions, calling them "a Cubist dream."[3] New York department stores soon dressed their windows in the new style. Works from the Expo were shown in 1926 at The Metropolitan Museum of Art in New York and then around the country. In 1927, Macy's put on an exposition of art in industry, showing furniture in the Art Deco style; other stores did the same. The Paris Exposition style, as it was perceived to be through these influential presentations, had an immediate and forceful impact on American design.

The highly sophisticated excellence of objects at the Paris Exposition, designed by Émile-Jacques Ruhlmann in furniture, René Lalique in glass, Christofle in silver, Edgar Brandt and J. Martel in decorative ironwork, and hundreds of other designers and craftsmen in other mediums eventually was imitated and manufactured worldwide in countless objects, from luxury objects such as jewelry—bracelets and brooches, especially—and apartment décor, to lesser copies that eventually degraded the style. But in the skyscrapers of the period in New York , it introduced new beauty to utility.

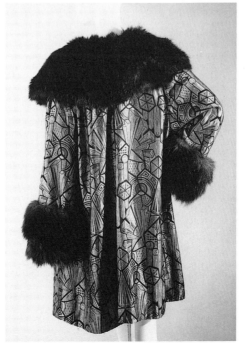

An American evening coat of the period (c. 1928) worked Art Deco motifs into a typical luxe weave of gold, black, and yellow silk. It piles skyscraper towers together in dizzying perspective and surrounds them with Art Deco hexagons, lines, circles, and rays. The flashy opulence of the coat is undermined by the brown-dyed skunk-fur trim. The chaotic surface of the *Oasis* screen (opposite) and the gold coat, densely packed with geometric, abstract bands and lines and rigid shapes on shimmering materials, typified the abundant, crowded surfaces seen in so much Art Deco. Dazzling, brash, and irrational, the coat and screen show Art Deco's eventual turn into spectacle and sensation.

The Metropolitan Museum of Art, Gift of the Fashion Group, Inc., 1975

ARCHITECTURE:
NEW YORK CITY AND ART DECO

Although the skyscraper originated in Chicago, a spurt of construction in New York between 1927 and 1931 meant that engineering coincided with the fashionable ornamental style of Art Deco. A series of extraordinary buildings united both, making the interwar period the "Great Age of the American Skyscraper."[4] Pavilions of the French Expo, like the Galeries Lafayette, had achieved, paradoxically, monumentality in chunky, low-rise structures—combining massive sunbursts over small entrances, and evoking grandeur through gilded allegorical sculptures atop nonsupporting columns. Exaggerated like all Art Deco, these pavilions were illogical and stunning. The skyscraper, on the other hand, conceived by rational engineering, rose on steel skeletons to super heights and achieved awesome, legitimate monumentality.

THE SKYSCRAPER'S STEPPED FORM

Civic concerns of New York determined the stepped-back form of local skyscrapers. The Equitable Building of 1915 was an oppressive addition to the urban landscape; having been built to the extremes of its site—a full city block—it cast a shadow of seven acres. To prevent further gloomy caverns, the New York City zoning law of 1916 provided formulas relating the size and height of the building to the width of the street. After a certain number of stories, the building had to be set back. Then it could continue to rise to a certain point, where another setback was mandated. Skyscrapers built from 1916 to 1960, when a new law was passed, conformed to this law, giving New York its "setback," or stepped silhouette. The skyline of the skyscraper city, New York, developed from municipal policy, not temple worship—although Bossom's poetic theory appeals to native North American pride.

The stepped form appeared in letterforms as well as buildings. In 1931 Robert Foster designed Foster Abstract (top), a typeface with stepped arrangement of parts, as well as chunky, jagged strokes and the Art Deco zigzag. Foster Abstract shares Art Deco's feat of seeming monumental in 72 points. Several decades later, the stepped form was still potent to inspire letterforms, as seen in the typeface "Baby Teeth" (bottom), designed by Milton Glaser and George Leavitt in the mid-1960s to the mid-1970s.

HOTEL NEW YORKER, NEW YORK CITY

This period postcard of The Hotel New Yorker, at 34th Street at 8th Avenue, built in 1930, clearly shows the step-backed effect of New York City zoning law.

Private Collection

THE CHRYSLER BUILDING

The Chrysler Building, designed by William Van Alen and commissioned by Walter Chrysler, the automobile manufacturer, was the tallest building in the world when it was completed in 1930.[5] The spire, radiating sharp steep triangles on four sides and filled with faceted metal plates, shines like an Art Deco beacon. Unique features distinguish the building, such as the automobile motifs of hubcaps, and wheels in a frieze. Gargoyles stick out against the sky in unforgettable silhouettes. At the entrance level, angled glass (or black glass) catches the light; on other parts of its façade, zigzags, crenellations, and beveled metal triangles do the same. In a well-known essay[6] that he wrote at the end of the nineteenth century, the Chicago architect Louis Sullivan wondered whether "brutal" commercial structures could attain the "graciousness of higher forms." The great Chrysler Building can be seen as an answer to Sullivan's question of making art out of tall buildings.

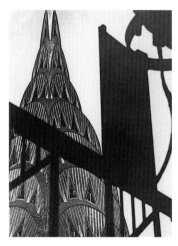

Spire of the Chrysler Building

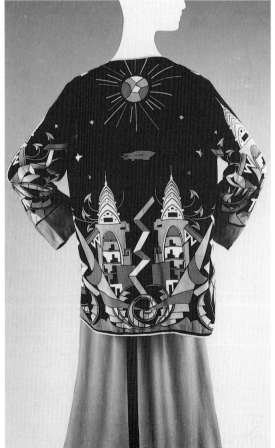

The Chrysler Building was so popular that it appeared in couture, as here in an American costume of the period. This day ensemble from the mid-1930s was made of dyed rayon crepe, multicolored for the top, solid red for the trousers.

The Metropolitan Museum of Art, Gift of The Jacqueline Loewe Fowler Costume Collection, 1996

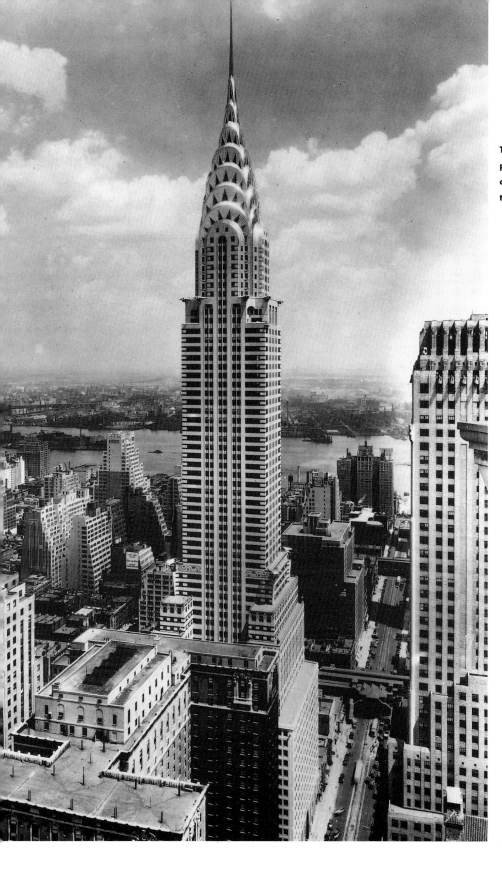

The Chrysler Building, 1928–30. This period photograph was taken soon after the completion of the building, when, for a brief time, it was the tallest building in the world.

THE CHANIN BUILDING

Erected at the corner of Lexington Avenue and 42nd Street in New York between 1927 and 1930, the Chanin Building is one of the first and greatest skyscrapers. Opulent ornament in terra-cotta and metal covers its exterior and interior, and specially commissioned radiator grills, gates, and elevator doors in the lobby—designed by the French-born ironworker Jacques Delamarre—add further embellishment. The elegance that Modernists in Europe had achieved in the individual villa, factory, store, or even the low, spread-out housing project, was now achieved in America in the native-grown skyscraper.

The Chanin Building's surfaces provided opportunities for bands of contorted leaf and plant forms and stylized human figures; for zigzags, spirals, and fronds on elevator doors; and for patterned walls and etched glass in private offices. Perhaps architects welcomed the reappearance of packed surface decoration, since it had its American precedent in the ornamented buildings of Sullivan and other Chicago architects of the nineteenth century.

A sign from the Chanin Building on the Lexington Avenue side shows the expanded stems of Art Deco types, affording a planar surface to decorate with Art Deco motifs. Here the wavy lines seen in Art Deco objects such as screens and rugs have found their way onto the exaggerated, flat metal surface of this Deco typeface.

In bands of decoration on the Chanin Building, rioting forms— plant, animal, and human—are bound by geometric limits.

This Chicago auditorium from 1889, by Louis Sullivan and Dankmar Adler, is an earlier example of American architectural ornamentation.

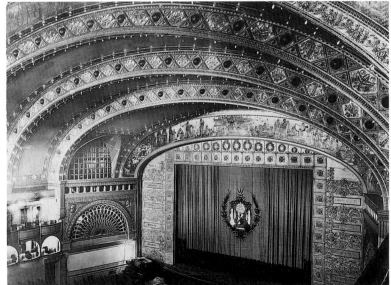

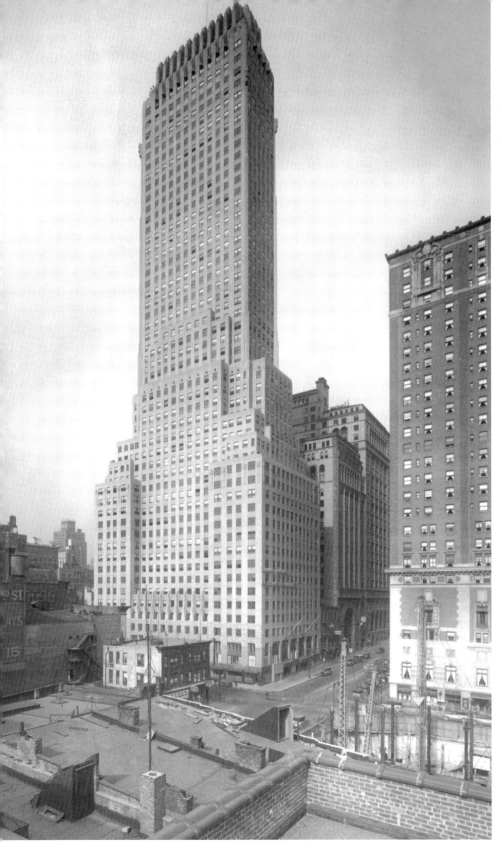

The Chanin Building was designed by Sloan & Robertson for the construction company owned by the Chanin brothers, who built many New York skyscrapers. Its stepped form, exhuberant decoration, and unusual top make it unique.

ARCHITECTURE REJECTS MODERNISM

In a landmark book of 1972, architects Robert Venturi and Denise Scott Brown analyzed the city of Las Vegas, Nevada.[18] They looked at the glitzy, gambling town in the Nevada desert, previously considered trashy, and interpreted it in classic architectural terms—discovering innate order in which buildings are read as signs, swimming pools as oases, and the strip as a continuous highway supplying every need.[19] In reading Las Vegas symbolically, they condoned the tastes and values of people other than architects, whom they called "socially coercive." And it was true that Le Corbusier and others had intended their pure white boxes only for those "fit" for them. Modern architecture had intended to correct social problems—disease, slums, and poverty. In Las Vegas, Venturi and Scott Brown accepted the built city as they found it, and discovered fresh meaning in it.

In literary circles, the prestige of Walter Gropius was attacked. Tom Wolfe, the ebullient author and scholar of American culture, challenged Walter Gropius (naming him "The Silver Prince") and his followers, seeing them as the ruin of a native American architectural tradition represented by Louis Sullivan, Henry Hobson (H. H.) Richardson, and Frank Lloyd Wright. In *From Bauhaus to Our House* (1981), Wolfe merrily ridiculed the German origins of Mies van der Rohe's and Gropius's styles[20] and the illogic of transplanting them to the United States. In both architecture and graphic design, the unquestioned reputation of classic Modernism was unraveling.

Indeterminate Façade Showroom (store for Best Products, Inc., Houston, Texas), designed by SITE, 1975

RECOVERING MEANING

James Wines's SITE, an environmentally-oriented architectural firm, departed from Modernism by investing architecture with communicative power, and by treating it more as sculpture in a public place than as a formal solution. SITE took a position of rejecting certainties for ambiguities, formal perfection for expressive use of form, and cool detachment for emotional involvement. It proposed oppositions to Modernism on a grand scale.

SITE designed an irregular roofline for a Best Products store in 1975, causing it to appear to be in a stage between construction and demolition. Calling it the "Indeterminate Façade Showroom," a cascade of bricks seemed to tumble from the roof down the side, suggesting the temporal nature of the building, rather than the permanent.

SITE's work was a major challenge to the principles of the International Style. Essential to their Modernism was the concept of planes enclosing a volume, not massive brick or stone supporting the roof. Here, SITE blatantly exposes its brick construction. Or perhaps it is saying that such constructions fail.

PLAYING WITH GRIDS AND CUBES

Bernard Tschumi's design for the Parisian grand project of 1982–85, a park with small buildings, or "follies," subordinated purpose to intellectual play. The government required no real function from the park, supporting theorists who argued, as Tschumi did, for architecture that "means nothing…one that is pure trace or play of language."[21] Yet the Paris Parc de la Villette redefines the concept of a park. It is no place of repose, no idyll of greenery, but rather an agglomeration of information and experiences. Variations on the possibilities are to be found in the cubes; no two of the red enameled follies are the same. They dot the park in a grid that anchors the chaotic mix of walkways, waving mesh arcades, ramps, cinemas, and objects such as an actual submarine moored near one folly.

Tschumi's design pulls elements out of the idea of a park and distributes them in an arrangement of forms. Here, he subordinates the Modern concept of function, and logic, to color the parkscape with abstract constructions, with no clue as to their function. Admittedly drawn to theories of "Deconstruction,"[22] Tschumi replaces a Modernist zeal for purity and clarity with an elaborate system requiring mental sophistication. There may be no meaning, or infinite meanings.

A grid of Parc de la Villette, designed by Bernard Tschumi, 1982–1985

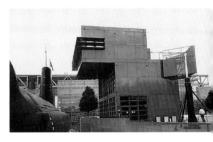

L'Argonaute submarine next to a folly, Parc de la Villette

One of the follies of La Villette, showing proximity to its Parisian neighborhood.

VERTICALITY

Built in 1930–31 by Shreve, Lamb, & Harmon, the 102-story Empire State Building is a silvery sheath, stripped and thin, topped with a spire to extend it, and further extended by antennae. Erected in just over a year, this miracle of the Depression years created a taste for extremely thin and long shapes in fashion and typefaces throughout the 1930s. A bizarre costume designed for actress Katharine Hepburn for the film *Christopher Strong* two years after the Empire State Building was completed accentuated the verticality of her figure, extending it by the silver helmet, with antennae topping the helmet. She is a column, as is the building, defined by base, sheath, and capital. Intuitively the costume designer tapped the change in taste from Art Deco's stubby forms to the elongated lines that became the desired slim look of the 1930s. Art Deco's shimmering metallic surface remained, along with its fantasy world of oddities. In type, vertical, attenuated letters suggested chic modernity.

The Empire State Building, 1930–31

EMPIRE FOR HEPBURN

Line of Empire typeface, issued by ATF in 1937, took its name from the impressive achievement of the Empire State Building at the beginning of the decade.

Katharine Hepburn in the 1933 film
Christopher Strong

In the late part of the century, irreverence, cynicism toward old standards, and having fun is apparent in the names designers gave typefaces—Fontsoup, Dirty Faces, Stoned, Soupbone, Derision, Heimlich Maneuver, Dominatrix (a German blackletter), Boxspring, and Mattress. Sources for these new inspired digital fonts came from anywhere but geometry: Superior Smudged, 1996, derives from a 1930s set of rubber stamps; Ooga Booga comes from a painted sign on the side of a factory; and Template Gothic from the signs in a laundry room, noticed by a graphic designer while waiting through the spin cycle. Hard-to-read typefaces, such as FontShop's Dirty Faces, are the end of the millennium's rejection of the New Typography's clarity and logic. Some of these 1990s faces are FF Bull, Burokrat by Matthias Rawald, Dirty by Neville Brody, Metamorph by Markus Hanzer, and Littles by Simone Schopp. Faces drawn to look like children's writing instead of type became available.

Typefaces alluded to social realities, imitating graffiti in Innercity by James Closs, 1994, or cult life in Voodoo by Klaus Dieter Lettau, or the supernatural in Witches by Manfred Klein. Designed purposely to challenge accepted standards, the typefaces Why Not and Contrivance lost all reference to traditional typeface form and structure.

Why Not by Manfred Klein, 1993

Contrivance by Frank Heine, 1993

THE VIOLATING IMPULSE IN COUTURE

Couture, as timely and trend-conscious as type, picked up the same violating impulse. "Grunge" appeared when Marc Jacobs showed his line for Perry Ellis and declared it was "about doing everything wrong."[26] Grunge was originally reviewed as a "deliberately shabby and sloppy look based on Seattle rock bands—a mess of combat boots, flannel shirts, exposed midriffs, clashing layers"; it was called "disgusting."[27] Just as models with greasy hair, torn floral dresses, and clunky shoes went against traditional ideals of beauty, dirty typefaces degraded the letter. Everything was done against accepted form. The letters are scrawny, scribbled, with their insides and outsides confused. Nothing is beautiful. They have the pretension to offer themselves in standard point sizes with a lowercase and an italic.

INVERTING

Inversion in couture—turning clothes inside out—became a style. In a campaign for jeans, the wholeness of the clothing—its completed, final shape—was challenged; the inside was exposed on the outside, and underwear presented as outerwear. Instead of a protective garment, the jeans became a "look." Tops that don't tuck in emphasized the belly. Blue jeans once again sent a message. Observers suggested it was the rejection of consumer culture by young Americans, who composed the largest market for blue jeans.

In a Best Products store from 1984 the architectural firm SITE inverted the classic interior/exterior form of buildings. They broke away a large section of the exterior wall to reveal the inside. Only glass protects the exposed interior of the store. This allows many interpretations—the voyeurism of the spectator, the enticement of consumer culture, or a reference to architectural icons such as Johnson's own glass house, where the owner looks out at his private world, not vice versa.

Inside/Outside Building (store for Best Products, Inc., Milwaukee, Wisconsin), designed by SITE, 1984

Calvin Klein inside-out ad campaign

Posed photographs of contemporaneous film stars conveyed an insupportable languor, as in this studio shot of the popular Jean Harlow. Limp fringe, the drooping cowl falling off the back, the shawl itself sliding off the arm, together with the swaying stance of the star, all gave off an aura of ennui beyond endurance. A lack of hard edges and absence of sharpness anywhere signal boredom with strict geometric forms and their rigor. This drooping linearity softened the rigidity of early Modern furniture. It's difficult to imagine Harlow relaxing in Breuer's "Executioner's chair" from the previous decade; yet she seems ready to sink into the designer's Lounge Chair of 1936.

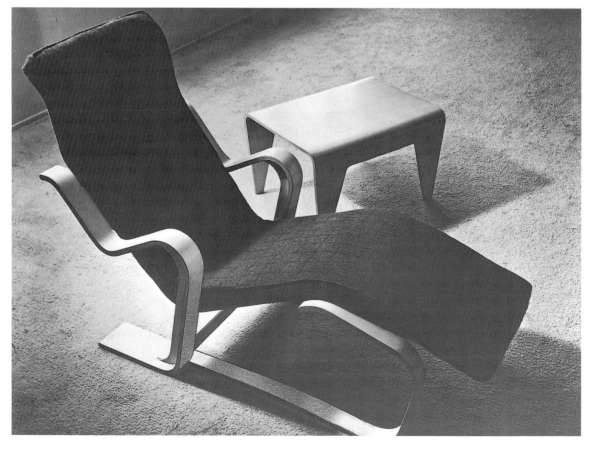

Marcel Breuer's Lounge Chair of bent birch wood and an upholstered cushion, 1935–36
The Museum of Modern Art, New York, Purchase Fund

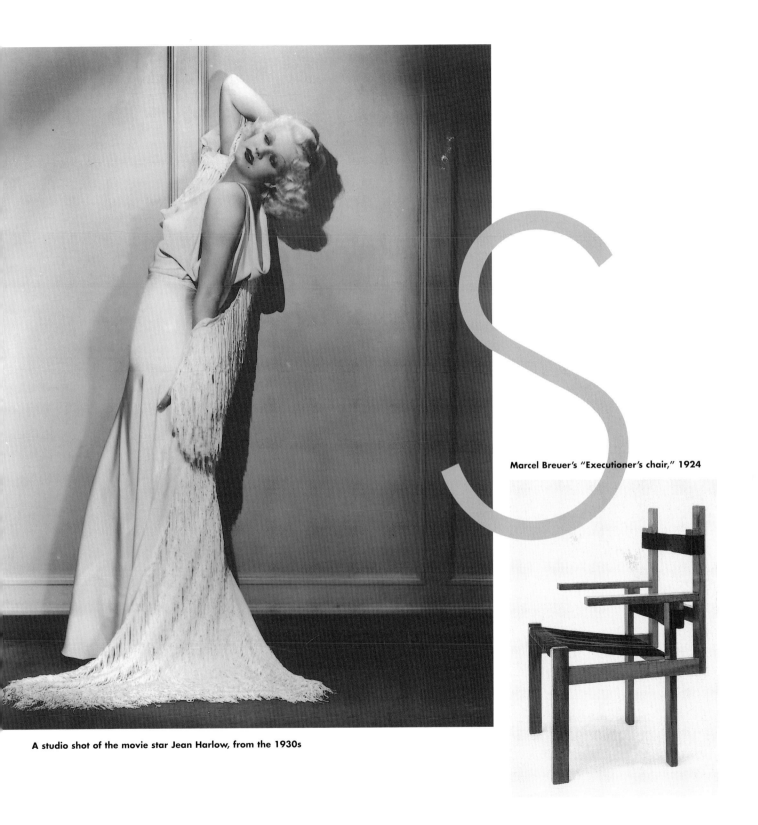

Marcel Breuer's "Executioner's chair," 1924

A studio shot of the movie star Jean Harlow, from the 1930s

REDISCOVERING FORMS

A practice of postmodernism shared by all the design arts was the retrieval of forms from other periods for the purpose of shaping or reapplying them in new contexts, often with irony or cynicism. The past was discovered as a historic encyclopedia of forms and styles. Taking these forms and using them in odd contexts became known as "quoting." A form could be quoted for wit or attention or for a serious reference to a treasured historical style. Implicit in this practice was an abandonment of the quest to discover, through rational analysis and experiment, the ultimate, universal typographic letterform. Implied in this was the failure of Modernism, the Bauhaus, Organic Design, Corporate Cool, "universal" alphabets—or any other Modern movement promising peace, social justice, and human progress.

First Michael Graves's grand postmodern Portland Building of 1980 quoted from earlier periods. Pediments and keystones appeared without performing their original functions of pediments and keystones; they appeared as a memory. Johnson, who had heralded the International Style into America in the late 1930s, and collaborated with Ludwig Mies van der Rohe on the iconic International Style Seagram

"The Classics of Modern Furniture" chart from Palazzetti, Inc., iconic designs of Modernism

AT&T Building by Philip Johnson, 1984

Building in New York, retrieved historic design elements in his AT&T Building of 1984. The top seemed a "Chippendale" pediment on top of a granite column, a composition that some architects saw as a return to real architecture.[29] Furniture makers, too, revived the classics of early Modernism. These popular artifacts appeared in the homes of designers and architects, who valued both their form and their origins.

TYPE REVIVALS AND REDESIGNS

In the same period, graphic designers freely appropriated type forms. Graphic styles of the 1920s—Constructivism, Art Deco, Bauhaus, and De Stijl—appeared, but in many cases without the ideological views of their founders. The phenomenon of historical mining began to be documented in typeface collections from previous eras[30] and redesigns. More than a hint of Paul Renner's circles of Futura showed in Avant Garde Gothic, a typeface that immediately became outrageously popular after its introduction in 1970.

Avant Garde Gothic letterforms, 1970–77. Designers Herb Lubalin and Tom Carnase based the Avant Garde Gothic typeface on the logo Lubalin designed for *Avant-Garde* magazine, introduced in the late 1960s.

Cover of an *Avant-Garde* magazine from 1969, showing the original all-capitals font

Book cover designed by the author in the 1970s, using the trendy Avant Garde Gothic typeface

5 MID-CENTURY MODERN

The life of forms has absolutely no aim other
than itself and its own renewal.[1]
Henri Focillon, *The Life of Forms in Art*, 1942

Modernism produced forms previously unknown; once fully realized, they did not continue unchanged. Architects and designers, with their creative energy and invention, refined or renewed existing forms. Technical changes in all fields affected form creation. New attitudes emerged: for some designers the rigid rules of early Modernism yielded to the appeal of the human hand; others found organic sources to replace geometry. Rather than abstract geometry, the endless repertory of nature was the new form source—the earth and its inhabitants, landscape and plant life, waves, leaves, bones, amoebae, and more. Natural forms inspired the buildings, chairs, lamps, tables, and kidney-shaped swimming pools of the 1940s through the early 1960s, and the printed page as well.

The Soaring shells and curving interiors of Eero Saarinen's Trans World Airlines terminal (1959–62) at New York's JFK airport evoke in concrete the sense of flight experienced by its passengers.

TYPE AND ARCHITECTURE, TOGETHER AT LAST

A continuing impulse in Modernism had been the integration of typefaces into buildings. Type as an integral part of architecture appeared in the first decades of the twentieth century. The avant-garde movement in art, design, and architecture in the Netherlands, De Stijl, incorporated identifying signs into its facades, as in the Café Unie of 1925 in Rotterdam (see page 37), designed by the De Stijl architect J. J. P. Oud. The strong horizontal and vertical slabs with letters repeat the geometric divisions of the façade; the letters fill their panels—a further means of integrating them into the overall design. The letterforms were, of course, sans serif, and confined to geometric bases of square, rectangle, triangle, and circle.

In the same year, the Russian Pavilion at the Paris Exposition (see page 60), designed by Konstantin Melnikov, had identified itself through letters hanging from the hammer and sickle shapes of the socialist Republic that were attached to the pavilion. The Bauhaus had placed large letters with its name on the side of the Dessau building. In the United States, progressive architects put signs on top of their buildings; Raymond Hood's iconic and still-standing Philadelphia Savings Fund Society building of 1932, now a hotel, was one of the first to broadcast its name in this blatant manner by putting "PSFS" in large sans serif letters on the top.

At the beginning of the twenty-first century, a project for a new skyscraper in New York takes integration of typography and architecture to its ultimate point. Here, in a sketch for the new tower to be constructed for the *New York Times* (never built), Frank Gehry proposed the *Times* logo itself to be part of the structure.

Proposed Frank Ghery–designed tower for the *New York Times* building (2000), with *Times* logo integrated into the structure (not realized).

SCRIPTS

The American fashion press familiarized readers of Vogue, Bazaar, and Mademoiselle with Parisian haute couture.[2] Popular metal scripts of the 1950s resembled sketches, or croquis, rushed from couture collections to American magazines. At that time, photographing couture collections was not permitted, so commercial artists in Paris quickly sketched models as they walked the runways, and wired the look to New York publishing houses. The script used with the sketches in the layout conveyed a look of "the latest thing." Casual typefaces such as Dom and Brush matched the sense of immediacy. ATF introduced Brush, designed by Robert E. Smith, in 1942. Brush is deeply slanted, increasing its look of tossed-off letters. The capitals descend below the baseline and become a kind of "swash" casual.[3]

**Sketches of Christian Dior couture, 1950s
(left and opposite)**

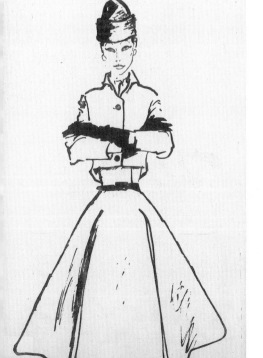

Brush Mirrored the

Fashion Styles of the Fifties

Brush script by Robert E. Smith, 1942

Richardson and Goudy shared stylistic tendencies that suggest the name "Lyric Masculinity," or the American Heroic. Their works are robust, yet romantic. They work with masses that confidently occupy their territory. Craftsmanship is important: sometimes a rugged, unfinished surface is left to recall the tools used. On the column in an early church in Springfield, Massachusetts, Richardson left the marks of the chisel as evidence of the stonecutter's hand. Goudy, an intense craftsman, ran his own press, often engraving matrices from his own drawings and casting type from those matrices. He too left the mark of his hand on the product of his imagination.

Architect and type designer functioned within the American power establishment of their time. Their taste for vigorous, traditional form was akin to that of the Establishment clients for whom they worked—Ivy League college presidents (Yale and Harvard), millionaire manufacturers (Ames and Glessner), the Episcopal Church (Trinity), state and local governments (Allegheny Courthouse and Jail and New York State Capitol Building), or prominent commercial organizations (American Type Foundry and Marshall Field). Rugged, independent, and creative, they also displayed a delicate sensitivity in creating form that was both moving and poetic.

Ames Gate Lodge by H. H. Richardson, North Easton, Massachusetts, 1881. The millionaire's estate in North Easton, now Stonehill College, was noted for its "boulders of brute coarseness."

Column on H. H. Richardson's North Congregational Church, Springfield, Massachusetts, 1868

Goudy Handtooled repeats the forms of Richardson's arches at Trinity Church in its strong, carved curved strokes. This face, with its carved appearance, was designed by Morris Fuller Benton in the 1920s, who cut a line through Goudy Old Style and renamed it to evoke Goudy's handcrafting inclinations.

Both men historicized,[4] in the sense of visiting, sketching, and then copying forms from medieval and Renaissance architecture and books, imitating those older prototypes, and adapting them for American clients, who flooded them with commissions. A French-speaking native of New Orleans, Richardson studied architecture at the École des Beaux-Arts in Paris for six years, copying models of European architecture for which he became famous—the "Richardsonian Romanesque."[5] He also absorbed the earlier architectural ornamental style of Chicagoan Louis Sullivan.

New York State Capitol Building, Albany, New York. The most important building in the state was commissioned to Richardson and built between 1875 and 1886.

Mark designed by Goudy for the Village Press, which he owned and operated

GESTURAL TYPE

The desire to employ metal typefaces resembling hand lettering was not confined to the United States. A category existed called *gestuel*, or "images flowing naturally from the hand and spirit,"[7] and translated into English as "gestural." It was the French painter and designer Roger Excoffon whose insouciant personal style expressed itself in a series of idiosyncratic typefaces.

Excoffon's Mistral, based on his own handwriting, was issued by Fonderie Olive, located in Marseilles.[8] The sudden, sweeping popularity of this typeface, which continued for years, testifies to the demand for casual looks in the 1950s among one sector of designers, who were ready to ditch the austerity of the early Moderns. Excoffon's "*style gestuel*" appeared in Choc, Fonderie Olive's offering of 1953. The popularity of this brushstroke alphabet and Excoffon's pseudohandwriting typeface called Diane spread to the United States.

In Banco, Excoffon worked with flat planes, bending them into tortured planes that followed the rudimentary strokes of letterforms. The sheared-off terminals rest exactly on the baseline; they are cut to fit. The even, regular slant to the right of the all-capitals typeface appealed to art directors as another dynamic casual script in lead.

ABCDEFGHJKLMNOPQRST
abcdefghijklmnopqrstuvxy

ABCDEFGHIJK
LMNOPQRSTUV
WXYZ ABCDEF
abcdefghijklmnopqrstuvwxyz abcdefghi

ABCDEFGHIJKLMN1
OPQRSTUVWXYZ!23
abcdefghiklmnopqrstuvx

ABCDEFGHIJKLMNOPQRSTUVXYZ
1234567890

NOTES

PREFACE: TYPOGRAPHY'S ROLE IN MODERNISM

1 Ulrich Conrads, *Programs and Manifestos on 20th Century Architecture* (Berlin: Ullstein, 1964), trans. Michael Bullock (Cambridge, Massachusetts: The MIT Press, 1970), p. 38.

2 Le Corbusier, *Towards a New Architecture* (New York: Praeger, 1960), trans. Frederick Etchells. English version of *Vers Une Architecture*, 1923. Quoted in Conrads, *Programs and Manifestos*, p. 60.

3 Alvin Lustig, "Designing, a Process of Teaching." Reprinted from the *Western Arts Association Bulletin*, (September 1952). In: Holland R. Melson, ed., *The Collected Writings of Alvin Lustig* (New Haven, Connecticut, 1958).

4 To use the phrase of Whitehead revived by N. Katherine Hayles in *The Cosmic Web* (Ithaca, NY: Cornell University Press, 1984), quoted by Dell E. Mook and Thomas Vargish in *Inside Modernism: Relativity Theory, Cubism, Narrative* (New Haven, CT: Yale University Press, 1999), p. 5.

5 Debora L. Silverman, *Art Nouveau in Fin-de-Siècle France* (Berkeley, CA: University of California Press, 1989).

6 Kenneth Frampton, *Modern Architecture: A Critical History* (New York: Thames & Hudson, 1992), p. 99.

7 Philip Johnson and Mark Wigley. *Deconstructivist Architecture*, published in connection with the exhibition "Deconstructivist Architecture," June 23–August 30, 1988 (New York: The Museum of Modern Art, 1988), p. 11.

CHAPTER ONE: EARLY EUROPEAN MODERNISM

1 Adolf Loos, "Ornament and Crime," 1908, in: Conrads, p. 19.

2 Bruno Taut, "Daybreak," p. 63. Taut, an architect and theorist, worked in Berlin with the November group of revolutionary German artists after the war. Taut's "Programme for architecture" saw all spiritual forces combine "in the symbol of the building."

3 Ibid., p. xviii.

4 Jan Tschichold, *The New Typography: A Handbook for Modern Designers*, trans. Ruari McLean (Berkeley: University of California Press, 1995). Facsimile of *Die neue Typographie: Ein Handbuch für Zeitgemass Schaffende.* (Berlin: Brinkmann & Bose, 1987). Original published in Berlin in 1928.

5 Tschichold cited *Die Form* and *110* as German journals of the time that met his criteria. He also alluded to the work being done for the City of Frankfurt under the direction of architect Ernst May.

6 Ibid., p. xv.

7 Ibid., p. 64.

8 Ibid., p xxvi.

9 Ibid., p. 66.

10 Ibid., p. 11.

11 Le Corbusier, *Vers Une Architecture* (Paris: Les Éditions D. Crès, 1923), p. 102.

12 Christopher Burke, *Paul Renner: The Art of Typography* (New York: Princeton Architectural Press, 1998), pp. 86–88.

13 Tschichold, *The New Typography*, p. xv.

14 Burke, *Paul Renner*, p. 65

15 Tracy, *Letters of Credit*, p. 158.

16 John. D. Berry, "New From ITC. ITC Johnston." *U&lc*, (Summer 1999), pp. 25–26.

17 Eric Gill, *An Essay on Typography* (London: Sheed & Ward). Republished, 1988. Introduction by Christopher Skelton, p. 6. Original 1931.

18 Le Corbusier, "Three Reminders to Architects," 1923, trans. Frederick Etchells and rep. in *The Essential Le Corbusier: L'Esprit Nouveau Articles* (Auckland: Reed Educational and Professional Publishing Ltd., 1998), p. 29.

19 Jacques Guiton, *The Ideas of Le Corbusier* (New York: George Braziller, Inc., with Fondation Le Corbusier, Paris, 1981).

20 Ulrich Conrads, *Programs and Manifestos on 20th Century Architecture* (Cambridge, Massachusetts: The MIT Press, 1970), p.74

21 Ibid., p. 58.

CHAPTER TWO: THE BAUHAUS

1 Walter Gropius, *The New Architecture and the Bauhaus*, 1937. Translated from German by Morton Shand (Cambridge, Massachusetts: The MIT Press, 1965), p. 92, paperback version.

2 Gropius, *Scope of Total Architecture* (New York: Harper & Brothers, 1955).

3 Ibid.

4 Elaine S. Hochman, *Bauhaus, Crucible of Modernism* (New York: Fromm International, 1997), p. 23.

5 Gropius, *"Idee und Aufbau des Staatlichen Bauhauses, (The Conception and Realization of the Bauhaus),"* 1923, quoted in *The New Architecture and the Bauhaus*, 1937, p. 57.

6 Gropius, "Is There a Science of Design?" *Scope of Total Architecture.* originally "Design Topics" in *Magazine of Art*, (December 1947).

7 Frampton, *Modern Architecture*, p. 96.

8 *Wellesley College News*, April 11, 1929, Wellesley College Archives, Massachusetts.

9 Magdalena Droste, *Bauhaus, 1919–1933* (Berlin: Taschen and Taschen Benedikt, Bauhaus-Archiv, 1990), p. 24.

10 Ibid., p. 54 ff.

11 Herbert Bayer, Walter Gropius, and Ise Gropius, eds. *Bauhaus 1919–1938* (New York: The Museum of Modern Art, 1938), p. 36.

12 Droste, *Bauhaus, 1919–1933*, p 54.

13 Bayer et al., *Bauhaus 1919–1938*, p. 78.

14 Ibid., p. 36.

15 "The Bauhaus at Dessau," Department of Art Scrapbook, 1928–32. Wellesley College Archives, Massachusetts.

16 Bayer et al., *Bauhaus 1919–1938*, p. 149.

17 Ibid., p. 78.

18 Ibid.

19 Droste, *Bauhaus, 1919–1933*, p. 252.

20 Gropius, *The Conception and Realization of the Bauhaus*, p. 82.

21 Ibid., p. 82.

22 Droste, *Bauhaus, 1919–1933*, p. 40.

23 Anja Baumhoff, *The Gendered World of the Bauhaus: The Politics of Power at the Weimar Republic's Premier Art Institute* (Frankfurt am Main: Peter Lang, 2001). A fresh look at the Bauhaus in 1919–32 with special emphasis on gender discrimination appears in this study based on records from women students, Gunta Stölzl in particular.

24 Internal Bauhaus document of March 15, 1921, quoted in Baumhoff, p. 60.

25 Baumhoff, *The Gendered World of the Bauhaus*, p. 84.

26 Droste, *Experiment Bauhaus* (Berlin: Bauhaus-Archiv, 1988).

CHAPTER THREE: DUELING MODERNISMS

1 Le Corbusier, *L'Art Décoratif d'Aujourd'hui* (Paris: Les Editions D. Crès et Cie, 1925), p. 84.

2 Bevis Hillier, *Art Deco of the 20s and 30s* (London: Studio Vista, 1968), p. 82.

3 Ibid., p. 14.

4 Hillier, *The Style of the Century, 1900–1980,* 2nd ed. (New York: Watson-Guptill, 1998), p. 75 ff.

5 Hillier, *Art Deco*, pp. 46–47.

6 "Rapport Général, Section Artistique et Technique i Livre." in *Exposition Internationale des Arts Décoratifs et Industriels Modernes*, Paris, 1925 (Paris: Larousse, 1925), p. 31.

7 Jérômne Peignot, *Petit Traité de la Vignette* (Paris: Imprimerie Nationale, 2000), p. 66 ff.

8 Deberny & Peignot Prospectus, 1926, courtesy Columbia University Libraries, Rare Book Collection.

9 W. Pincus Jaspert, with W. Turner Berry and A. F. Johnson, *The Encyclopedia of Type Faces* (London: Blanford Press, 1970), p. 254.

10 Henri Mouron, *A. M. Cassandre*, trans. Michael Taylor (New York: Rizzoli, 1985), p. 46.

11 Jaspert et. al., *The Encyclopedia of Type Faces,* p. 319.

12 Translated collection of *Journal de l'Esprit Nouveau* (New York: Da Capo Press, 1968), p. 100.

13 Ibid., p. 102.

14 *Journal de l'Esprit Nouveau*, #11–12 (Paris: *Revue Internationale d'Esthetique*, 1920–25), pp. 1245–156. (Author's translation from original issues in The Museum of Modern Art Library collection.)

15 See "Rapport Général," above.

16 *Journal de l'Esprit Nouveau*, #11–12, p. 1249.

17 Ibid., p. 1256.

18 Virginia Smith, "Robert Mallet-Stevens: Cul-de Sacs and Film Sets," in *DOCOMOMO*, (Winter 2003/4), p. 8.

19 Jacques Sbriglio, *Le Corbusier: La Villa Savoye* (Paris: Fondation Le Corbusier, 1999).

20 Found in many places, but in the original form in Conrads, *Programs and Manifestoes*, p. TK.

21 Charlotte Perriand, *Un Art de Vivre* (Paris: Flammarion, 1985), p. 13. (Published in connection with the exposition of her work at the Musée des Arts Décoratifs, Paris, in 1985).

22 Ibid., p. 21.

23 Richard Martin, Cubism and Fashion. Published in connection with the exhibition "Cubism and Fashion, 1998–99." (New York: The Metropolitan Museum of Art and Harry N. Abrams, 1998), p. 49.

CHAPTER FOUR: NATIVE AND IMPORTED FORMS

1 Alfred C. Bossom, *Building to the Skies: The Romance of the Skyscraper* (London: The Studio Limited, 1934), p.14.

2 Quoted in Hillier, *The Style of the Century*, pp. 36–37.

3 Ibid.

4 Ibid., p. 99.

5 Cervin Robinson and Rosemarie Haag Bletter, *Skyscraper Style: Art Deco, New York* (New York: Oxford University Press, 1975).

6 Louis H. Sullivan, "The Tall Office Building Artistically Considered," *Lippincott's Magazine*, (March 1896).

7 Mac McGrew, *American Metal Typefaces of the Twentieth Century,* 2nd rev. edition (New Castle, Delaware: Oak Knoll Books, 1993).

8 Ibid., p. 51.

9 Ibid., p. 55.

10 Ibid., p 33.

11 Frederic Ehrlich, *The New Typography & Modern Layouts* (New York: Frederick A. Stokes Company, 1934), p. 27 ff.

12 Ibid., pp. 41–42.

13 McGrew, p. 183.

CHAPTER FIVE: MID-CENTURY MODERN

1 Henri Focillon, *Vie des Formes* (Paris: Presses Universitaires de France; and New Haven: Yale University Press, 1942), p. 7. 1948 edition, George Wittenborn, Inc.

2 Brigid Keenan, *Dior in Vogue* (New York: Harmony Books, Crown Publishers, 1981), p. 60.

3 McGrew, *American Metal Typefaces*, p. 53.

4 Warren, Chappell, *A Short History of the Printed Word.* New York: Alfred A. Knopf, 1970), p. 85.

5 McGrew, p. 101.

6 Ibid.

7 Sebastian Carter, *Twentieth Century Type Designers* (New York and London: W.W. Norton, 1995), pp. 131–32.

8 Original typeface specimen sheets of Mistral, Banco, Diane, and Choc from Fonderie Olive through the Imprimerie Nationale, Paris.

9 Eliot F. Noyes, *Organic Design in Home Furnishings* (New York: The Museum of Modern Art, 1941).

10 Ibid., p. 6.

11 Peter Blake, "S. and E," *Interior Design*, (July 1994), pp. 29–30.

12 R. Roger Remington and Barbara J. Hodik, *Nine Pioneers in American Graphic Design* (Cambridge, Massachusetts: The MIT Press, 1989).

13 Bradbury Thompson, *The Art of Graphic Design* (New Haven, Connecticut: Yale University Press, 1988).

14 Martin Spector and Hodik, "Type Talks: Bradbury Thompson's Simplified Alphabet," 1958, quoted in Remington, *Nine*

ORGANIC DESIGN

Obviously the forms of our furniture should be determined by our way of life.[9]

Eliot Noyes, from the 1941 MoMA exhibition Catalogue for "Organic Design in Home Furnishings"

A key event at mid-century was The Museum of Modern Art's (MoMA) prewar competition, "Organic Design in Home Furnishings," inspiring and endorsing an alternative Modernism. MoMA's competition for the design of furniture, fabrics, and lamps aimed to discover talented designers in order to connect them with manufacturing contracts. It continued MoMA's adherence to the Bauhaus position of the oneness of each visual environment, not only their built structures, but in their contents—chairs, tables, rugs, and so forth.

Eliot Noyes headed MoMA's Department of Industrial Design. In presenting the competition, he wrote: "From [William] Morris' time until today, three distinct aspects of design may be observed in action. One of these is the reactionary, decorative, Arts and Crafts approach to design. The validity of traditional ornament was quickly undermined by the Industrial Revolution, and immediately there came attempts to create new decorative formulae to replace it. Art Nouveau at the turn of the century, the Viennese Kunstgewerbe, the decorative trivialities of Paris in 1925, and finally streamlining...are all of this package."[10] Here Noyes expresses the view that earlier twentieth-century design movements did not accomplish the Modern goal of removing surface ornament and developing new forms; rather, he suggests, the movements (singling out for special contempt Art Deco) were part of the same historical flow.

Cover for MoMA's "Organic Design in Home Furnishings" catalogue cover, designed by E. McKnight Kauffer, an American graphic designer of the period

Twelve stores sponsored the competition and guaranteed contracts as prizes, uniting artists with manufacturers—the Bauhaus hope. Marcel Breuer had first used tubular steel in the contemporary design spirit in his 1925 "Wassily" chair, and Mies van der Rohe followed in 1927 with the first chair using resilient legs made of bent steel. Le Corbusier's reclining chair had shown how to change sitting positions without mechanical apparatus. Alvar Aalto had produced a chair with a bent plywood seat on a tubular metal frame. Now molded forms advanced this exploration of materials and techniques for furniture. Saarinen and Charles Eames won the MoMA competition with prototypes for a molded plywood chair that gave support and comfort to the body. Their light plywood shells had resilience; their appearance was attractive, and they formed the chair in one piece. But the curved wood shells proved difficult to manufacture, and the designers had not addressed plywood's tendency to splinter. Constructing the chairs, cementing fabric to the shell, and fitting legs with special attachments took time. Some adjustments were made to their original sketches based on manufacturing realities, and chairs from these prototypes later came on the market. Some observers commented that, as the painters of the Abstract Expressionist movement moved the "center of gravity"[11] of Modern art from Western Europe to North America around this time, Saarinen and Eames paralleled them in transferring the "center of design" of furniture. The Organic competition was a success finding designers; interest in the results, however, was overshadowed by America's involvement in World War II.

GRAPHIC DESIGN GOES ORGANIC

The same impulse of relating design to the body that motivated Saarinen and Eames can be found in graphic design of the period. Both biomorphic shapes, and the direct representations of the hand as the creative tool, pervaded printed pieces of the period. Independent thinkers like Alvin Lustig and Paul Rand, although thoroughly Modern admirers of the principles of Jan Tschichold and the Bauhaus, designed intuitively, emphasizing the creative hand—the same hand that drew the type and the illustration. The hand and the craftsman's skill—the human touch—were in formal opposition to the cool geometry of early Modernism. By the 1950s, designers longed for warmth.

Lustig designed the catalogue cover for Black Mountain College, an avant-garde college in the South. The abstracted, wavy mountain form on Lustig's cover is of the period, as are the splayed legs of the treelike form, similarly seen in furniture. Lustig designed dozens of book jackets for New Directions Books between 1946 and 1952. Names of those authors comprise a list of what the college crowd, avant-garde, and city intelligentsia were reading: Dylan Thomas, Jean-Paul Sartre, Franz Kafka, Alain-Fournier, Ezra Pound, Djuna Barnes, Paul Bowles, and Charles Baudelaire.

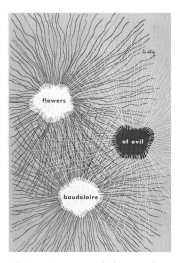

Alvin Lustig's cover of *Flowers of Evil* by Charles Baudelaire, 1947. The amoebaelike tails on the cover resemble specimens seen under a microscope.

Alvin Lustig cover for Black Mountain College catalogue, 1946

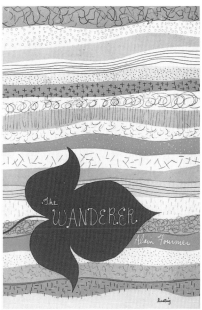

Alvin Lustig's cover of *The Wanderer* by Alain-Fournier, 1946. The cover design is composed of what appears to be strata of earth or waves; the title is hand-lettered.

BIBLIOGRAPHY

American Type Founders Company. *A Pamphlet Supplementing the Specimen Book of 1923, Showing Important Additions to the Goudy Family.* New York: Baruch College Trove, 1927.

Argetsinger, Mark. "Adobe Garamond." *The Journal of the American Printing History Association.* Vol. XIII, No. 2 (1991); Vol. XIV, No. 1 (1992), 69–86.

Bain, Peter and Paul Shaw, eds. "Type and National Identity: Blackletter." *Printing History: The Journal of the American Printing History Association.* Vol. XIX, No. 2, Vol. XX, No. 1 (1999), 4.

Barr, Alfred H. Jr. "The Bauhaus at Dessau." *Department of Art Scrapbook.* Wellesley, Massachusetts: Wellesley College Archives, 1928–32.

Baumhoff, Anja. *The Gendered World of the Bauhaus: The Politics of Power at the Weimar Republic's Premier Art Institute.* Frankfurt am Main: Peter Lang, 2001.

Bayer, Herbert, Walter Gropius and Ise Gropius, eds. *Bauhaus 1919–1938* Exh. cat. New York: The Museum of Modern Art, 1938.

Bayley, Stephen, Philippe Garner, and Deyan Sudjic. *Twentieth-Century Style & Design.* New York: Van Nostrand Reinhold, 1986.

Beilenson, Peter. *The Story of Frederic W. Goudy.* Mt. Vernon, New York: Peter Pauper Press, 1965.

Beissert, Gunter. *Jakob Erbar and the Sans Serif.* Translated by F. J. Maclean. Frankfurt: 1936.

Berger, Warren. "The Wunderkind of Graphic Design: David Carson." *Graphis,* Vol. 5 (January 1995), 18–33.

Bossom, Alfred C. *Building to the Skies: The Romance of the Skyscraper.* London: The Studio Limited, 1934.

Brody, Neville, and Jon Wozencroft. *The Graphic Language of Neville Brody,* Vol. 1. London: Thames & Hudson, 1988; Vol. 2, 1994.

Bruckner, D. J. R. *Frederic Goudy. Documents of American Design.* New York: Abrams, 1990.

Brunhammer, Yvonne. *Arts Décoratifs des années 20.* Paris: Editions du Seuil et Regard, 1991.

———. *The Nineteen Twenties Style.* London: Paul Hamlyn, 1969.

Bryson, Norman, ed. *Visual Culture, Images, and Interpretations.* Hanover, New Hampshire: University Press of New England, 1994.

Bryson, Norman, ed., with Michael Ann Holly, and Keith Moxey. *Visual Theory: Painting and Interpretation.* New York: Icon Editions, 1991.

The Bulletin of The Museum of Modern Art. Ed. John McAndrew (December 6, 1938).

Burke, Christopher. *Paul Renner: The Art of Typography.* New York: Princeton Architectural Press, 1998.

Cameron, Ian Alexander. *The Book of Film Noir.* New York: Continuum, 1992.

Carson, David. *David Carson: 2ndsight.* New York: Universe Publishing, 1997.

Carson, David, and Lewis Blackwell. *The End of Print: The Graphic Design of David Carson.* San Francisco: Chronicle Books, 1995.

Carter, Matthew. "Theories of Letterform Construction. Part I." *Printing History: The Journal of the American Printing History Association.* Vol. III, No. 2 (1991); Vol. XIV, No. 1 (1992), 3–16.

Carter, Rob, with Ben Day and Philip Meggs. *Typographic Design: Form and Communication,* 2nd ed. New York: Van Nostrand Reinhold, 1993.

Carter, Sebastian. *Twentieth-Century Type Designers.* New York and London: W.W. Norton, 1995.

Chappell, Warren. *A Short History of the Printed Word.* New York: Alfred A. Knopf, 1970.

Charles-Roux, Edmonde, et al. *Chanel and Her World.* Paris: Hachette-Vendome, 1981.

Cohen, Arthur A. *Herbert Bayer: The Complete Work.* Cambridge, Massachusetts: The MIT Press, 1984.

Conrads, Ulrich. *Programs and Manifestos on 20th Century Architecture.* Berlin: Ullstein, 1964. Translated by Michael Bullock. Cambridge, Massachusetts: The MIT Press, 1970.

Cullen, Moira. "The Space Between the Letters." *Eye: The International Review of Graphic Design.* Vol. 5, No. 19, 70–77.

Curtis, William. *Le Corbusier: Ideas and Forms.* London: Phaidon Press, 1995.

Deberny & Peignot Prospectus. New York: Columbia University Libraries, Rare Book Collection, 1926.

Deshouliéres, Dominique, et al. *Robert Mallet-Stevens, Architecte.* Bruxelles: Archives d'Architecture Moderne, 1980.

Droste, Magdalena. *Bauhaus 1919–1933.* Berlin: Benedikt Taschen and Bauhaus Archiv, 1990.

———. *Experiment Bauhaus.* Berlin: Bauhaus-Archiv, 1988.

Ehrlich, Frederic. *The New Typography & Modern Layouts.* New York: Frederick A. Stokes Company, 1934.

Feyrabend, Henriette, et al. *Quand l'Affiche Faisait de la Réclame!* Paris: Editions de la Réunion des Musées Nationaux, 1992.

Floyd, Margaret Henderson. *Henry Hobson Richardson: A Genius for Architecture.* Photographs by Paul Rocheleau. New York: The Monacelli Press, 1997.

Focillon, Henri. *The Life of Forms in Art.* Second English edition, enlarged. New York: George Wittenborn, Inc., 1948. First published in French as *Vie des Formes,* Librairie Ernest Leroux, Paris, 1934.

Frampton, Kenneth. *Modern Architecture: A Critical History.* New York: Thames & Hudson, 1992.

Gay, Peter. *Weimar Culture: The Outsider as Insider.* New York: Harper & Row Publishers, 1968.

Gerstner, Karl, and Markus Kutter. *The New Graphic Art.* Teufen, Switzerland: Arthur Niggli AG, 1959. English version by Dennis Stephenson. Distributed in the United States by Hastings House.

Ghirado, Diane. *Architecture After Modernism.* New York: Thames & Hudson, 1996.

Gill, Eric. *An Essay on Typography.* London: Sheed & Ward, 1931. Republished by David R. Godine, Boston: 1988.

Goudy, Frederic. *Goudy's Type Designs Complete: His Story and His Specimens.* New Rochelle, New York: The Myriade Press, 1978. Facsimilie of 1946 *Typophiles Chapbook.*

Gravagnuolo, Benedetto. *Adolf Loos: Theory and Works.* Preface by Aldo Rossi. New York: Rizzoli, 1982.

Graves, Michael. *Michael Graves, Buildings and Projects 1966–1981.* New York: Rizzoli, 1982.

Gropius, Walter. *The Conception and Realization of the Bauhaus,* 1923. Translated as *The New Architecture and the Bauhaus,* 1937. Reissued by The MIT Press, Cambridge, Massachusett, 1965. Translated from German by Morton Shand.

——. *Scope of Total Architecture.* New York: Harper & Brothers, 1955. Originally "My Conception of the Bauhaus Idea," 1937.

Guiton, Jacques. *The Ideas of Le Corbusier.* New York: George Braziller, Inc., with Fondation Le Corbusier, Paris, 1981.

Heller, Steven, and Anne Fink. *Faces on the Edge: Type in the Digital Age.* New York: Van Nostrand Reinhold, 1997.

Heller, Steven, and Gail Anderson. *American Typeplay.* Glen Cove, New York: PBC International Publishers, 1994.

Heller, Steven, and Julie Lasky. *Borrowed Design: Use and Abuse of Historical Form.* New York: Van Nostrand Reinhold, 1993.

Henket, Hubert-Jan, and Hilde Hennen, eds. *Back from Utopia: The Challenge of the Modern Movement.* Rotterdam: 010 Publishers, 2002.

Hillier, Bevis. *Art Deco of the 20s and 30s.* London: Studio Vista, 1968.

——. *The Style of the Century, 1900–1980.* 2nd ed. New York: Watson-Guptill, 1998.

Hillier, Bevis, and Stephen Escritt. *Art Deco Style.* London: Phaidon Press, 1997.

Hitchcock, Henry-Russell, and Philip Johnson. *The International Style.* New York: W.W. Norton, 1966 ed. of *The International Style: Architecture Since 1922.* Exh. Cat. New York: W.W. Norton, 1932.

Hofmann, Armin. *Graphic Design Manual: Principles and Practice.* New York: Van Nostrand Reinhold, 1965.

Jaffe, Hans L.C., et al. *De Stijl, 1917–1931: Visions of Utopia.* Catalogue of an exhibition organized by the Walker Art Center. Oxford: Phaidon, 1982.

Jaspert, W. Pincus, with W. Turner Berry and A. F. Johnson. *The Encyclopedia of Type Faces.* 4th ed. London: Blanford Press, 1970.

Johnson, Philip, and Mark Wigley. *Deconstructivist Architecture.* Exh. cat. New York: The Museum of Modern Art, 1988.

Kelly, Jerry. "Adobe Garamond: A New Adaptation of a Sixteenth-Century Type." *Printing History: The Journal of the American Printing History Association.* Vol. XIII, No. 2 (1991); Vol. XIV, No. 1 (1992), 101–6.

Kubler, George. *The Shape of Time. Remarks on the History of Things.* New Haven & London: Yale University Press, 1962.

Le Corbusier. *L'Art Décoratif d'Aujourd'hui.* Paris: Les Éditions D. Crès et Cie, 1925.

——. *Vers Une Architecture.* Paris: Les Éditions G. Crès, 1923. Translated by Frederick Etchells as *Towards a New Architecture.* New York: Warren & Putnam, 1927; and New York: Praeger, 1960.

——. "Three Reminders to Architects," 1923. Translated by Frederick Etchells and reprinted in *The Essential Le Corbusier: L'Esprit Nouveau Articles.* Auckland: Reed Educational and Professional Publishing Ltd., 1998.

Lustig, Alvin. *The Collected Writings of Alvin Lustig,* Ed. Holland R. Melson, Jr. New Haven, Connecticut: Holland R. Melson, Jr., 1958.

Martin, Richard. *Cubism and Fashion.* Published in connection with the exhibition "Cubism and Fashion." New York: The Metropolitan Museum of Art and Harry N. Abrams, 1998.

——. *Our New Clothes. Acquisitions of the 1990s.* New York: The Metropolitan Museum of Art and Harry N. Abrams, 1999.

McGrew, Mac. *American Metal Typefaces of the Twentieth Century.* 2nd rev. ed. New Castle, Delaware: Oak Knoll Books, 1993.

McLean, Ruari. *Jan Tschichold, Typographer.* London: Lund Humphries, Publishers Limited, 1975.

McLeod, Mary. "Architecture and Politics in the Reagan Era: From Postmodernism to Deconstructivism." *Assemblage* 8 (1989).

McQuiston, Liz. *Graphic Agitation. Social and Political Graphics Since the Sixties.* London: Phaidon Press, 1993.

"Modernism in the US After World War II." DOCOMOMO #31. (September 2004).

Morrison, Stanley. "First Principles of Typography." *The Fleuron* #7 (1930).

Mouron, Henri. *A. M. Cassandre.* Translated by Michael Taylor. New York: Rizzoli, 1985.

Müller-Brockmann, J. *The Graphic Artist and His Design Problems.* 3rd ed. New York: Hastings House Publishers, 1968.

Noyes, Eliot F. *Organic Design in Home Furnishings.* Exh. cat. New York: The Museum of Modern Art, 1941.

O'Gorman, James F. *Three American Architects: Richardson, Sullivan, and Wright, 1865–1915.* Chicago and London: University of Chicago Press, 1992.

O'Leary, Noreen. "Wolfgang Weingart." *Communication Arts* (May–June 1998.\).

Overy, Paul. *De Stijl.* London and New York: Studio Vista/Dutton Paperback, 1969.

Peignot, Jérôme. *Petit Traité de la Vignette.* Paris: Imprimerie Nationale Éditions, 2000.

——. *Typoésie.* Paris: Imprimerie Nationale Éditions, 1993.

Perriand, Charlotte. *Un Art de Vivre.* Paris: Flammarion, 1985.

Pevsner, Nikolaus. "The Return of Historicism," *Studies in Art, Architecture and Design, Vol. 2, 1961.* New York: Walker & Company, 1968.

——. *Pioneers of Modern Design from William Morris to Walter Gropius.* New York: Penguin Books, 1960. Originally published in 1936 by Faber & Faber, London.

——. *The Sources of Modern Architecture and Design.* London: Thames & Hudson, 1968.

Poynor, Rick. "Type and Deconstruction in the Digital Era." *Typography Now: The Next Wave.* London: Booth-Clibborn Editions, 1998.

Poynor, Rick, ed. *Typography Now Two. Implosion.* London: Booth-Clibborn Editions, 1996.

Rand, Paul. *Thoughts on Design.* New York: Van Nostrand

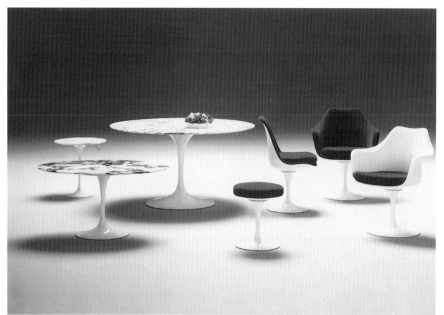

In the 1950s, Eero Saarinen designed a graceful table and chair series with a single support to replace the clutter of legs. Of his design, Saarinen said, "The undercarriage of chairs and tables makes an ugly, confusing, unrestful world. I wanted to clean up the slum of legs and make the chair all one thing again." The table and chair bases seemed to imitate a growing plant, with bases like stalks supporting a spread flower, so the series became known as the "Tulip" series upon its commercial manufacture in 1956.

A series of floor lamps designed by Japanese-American sculptor Isamu Noguchi, 1951. These popular manufactured lamps, which Noguchi called "Akari Light Sculpture," allowed light to glow through the leaflike texture of the paper skin. Their irregular form and fragile, anthropomorphic quality contrast markedly with the sturdy geometry of Bauhaus designs (see page 49).

ANOTHER CURRENT IN GRAPHIC DESIGN

Throughout the Modern period, no one method answered all type needs, nor appealed to all designers. Though the expressionist, or personal idiosyncratic form, was surfacing in type, many influential designers, now called "art directors," preferred the chaste excellence of the past. Another look pervaded mid-century graphic design. In 1940s and 1950s New York, several pioneers[12] of today's graphic design profession practiced a style based on limited choices, careful placement of type and art, and subtle humor. One of these "precisionists" was Bradbury Thompson, Art Director of the Year in 1950, who had absorbed the principles of the early Europeans, but moved beyond the strict rules of Tschichold and the idealism of Herbert Bayer and the Bauhaus. His work was characterized by exactness, minute attention to details, and super-high production standards of type, printing, and paper.

The Westvaco Series. Bradbury Thompson, whose witty layouts of type and old engravings for *Westvaco Inspirations for Printers*, a publicity publication for the paper company, made his reputation while he was art director for *Mademoiselle* Magazine for young women in the 1950s and 1960s. In addition, in working with periods of art history for The Metropolitan Museum of Art's anniversary, he had studied periods of architecture, sculpture, printing, and painting and type related to them. In tightly organized layouts[13] for Westvaco, he positioned engravings, alphabets, printers' marks—linear art and color—in a manner to show off the quality of the client's papers.

Layout by Bradbury Thompson from Westvaco series in the 1950s

Completed a year after Saarinen's death, the Trans World Airlines (TWA) terminal at Kennedy International Airport in New York evoked flight. It is seen as a wing form of some large prehistoric bird, or perhaps as a thin shell. The fluid interior is more like tendons of a body or a bird than a built structure.

Saarinen also designed the Ingalls Rink at Yale University—a hockey arena that shelters three thousand fans under a wood roof suspended by cables over the concrete shell. It immediately became known as "the turtle" after its opening in 1958, as locals quickly perceived its biomorphic form. On campus it is fondly referred to as "The Yale Whale."

**Trans World Airlines terminal,
designed by Eero Saarinen,
1959-62**

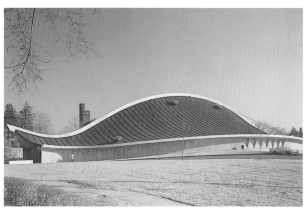

**Ingalls Rink, designed by Eero Saarinen,
1958**

**Trans World Airlines terminal,
interior**

Frank Lloyd Wright, the independently minded American architect, continued his own path with The Guggenheim Museum, his only building in New York City. Distinct from neighboring stone apartment houses and other museums along Fifth Avenue, this great concrete spiral takes its organic form from sea creatures and other forms in nature; an ancient design motif, the spiral was used in the island palace of Knossos, Greece. Wright's magnificent living form on upper Fifth Avenue enriched a city of boxlike buildings.

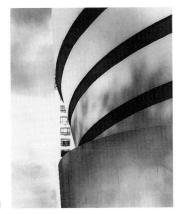

Side view of spiral

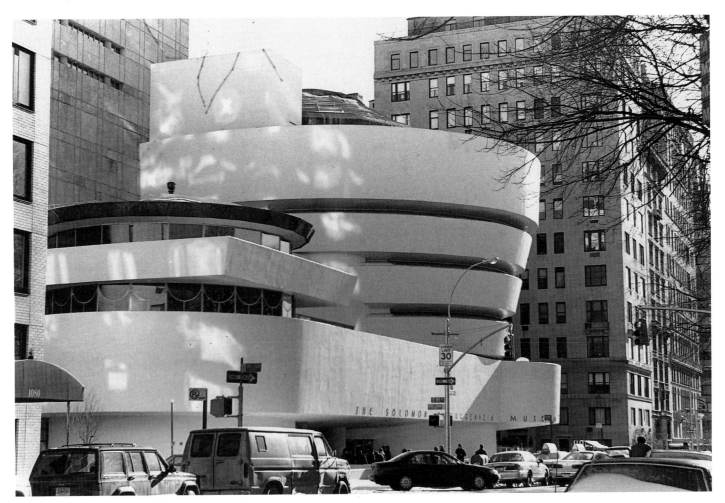

The Solomon R. Guggenheim Museum, designed by
Frank Lloyd Wright, 1956–59

SWISS STYLE COMES TO AMERICA

At the midpoint of the twentieth century, the principles of Modern typography set out in the 1920s had been received, adopted, rejected, rediscovered, and perfected in Europe and America. The spread of Modern architecture throughout the developed world exceeded the spread of Modern typographic principles, since language differences limited their adoption. By the 1930s, Jan Tschichold had renounced his earlier, dogmatic Modern beliefs and was now an advocate of centered layouts and serif typefaces, but it was too late: he had proposed a style that had its own life, and which had been adopted by devoted practitioners.

In the mid-1950s, many early Modern principles expressed by Tschichold and the Bauhaus typographers surfaced as "Swiss Style," and once again they dominated graphic design. The Swiss Style of graphic design developed in Zurich and Basel, and was disseminated internationally through magazines such as *Werk*, *Neue Grafik*, and *Graphis*, which were published in three languages. Its practitioners followed Tschichold's advocacy of sans serif typefaces, unjustified type, asymmetrical layouts, photography rather than illustration, and more white space. They advanced beyond him by inventing the Swiss grid, a division of the page into columns and modules formed by vertical and horizontal lines and based on the point size of type. This orderly, rational, clean design attracted followers in the United States, and the Swiss style dominated American corporate graphic design of the 1960s. Its overall starkness, based on geometry and mathematics, not expression, suited it for clean products like pharmaceutical companies and corporations with their restrained atmosphere and yearning for elegance. Swiss Style–printed pieces were orderly, objective, and lacking personal expression—esteemed qualities in some quarters.

TYPEFACES

New sans serif typefaces with warmer curves replaced the early geometric typefaces such as Erbar, Kabel, and Futura. To produce Swiss Style design, most European designers employed existing sans serif typefaces, such as Berthold Foundry's Akzidenz Grotesk, designed in the 1950s. But so many designers converted to this style of graphic design that more typefaces were needed. In 1957 the Haas foundry issued Neue Haas Grotesk, a redrawing by Max Miedinger of Akzidenz Grotesk.[17] This typeface was renamed Helvetica, after the Latin name for the region that became Switzerland. Stripped, yet subtly nuanced, the phenomenally popular typeface Helvetica appeared to be the counterpart of corporate architecture because of its "controlled rectitude."[18] Adrian Frutiger designed the typeface Univers in 1957 with enough variations in weight and slant to solve every design or production problem, he thought. Twenty-one typeface styles replaced the usual bold, italic, etc. Frutiger was a Swiss who moved to France. His Univers typeface for Deberny & Peignot resulted from the experiments he had started in Zurich, and was issued at almost the same time as Helvetica. Both Swiss typefaces influenced graphic work of the period and after

PRINCIPLES OF SWISS GRAPHIC DESIGN

In 1959 the editors of the influential Swiss magazine *Graphis* invited Emil Ruder, the typography instructor and theorist[19] at the Basel school, to summarize the style emanating from Basel and Zurich that had become known as Swiss Style. Some of Ruder's principles seem to repeat what Tschichold proposed in 1928.

Ruder stated that typography is primarily a means of ordering the various parts of a layout, and that "The rule that a text should be easily readable is an unconditional one." He recommended lines of fewer than sixty characters, limiting amount of text on a page so the reader could cope with it, correlation between word and line spacing, setting type in rectangular patterns, and eliminating "foreign intrusions." He advised reaching legibility and good typography through six principles:

- Interrelation of Function and Form. Type must be subordinated to legibility: function (legibility) comes before form.

- Unprinted Spaces. White space has a value of its own on the page, and should be used deliberately.

- "Overall" Design. All publications must have a "formal bond unifying all the pages of a printed production." This is widely known as a design "format."

- Grid. The page should be divided into small units, or modules for both type and art. Use of a grid system results in "a correct and consistent overall design."

- Written and Printed Text. Attempts to design typefaces in imitation of handwriting are "doomed to failure."

- Typography in Pictorial Work. Type can harmonize or contrast with art or photography through the weight (thickness or thinness) of letters, or their similarity with a shape in the art.

Knoll exhibition at the Louvre in Paris, 1972, designed by architect-graphic designers Leila and Massimo Vignelli. They used Swiss sans serif typefaces as architecture, as here, where the lowercase *n* functions as an arch for a doorway.

First prospectus for Helvetica typeface

Helvetica

ABCDEFGHIJKLMN
OPQRSTUVWXYZ
abcdefghijklmnopqrs
tuvwxyz
1234567890
!@#$%^&*()_+
{}|":<>?~`,./;'[]\=-

Helvetica type alphabet

Univers

ABCDEFGHIJKLMN
OPQRSTUVWXYZ
abcdefghijklmnopqr
stuvwxyz
1234567890
!@#$%^&*()_+
{}|":<>?~`,./;'
[]\=-

Univers type alphabet

INTERNATIONAL STYLE ADAPTED

The architecture exhibition at MoMA in 1932 had intended to "sum up the characteristics of the new architecture of the 1920s on the beginning of a new decade." Early Modernism was organized by architect Philip Johnson and historian Henry-Russell Hitchcock,[20] but the name "International Style" came from MoMA's Alfred H. Barr, Jr., the advanced thinker who had earlier recognized the Bauhaus. These writers named the originators of the International Style—Le Corbusier, J.J.P. Oud, Mies, and Walter Gropius— and described the aesthetic elements that characterized the new style. These central ideas were that mass is replaced by thin planes enclosing space; balance, or axial symmetry, is replaced with a unifying "regularity"; and applied ornament is replaced with the "intrinsic elegance of materials, technical perfection, and fine proportion."[21]

Corporations adapted International Style architecture for their headquarter buildings. The steel skeleton and glass curtain wall were integral elements as the style developed. Its neutrality, cool presence, and refinement of details formed the same basis for their choice of Helvetica for the graphic identity in their annual reports and other publications. In their austere form and undecorated beauty, the great corporate office buildings—such as the Seagram Building and Lever House—manifest the spirit of Modernism at mid-century. These two buildings are the monumental counterparts of the new sans serif typefaces, whose nuances and refinements of line give beauty to the unornamented form. Contemporary with, but miles apart from both, is the Guggenheim Museum of Frank Lloyd Wright, further up Fifth Avenue at 88th Street. At the midpoint of the century the two strains—the organic and the rationalist—rarely met; they played out their own lives.

Lever House, a corporate headquarters on Park Avenue, was designed by Gordon Bunshaft of Skidmore, Owings & Merrill, a firm that, as early as 1932, had been cited by the MoMA organizers as understanding and practicing International Style. Stripped of ornament, both building and the Helvetica letterform were composed of huge blocks placed at right angles. These mid-century versions of early design principles seemed clean, pure. Yet modifications in detail softened their rigid geometry.

The capital *H* of Helvetica was equally bold, but refined.

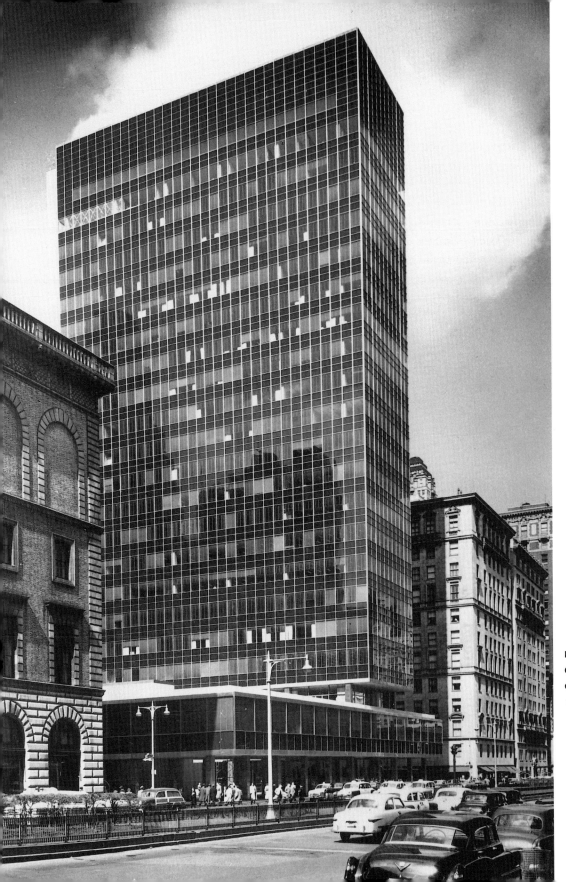

Lever House, designed by
Gordon Bunshaft of Skidmore,
Owings, & Merrill, New York City,
1950–52

REDUCED TO PERFECTION

The slender glass and metal Seagram Building soars thirty-eight stories above Park Avenue. Designed by Mies and Johnson, its innovative engineering and construction were immediately appreciated. Clad in bronze with amber-tinted glass, it was the refinement in the details—as the use of sumptuous materials such as travertine and granite—and its perfect proportions that were so admired. Aristocratic, standing aloof over its plaza, this building would be the gold standard by which others could be measured. The perfection demanded and achieved in the 1950s and the insistence on a flawless surface and subtle form characterize both the Seagram Building and the Helvetica typeface.

The capital *I* from the Helvetica Bold font was an unadorned slab.

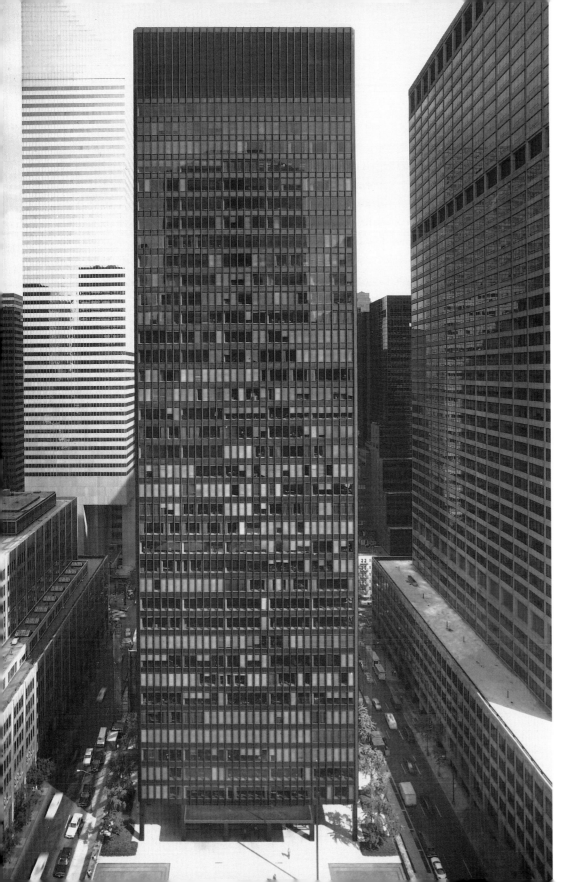

Seagram Building,
designed by Ludwig Mies van der
Rohe and Philip Johnson, New
York City, 1954–58

TRANSCENDENT MODERNISM

American architect Louis I. Kahn, whose most significant work was built from the mid-1950s through the early 1970s, invested structures with emotional power that equaled Modernism's early phase. Kahn animated Modernism at the moment when the aesthetic of Modernism, devoid of its original principles, had been appropriated by corporations. Rather than emanating from an idealism centered on social problems, as in early Modernism, the Modern movement in architecture now spoke for the power of capitalism. Kahn revealed other possibilities: his Salk Institute in La Jolla, California, opened onto the Pacific Ocean in an inspirational vista composed by the functional buildings. An essential component of early Modern style—its classic calm—is preserved; to it is added the human search for union with infinity.

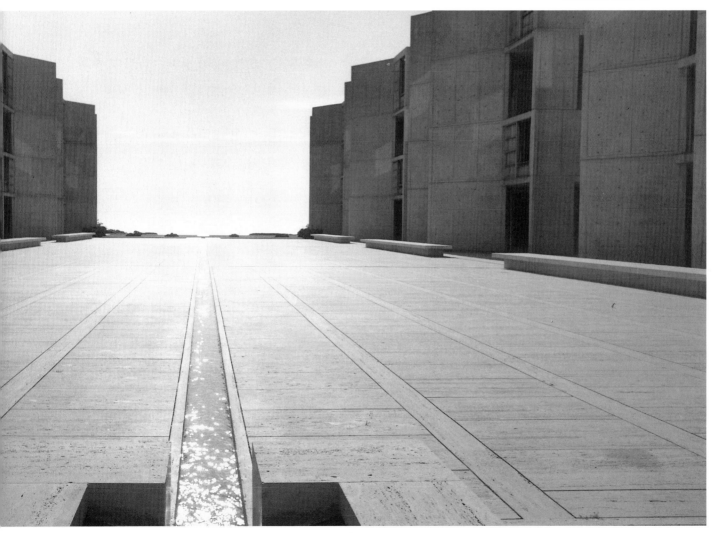

Louis I. Kahn, Salk Institute of
Biological Research, La Jolla,
California, 1959–66

6

THE END OF THE MODERN MOVEMENT

Architects can no longer afford to be intimidated by the puritanically moral language of orthodox Modern architecture. I like elements which are hybrid rather than "pure"…ambiguous rather than "articulated"…accommodating rather than excluding: I am for messy vitality over obvious unity.[1]

Robert Venturi, *Complexity and Contradiction in Architecture,*1966

From the distance of the twenty-first century, we can look back and see stages of Modernism—its theoretical statements and experimental beginnings (think of Le Corbusier's Pavilion of the New Spirit of 1925)—and its achieved perfection in such iconic buildings as the Villa Savoye or the Seagram Building. Those large monuments make it easy to see; but we notice, too, that typography manifested similar stages, in Futura and Helvetica and Bauhaus layouts, in its smaller-scale world. The rejection of classic Modernism came in part from its failure to change things. After still another world war, claims of the early post–World War I Modernists were examined. In the 1960s, social upheavals made it ridiculous to hold any longer to the idealistic notion of Modernism being the agent of a finer world. That was now seen as "Utopia."[2]

**Detail of Indeterminate
Façade Showroom
(store for Best Products,
Inc., Houston, Texas),
designed by SITE, 1975**

The seeds of dissenting Modernism are seen in the Sydney Opera House and the Ronchamp chapel, both of the 1950s, where "a split between two Modernisms"[3] is clear. Such buildings opened the way to individualism, and that led to irreverent, extravagant, personal expressions in form and style for the rest of the century on the part of many designers. The life of the Modern movement can be framed by the writing of the architectural historian Nikolaus Pevsner who, in attendance at the construction of the Bauhaus Dessau building in 1925, championed the Walter Gropius style of Modernism all his life; in the 1960s it was the Ronchamp chapel and the Sydney Opera house he criticized as too extreme to express the spirit of Modernism.[4]

Technical innovation, in the form of the computer, changed design irrevocably. The old experts in type design, and the craftsmen who executed their typefaces in metal, became obsolete. The grand type foundries in Europe and America—ATF, Bauer, and Deberny & Peignot—closed, and after years of attempting to set type in film rather than metal, the definitive solution appeared with digitized type on Mac and PC computers in the 1980s.[5] Now, anyone could design an alphabet. Soon hundreds did, and countless typefaces came into existence. In architecture the computer made possible complex forms, causing new shapes to appear in the built landscape. Frank Gehry's Guggenheim Museum Bilboa in Bilboa, Spain, built in the 1990s, could not have been constructed without thousands of computer commands, and the resulting dramatic shape was a huge success.

Computer drawing and early study model for Frank Gehry's Guggenheim Museum Bilboa

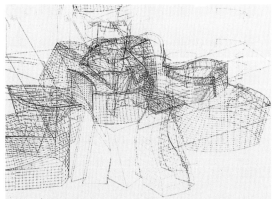 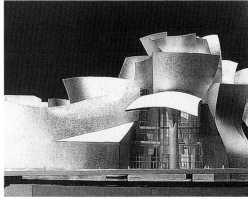

ANTI-MODERN TENDENCIES IN TYPE

The early European Modernism of Jan Tschichold and Herbert Bayer, and others, was remote to graphic designers who emerged in the 1960s and 1970s. Following an instinctive will to make form, they created new kinds of design. Some consciously rejected Modern ideals and refused to follow established style. It was not possible any longer to believe that a "universal" typeface could answer all the needs of vast and restless populations. Instead, they practiced iconoclastic, irreverent innovation. Graphic designers replaced former goals of logic, clarity, and legibility with intuition, clutter, and expression. They preferred to be originators rather than disciples, and they moved in the same current of time as their audience—postmodern, as the period began to be called.[6]

Type design by Wolfgang Weingart and students, Basel, 1968

Postmodernism, a complex concept of style drawing on theories in politics and literary criticism, erupted during the artistic, social, and political movements of the 1960s. During this period, a persistent strand of twentieth-century design surfaced: the personal expression of creativity, intuition, play, imagination, and delight in one's creative abilities. The Bauhaus had not put a stake through its heart, after all. Meaning, communicated through form—another remnant of the past scorned by Modernism—plowed through austere, rational, pure forms to deliver its emotional freight of surprise, shock, nostalgia, or wit.

INTUITION, NOT LOGIC

Wolfgang Weingart replaced masters of Swiss design Emil Ruder and Armin Hofmann as instructor at the Basle School of Design.[7] In his own work, Weingart often used traditional type, like Akzidenz Grotesk, for posters and book cover designs. As he developed alternatives to the "rigid" Swiss design of the 1950s, his work and his classes attracted attention. He required his students to use metal type (later adding film and computers) to explore "the possibilities of classical typography, computer typography, crazy typography, do-it-yourself typography, Swiss typography, etc."[8] Although the results could appear chaotic, students were liberated. Soon graduates spread Weingart's approach, initiating "New Wave" graphic design in the 1970s, a kind of graphic design that ignored the formulaic principles of Modernism and played with composition, images, and letters in freer arrangements (well before the advent of the Mac computer).

Student work (1971) from Wolfgang Weomgart's classes seem to explode any notion of order.

ILLEGIBILITY

British graphic designers disregarded their design tradition, ignoring its famous historical type revivals—notably Times New Roman or the innovative sans serif typefaces by Johnston and Gill—to develop new, difficult-to-read typefaces. In his work for *The Face*, Neville Brody designed both layouts and type, creating alphabets such as Typeface Four, with an elongated, strained, compression—uptight, with spastic jerks of asymmetric serifs in some letters and rigid centered serifs in others. He created many other faces for magazines and commissions. Blur is a rejection of clarity in favor of fun. Is it a television set that's not focused? Or tired eyes? Does it matter? Brody, a productive and articulate designer, analyzed and published his process; in that practice he continued the didactic tradition of early Modernists.[9]

David Carson was another designer making changes in the appearance of the printed page.[10] His design was successful because it expressed the taste of the West Coast readers of the publications he designed—*Beach Culture* and *Ray Gun*. Carson, too, published his work and comments.[11] Self-taught Carson demonstrated the role of intuition in his profession. He laid out pages with text columns that sloped away, butted against more text, and veered and faded away—the obvious disregard for principles of legibility didn't faze his editors or audience.[12]

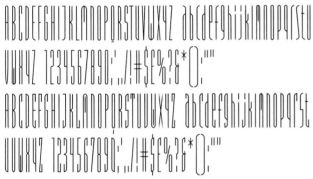

Typeface Four by Neville Brody, 1991

ABCDEFGHIJKLMNOP
QRSTUVWXYZ
abcdefghijklmnopqrs
tuvwxyz1234567890;',
./!#$£%?&*():“”

Blur Light by Neville Brody, 1992

the photos that changed the way we surf

by matt george

Magazine spread designed by David Carson

April Greiman's poster for
California Institute of the Arts,
1970s

DENSITY, NOT CLARITY

A proponent of California "New Wave" in the 1970s was April Greiman, a student of Weingart's in Basel. Before the Mac computer arrived, she had created a new design style for a client, the California Institute of the Arts. Since the school taught many arts, its need was to communicate diversity through photos, symbols, and type. Greiman designed collages made from color copies, photographs, Letraset sheets, cut shapes, spray paint, type and typewriter type, pasting them together in what she called a "hybrid technique." When computers and other new technology arrived, she incorporated scanned art, pixilated images, and graphic software into this process of "hybridization." Type, in columns, ribbons, or bands, could be blurred, sharpened, or pixilated.

Greiman worked in a style characterized by layering, suggesting three-dimensional space on a two-dimensional surface. Numerous images accumulate and move into imaginary deep space, covering every part of the surface. The reader is invited to concentrate on multiple messages in any sequence, repeating or looping back between images—not unlike cassette tapes and videotapes, which can be rewound and replayed at any desired point in time. The treatment of the space implies actions in time. The use of her naked body as the central image on an early poster sensationally opposed the objectivity and denial of the personal in Swiss graphics, as well as its masculine dominance. The subject matter of graphic design had changed in addition to its techniques.

FRAGMENTATION

Fragmentation, rather than completion, was another typical postmodern practice that indicated, from the late 1960s onward, that graphic design had entered a new period. The only "ism" that fit was "Deconstructivism," a term borrowed from architecture to describe a practice of taking a building apart and reassembling it to produce a fresh form. The pure cubes and boxes of classic

Zaha Hadid, one of the featured architects in the "Deconstructivist Architecture" show at MoMA,[15] won first prize in 1982 for her design for The Peak, a private club in the hills above Hong Kong harbor. Hadid planned to excavate the site and construct cliffs of huge abstract polished granite slabs on several levels. They appeared as conflicting planes, but construction techniques assured they would not collide or slide. This rendering is of the lowest level.

Modernism exploded. With Deconstructivist architecture, as described by one of the organizers of the important 1988 exhibition at The Museum of Modern Art (MoMA),[13] architects placed "simple forms in conflict," the result producing "an unstable, restless geometry."[14] The fragments were recombined to make new forms.

Similar actions took place in the work of Weingart, Carson, Greiman, and those influenced by their graphic design. Order was destroyed. The parts were reused. The integrity of a typeface could be attacked, and its geometric base disregarded. The grid organizing elements on the page was rethought and elements scrambled. Graphic designers employed specific graphic strategies of mingling images and texts, overlapping and cutting into their areas, layering of visual elements, and using type and the page layout to suggest a meaning.

What Deconstructivist design revealed was the assertiveness of the designer, who had become typesetter, printer, and sometimes publisher. It is not so much a rejection of the past, as was Modernism, but a dismissal of the past as irrelevant.

In its relation to authority, Deconstructivism is skeptical design—it does not accept that type tells the truth or that a printed page is accurate. Even in the early Modern period, independent thinkers knew that the press was not to be trusted. Throughout the century, media watchers noted that the press made the news as much as it reported it; it was not a neutral "crystal goblet."[15] Openly skeptical, the postmodern graphic designer is independent and uses the meaning she or he finds, and plays with it to send that message to anyone interested.

In the sixteenth century, Albrecht Durer had analyzed the blackletter, constructing an alphabet composed entirely of straight-lined segments.[16] He also gave instructions for combining the segments to form letters.

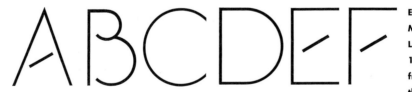

An alphabet grid by an Italian designer, 1920s. An unknown Italian designer in the 1920s constructed a typeface made up of parts of a grid. Units could be combined to make short, fat faces or tall, extended letters. Here the type designer plays architect, putting one stone on top of another. They connect visually because the white verticals align. Serifs can attach to different stems.

Einstein Light, designed by Milton Glaser and George Leavitt, mid-1960s to mid-1970s. Glaser and Leavitt fragmented the letter in the "Einstein" typefaces. Originality makes the face noticeable. The letter still reads clearly; both designers and reader know what has happened.

As a comment on the social order, this new manner of designing is subversive in a noncombative way. It is subversive in ignoring order, so prized by Modernism, and in dismissing rules, so necessary to achieve order. The grid, which supplied underlying order, is now tipped, altered, or ignored. In accepting vernacular typefaces, any source is valid. Any voice is heard. There are no authorities, no one who gives out "rules" to follow, whether traditional or Modern. It is a working form of anarchy.

Fragmenting and recomposing letters is not new. The urge to disassemble letters or construct them in parts had existed as early as the sixteenth century in the experiments of Albrecht Dürer and, in the twentieth century, in the work of Josef Albers (see his alphabet composed of ten parts, page 42), Milton Glaser, and others.

In 1995 Matthew Carter designed a proprietary typeface for the Walker Art Center in Minneapolis for use by staff designers. Its purpose was to create an identity running through all communications for the contemporary art museum. Carter made a flexible identity for them by creating the typeface Walker. It has "snap-on" serifs (he originally called them "deputy serifs"), which can be added by the staff designers.[17] The concept of Walker, the collaboration with the museum, and the thoroughness with which Carter carried through his original notion of a constructed type—changeable yet recognizable—raises the technical capabilities of the computer to the level of the skilled punch cutters of the past.

INSTABILITY

The Dutch designers Erik van Blokland and Just van Rossum are the millennium-end opposite of the De Stijl adherents who attempted to control the visual world by limiting graphic design and architecture to the use of primary colors and geometric shapes. Van Blokland and van Rossum have introduced a radically new approach to type, discovering that the computer brings more, not less, human expression into it. Their studio, LettError, digitizes the handwriting of clients for its use as type, as they have digitized their own, finding the original source of letterform to be the human gesture—writing.

With more than a touch of irreverent humor, LettError gives instructions on how to ruin the meaning of documents. On their website they ask: "Remember the days when everybody was concerned about legibility, in typography and type design?" No more. They offer two fonts for use in critical documents— such as letters to your boss or for the fine print in that new contract. "Stop trying to subvert regular typefaces into unclear and muddy typography," they say. "Use the fonts that were specifically designed for this purpose." They give away two such fonts for free.

Walker by Matthew Carter, 1995

VISUAL SET
VISUAL SET
VISUAL SET

**Erikrighthand by
Erik van Blokland, 1990**

Erik's Handwriting!

**Justlefthand by
Just van Rossum, 1990**

Just's Left Hand!

ARCHITECTURE REJECTS MODERNISM

In a landmark book of 1972, architects Robert Venturi and Denise Scott Brown analyzed the city of Las Vegas, Nevada.[18] They looked at the glitzy, gambling town in the Nevada desert, previously considered trashy, and interpreted it in classic architectural terms—discovering innate order in which buildings are read as signs, swimming pools as oases, and the strip as a continuous highway supplying every need.[19] In reading Las Vegas symbolically, they condoned the tastes and values of people other than architects, whom they called "socially coercive." And it was true that Le Corbusier and others had intended their pure white boxes only for those "fit" for them. Modern architecture had intended to correct social problems—disease, slums, and poverty. In Las Vegas, Venturi and Scott Brown accepted the built city as they found it, and discovered fresh meaning in it.

In literary circles, the prestige of Walter Gropius was attacked. Tom Wolfe, the ebullient author and scholar of American culture, challenged Walter Gropius (naming him "The Silver Prince") and his followers, seeing them as the ruin of a native American architectural tradition represented by Louis Sullivan, Henry Hobson (H. H.) Richardson, and Frank Lloyd Wright. In *From Bauhaus to Our House* (1981), Wolfe merrily ridiculed the German origins of Mies van der Rohe's and Gropius's styles[20] and the illogic of transplanting them to the United States. In both architecture and graphic design, the unquestioned reputation of classic Modernism was unraveling.

Indeterminate Façade Showroom (store for Best Products, Inc., Houston, Texas), designed by SITE, 1975

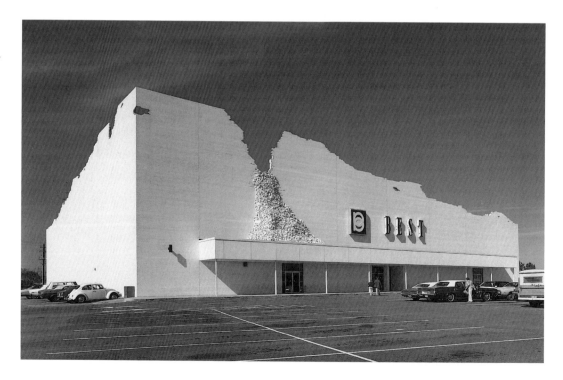

RECOVERING MEANING

James Wines's SITE, an environmentally-oriented architectural firm, departed from Modernism by investing architecture with communicative power, and by treating it more as sculpture in a public place than as a formal solution. SITE took a position of rejecting certainties for ambiguities, formal perfection for expressive use of form, and cool detachment for emotional involvement. It proposed oppositions to Modernism on a grand scale.

SITE designed an irregular roofline for a Best Products store in 1975, causing it to appear to be in a stage between construction and demolition. Calling it the "Indeterminate Façade Showroom," a cascade of bricks seemed to tumble from the roof down the side, suggesting the temporal nature of the building, rather than the permanent.

SITE's work was a major challenge to the principles of the International Style. Essential to their Modernism was the concept of planes enclosing a volume, not massive brick or stone supporting the roof. Here, SITE blatantly exposes its brick construction. Or perhaps it is saying that such constructions fail.

PLAYING WITH GRIDS AND CUBES

Bernard Tschumi's design for the Parisian grand project of 1982–85, a park with small buildings, or "follies," subordinated purpose to intellectual play. The government required no real function from the park, supporting theorists who argued, as Tschumi did, for architecture that "means nothing…one that is pure trace or play of language."[21] Yet the Paris Parc de la Villette redefines the concept of a park. It is no place of repose, no idyll of greenery, but rather an agglomeration of information and experiences. Variations on the possibilities are to be found in the cubes; no two of the red enameled follies are the same. They dot the park in a grid that anchors the chaotic mix of walkways, waving mesh arcades, ramps, cinemas, and objects such as an actual submarine moored near one folly.

Tschumi's design pulls elements out of the idea of a park and distributes them in an arrangement of forms. Here, he subordinates the Modern concept of function, and logic, to color the parkscape with abstract constructions, with no clue as to their function. Admittedly drawn to theories of "Deconstruction,"[22] Tschumi replaces a Modernist zeal for purity and clarity with an elaborate system requiring mental sophistication. There may be no meaning, or infinite meanings.

A grid of Parc de la Villette, designed by Bernard Tschumi, 1982–1985

L'Argonaute submarine next to a folly, Parc de la Villette

One of the follies of La Villette, showing proximity to its Parisian neighborhood.

THE CONCEPT OF "VIOLATED PERFECTION"

An aim of early Modernist practitioners in most art disciplines was an impeccable production of their product, be it a villa, type design, or gown. Surfaces and proportions were scrupulously monitored. Typefaces passed through many steps before completion, as did couture, and the construction of a concrete villa was carefully overseen to result in flawless surfaces and seamless joinings.

Architectural theorists challenged Modernism's tenets, reevaluating what had been thought trash, challenging the pure form of the Modernist masters. The new attitudes permitted different results. In his introduction to the 1988 MoMA exhibition "Deconstructivist Architecture," architect Philip Johnson employed the phrase "violated perfection"[23] to describe actions performed on the forms of the International Style architecture he himself had introduced in the landmark exhibition at MoMA of 1932. In the work of seven featured architects he found no organized movement, as with early Modernism, but a "similar approach with very similar forms as an outcome…a concatenation of similar strains from various parts of the world."[24] Gehry, Hadid, and Daniel Libeskind violated classic forms, bringing attention to a new aesthetic.

VIOLATED PERFECTION IN TYPOGRAPHY

In typography, a similar impulse erupted to violate the perfection that had been sought in the 1920s geometric sans serif typefaces and their legacies, dominant Helvetica and universalizing Univers. Typographers wrenched the squares, triangles, and circles underneath geometric letterforms into new alphabets, in the same way that architects now took apart cubes, pyramids, cylinders, and spheres to discover the expressive possibilities in instability, tension, and fragmentation. Violating the perfect page, art directors of popular magazines reproduced photographs—full frame, black edge, sprockets, and all.

In the process of punching away at the past, classic typefaces were desecrated by anti-Modernists. Ubiquitous Franklin Gothic, called the "patriarch" of American sans serif typefaces since its introduction in 1902, reappeared in the 1970s as the digital type Frankie, which takes Franklin Gothic letters and defaces their surfaces.

Irreverent designers found humor in the classics, as in the names of Fudoni and Cutamond. Fudoni, by Max Kisman of the Netherlands, wants to be a combination of Futura and Bodoni. It's a vertical face with the thick stems of Bodoni scattered wherever the designer likes them. Frank Heine, the designer of Cutamond, took scissors and cut letters from black paper. It is not Garamond in any way, but some letters have old-fashioned ligatures.

Typefaces such as Helvetica, Bodoni, and Futura—precious for years—were subjected to parodies, as the computer allowed designers to play, and this practice continued for the rest of the century. In 1994 Chester (his preferred professional name) designed Schmelvetica. Chester modified the iconic Swiss 1957 typeface Helvetica as he describes here:[25]

The late, great Ed Cleary, founder of FontShop Canada in Toronto and type historian, had contributed a piece to Font Bureau's publication on the history of Helvetica. In it, Cleary made the point that Helvetica was cobbled together as a marketing effort by the Haas foundry. There had existed all kinds of really beautiful and serviceable grotesques before Helvetica came along, and Cleary was much fonder of Akzidenz Grotesk and Monotype Grot. His piece's title was "Helvetica, Schmelvetica." Suitably inspired, I went to work the next day, and parsed the code of Helvetica in Fontographer, then proceeded to move every Bezier control point in every character. It took less than an hour, and there were no revisions. I printed out a sample of the face, and faxed it to Mr. Cleary in Toronto. He called me back almost immediately, suggested that I submit the design to FUSE in London.

Which I did.

I didn't hear back from FUSE, but when I found myself in London a few months later, I stopped by the offices (actually Neville Brody's studio) where I was advised to send the design to FontShop International in Berlin. They let me use their fax machine. Schmelvetica was published by FontShop in October of the following year. I was 22.

How do I see it being used? Quite well, usually. Because the face is so stupid, it doesn't need much fussing to get its stupidity across. I am told that it has been used on ad reels, and it pops up from time to time on billboards for motorcycle shops, ice cream, and steakhouses. I've seen it on cereal boxes. When I was in Paris last year, it was being used by a cell phone company and the lotto. I've never really used it myself.

Schmelvetica Is Bad

Schmelvetica by Chester, 1994

I'm Fudoni not Bodoni

Fudoni by Max Kisman, 1991

ABCDEFGHIJKLM NOPQRSTUVWXYZ

Cutamond Old Style by Frank Heine, 1990s

In the late part of the century, irreverence, cynicism toward old standards, and having fun is apparent in the names designers gave typefaces—Fontsoup, Dirty Faces, Stoned, Soupbone, Derision, Heimlich Maneuver, Dominatrix (a German blackletter), Boxspring, and Mattress. Sources for these new inspired digital fonts came from anywhere but geometry: Superior Smudged, 1996, derives from a 1930s set of rubber stamps; Ooga Booga comes from a painted sign on the side of a factory; and Template Gothic from the signs in a laundry room, noticed by a graphic designer while waiting through the spin cycle. Hard-to-read typefaces, such as FontShop's Dirty Faces, are the end of the millennium's rejection of the New Typography's clarity and logic. Some of these 1990s faces are FF Bull, Burokrat by Matthias Rawald, Dirty by Neville Brody, Metamorph by Markus Hanzer, and Littles by Simone Schopp. Faces drawn to look like children's writing instead of type became available.

Typefaces alluded to social realities, imitating graffiti in Innercity by James Closs, 1994, or cult life in Voodoo by Klaus Dieter Lettau, or the supernatural in Witches by Manfred Klein. Designed purposely to challenge accepted standards, the typefaces Why Not and Contrivance lost all reference to traditional typeface form and structure.

Why Not by Manfred Klein, 1993

Contrivance by Frank Heine, 1993

THE VIOLATING IMPULSE IN COUTURE

Couture, as timely and trend-conscious as type, picked up the same violating impulse. "Grunge" appeared when Marc Jacobs showed his line for Perry Ellis and declared it was "about doing everything wrong."[26] Grunge was originally reviewed as a "deliberately shabby and sloppy look based on Seattle rock bands—a mess of combat boots, flannel shirts, exposed midriffs, clashing layers"; it was called "disgusting."[27] Just as models with greasy hair, torn floral dresses, and clunky shoes went against traditional ideals of beauty, dirty typefaces degraded the letter. Everything was done against accepted form. The letters are scrawny, scribbled, with their insides and outsides confused. Nothing is beautiful. They have the pretension to offer themselves in standard point sizes with a lowercase and an italic.

INVERTING

Inversion in couture—turning clothes inside out—became a style. In a campaign for jeans, the wholeness of the clothing—its completed, final shape—was challenged; the inside was exposed on the outside, and underwear presented as outerwear. Instead of a protective garment, the jeans became a "look." Tops that don't tuck in emphasized the belly. Blue jeans once again sent a message. Observers suggested it was the rejection of consumer culture by young Americans, who composed the largest market for blue jeans.

In a Best Products store from 1984 the architectural firm SITE inverted the classic interior/exterior form of buildings. They broke away a large section of the exterior wall to reveal the inside. Only glass protects the exposed interior of the store. This allows many interpretations—the voyeurism of the spectator, the enticement of consumer culture, or a reference to architectural icons such as Johnson's own glass house, where the owner looks out at his private world, not vice versa.

Inside/Outside Building (store for Best Products, Inc., Milwaukee, Wisconsin), designed by SITE, 1984

Calvin Klein inside-out ad campaign

Seen by leading costume historians to be an heir of the Franco-Belgian Deconstructivist intellectual movement, Ann Demeulemeester[28] reexamined common outfits, such as a woman's suit. This day ensemble from her 1996–97 winter collection comprises a jacket, pants, shirt, and skirt, in black wool and red and black synthetics. Demeulemeester takes apart the usual black jacket and rearranges it, going beyond changing the surface or detail of an outfit to radically re-present the parts of the total. The peeling fabric, not unlike SITE's Peeling Showroom for Best Products, scrambles the accepted division between inside and outside. The letterform in Heine's Motion typeface appears ripped from the inside out; its integrity appears compromised with the boundaries of inside and outside dissolved. In all, inversion questions the stability and integrity of the structure, usually taken for granted.

Motion typeface by Frank Heine, 1992

**Ann Demeulemeester day ensemble,
1996–97**

The Metropolitan Museum of Art, Gift of
Ann Demeulemeester, 1988

**Peeling Showroom (store for Best
Products, Inc., Richmond, Virginia),
designed by SITE, 1972**

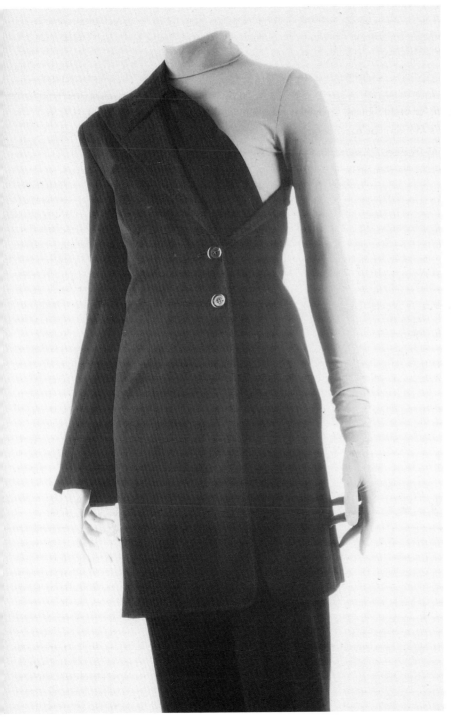

Corner of Peeling Showroom

REDISCOVERING FORMS

A practice of postmodernism shared by all the design arts was the retrieval of forms from other periods for the purpose of shaping or reapplying them in new contexts, often with irony or cynicism. The past was discovered as a historic encyclopedia of forms and styles. Taking these forms and using them in odd contexts became known as "quoting." A form could be quoted for wit or attention or for a serious reference to a treasured historical style. Implicit in this practice was an abandonment of the quest to discover, through rational analysis and experiment, the ultimate, universal typographic letterform. Implied in this was the failure of Modernism, the Bauhaus, Organic Design, Corporate Cool, "universal" alphabets—or any other Modern movement promising peace, social justice, and human progress.

First Michael Graves's grand postmodern Portland Building of 1980 quoted from earlier periods. Pediments and keystones appeared without performing their original functions of pediments and keystones; they appeared as a memory. Johnson, who had heralded the International Style into America in the late 1930s, and collaborated with Ludwig Mies van der Rohe on the iconic International Style Seagram

"The Classics of Modern Furniture" chart from Palazzetti, Inc., iconic designs of Modernism

AT&T Building by Philip Johnson, 1984

Building in New York, retrieved historic design elements in his AT&T Building of 1984. The top seemed a "Chippendale" pediment on top of a granite column, a composition that some architects saw as a return to real architecture.[29] Furniture makers, too, revived the classics of early Modernism. These popular artifacts appeared in the homes of designers and architects, who valued both their form and their origins.

TYPE REVIVALS AND REDESIGNS

In the same period, graphic designers freely appropriated type forms. Graphic styles of the 1920s—Constructivism, Art Deco, Bauhaus, and De Stijl—appeared, but in many cases without the ideological views of their founders. The phenomenon of historical mining began to be documented in typeface collections from previous eras[30] and redesigns. More than a hint of Paul Renner's circles of Futura showed in Avant Garde Gothic, a typeface that immediately became outrageously popular after its introduction in 1970.

Avant Garde Gothic letterforms, 1970–77. Designers Herb Lubalin and Tom Carnase based the Avant Garde Gothic typeface on the logo Lubalin designed for *Avant-Garde* magazine, introduced in the late 1960s.

Cover of an *Avant-Garde* magazine from 1969, showing the original all-capitals font

Book cover designed by the author in the 1970s, using the trendy Avant Garde Gothic typeface

In types like Galliard and Snell Roundhand, Carter evokes the most beautiful achievements of the past. In 1978 he designed Galliard for phototypesetting. Based on Robert Granjon's typeface Gros Cicero of about 1560,[31] its verve and grace evoke a Renaissance *galliard*, or dance, of the French Renaissance courts. Snell Roundhand is based on the hand of English writing master Charles Snell, who advocated a roundhand without ascender or descender loops as easier to both read and write.

Adobe Corporation's designer Robert Slimbach studied proofs of the authentic Garamond types in the Egenolff specimen sheet of 1592. He redrew it for the Postscript digital format with results that today's experts find to be the "closest replica of the sixteenth-century original…no other Garamond-inspired type comes as close in proportion, refinement of drawing, evenness of fit, and general elegance of appearance."[32] Some other reviewers disagreed, but the type has appeared everywhere since its appearance in 1989.[33]

Visual Set is the Eye's Mindset

Snell Roundhand by
Matthew Carter, 1966

Visual Set

ITC Galliard by
Matthew Carter, 1978

Visual Set

Adobe Garamond by Robert
Slimbach, 1989

Even Tschichold, one of the early Modernists, looked to the past. In 1966 he drew Sabon for a group of German printers desiring a conservative beautiful type like Garamond. It is narrower, so they could fit more letters in a line. Sabon is named after Jacob Sabon, a punch cutter from Lyons, who is thought to have brought some of Claude Garamond's matrices to Frankfurt.[34]

Neuland, the German Expressionist typeface of 1923, was evoked in a typeface by Joseph Treacy called TFNeueNeuland, which added the lowercase that Rudolf Koch had omitted, and several weights.

Forgetting sanserifs, Tschichold designed Sabon
And even the italic to accompany it

**Sabon typeface by
Jan Tschichold, 1966**

Visual Set is the Mind's Eyeset (Medium)
Visual Set is the Mind's Eyeset (Demi)

**TFNeueNeuland typeface from
Joe Treacy, 1990s**

CD cover design by Henrietta Condak using Snell Roundhand, Goudy Text, and Ariel. Condak, former art director of CBS Masterworks Label and noted album cover designer, explores the typographic design possibilities with old and new typefaces for an unpublished CD from 1997 of Johann Sebastian Bach's Brandenberg Concertos.

Alternate CD cover design using Snell Roundhand, Garamond 1050, and Copperplate Gothic

TYPE AND ARCHITECTURE, TOGETHER AT LAST

A continuing impulse in Modernism had been the integration of typefaces into buildings. Type as an integral part of architecture appeared in the first decades of the twentieth century. The avant-garde movement in art, design, and architecture in the Netherlands, De Stijl, incorporated identifying signs into its facades, as in the Café Unie of 1925 in Rotterdam (see page 37), designed by the De Stijl architect J. J. P. Oud. The strong horizontal and vertical slabs with letters repeat the geometric divisions of the façade; the letters fill their panels—a further means of integrating them into the overall design. The letterforms were, of course, sans serif, and confined to geometric bases of square, rectangle, triangle, and circle.

In the same year, the Russian Pavilion at the Paris Exposition (see page 60), designed by Konstantin Melnikov, had identified itself through letters hanging from the hammer and sickle shapes of the socialist Republic that were attached to the pavilion. The Bauhaus had placed large letters with its name on the side of the Dessau building. In the United States, progressive architects put signs on top of their buildings; Raymond Hood's iconic and still-standing Philadelphia Savings Fund Society building of 1932, now a hotel, was one of the first to broadcast its name in this blatant manner by putting "PSFS" in large sans serif letters on the top.

At the beginning of the twenty-first century, a project for a new skyscraper in New York takes integration of typography and architecture to its ultimate point. Here, in a sketch for the new tower to be constructed for the *New York Times* (never built), Frank Gehry proposed the *Times* logo itself to be part of the structure.

Proposed Frank Ghery–designed tower for the *New York Times* building (2000), with *Times* logo integrated into the structure (not realized).

AFTERWORD:
AMERICAN HEROIC

Being abroad is just like being in a strange country: the grass is
the same as we grow at home.[1]

Frederic Goudy

Before the entrance of European Modernism to the United States in the Trojan horse named the Bauhaus, Americans had established a store of forms and styles that covered the visual landscape from the Northeast to the West Coast. Today, as the influence of early European Modernism lessens, achievements of American designers resurface, and new attention is paid to them. Striking visual comparisons from the American past can be seen between the work of prolific type designer Frederic Goudy and the prodigious architectural designer Henry Hobson (H. H.) Richardson. Every computer type library offers digitized

Trinity Church by H. H. Richardson, Boston, 1872–77. In this great masterpiece, Richardson created the sublime in space, with the great vaulted nave and apse rich with ornament. The interior walls of the Episcopal church are covered with stenciled patterns, gold leaf, and mural paintings, showing Richardson's interest in decorative arts and his collaboration with American artist John La Farge, while the exterior shows the alternating bands of stone he had observed traveling in Normandy, as do the turrets, gables, and arches.

Interior of Allegheny Courthouse, Pittsburgh, designed by H. H. Richardson, 1883–88. With stone masses, low and wide elliptical arches, strong definitions of turns and spaces, and changing views of the outside, the awesome space of the grand entrance staircase ranks as a masterpiece of design.[2]

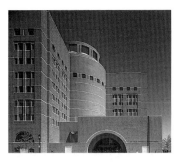

John Joseph Moakley United States Courthouse by Henry N. Cobb, 1998

Goudy Old Style, and Richardson's Trinity Church of Boston—ranked the best building in America back in 1885—still ranked sixth in a poll taken by the American Institute of Architects a century later. Architects practicing at the end of the twentieth century evoke Richardson's forms: his signature low or "Syrian"[3] arch distinguishes the entrance façade of a new courthouse on the Boston harbor. And graphic designers find Goudy's many typefaces appropriate for contemporary assignments such as CD covers (see page 141).

John Joseph Moakley United States Courthouse by Henry N. Cobb of Pei Cobb Freed & Partners, Boston, 1998. Here, Cobb evokes H.H. Richardson's signature low "Syrian" arch.

Digitized Goudy Handtooled

Richardson and Goudy shared stylistic tendencies that suggest the name "Lyric Masculinity," or the American Heroic. Their works are robust, yet romantic. They work with masses that confidently occupy their territory. Craftsmanship is important: sometimes a rugged, unfinished surface is left to recall the tools used. On the column in an early church in Springfield, Massachusetts, Richardson left the marks of the chisel as evidence of the stonecutter's hand. Goudy, an intense craftsman, ran his own press, often engraving matrices from his own drawings and casting type from those matrices. He too left the mark of his hand on the product of his imagination.

Architect and type designer functioned within the American power establishment of their time. Their taste for vigorous, traditional form was akin to that of the Establishment clients for whom they worked—Ivy League college presidents (Yale and Harvard), millionaire manufacturers (Ames and Glessner), the Episcopal Church (Trinity), state and local governments (Allegheny Courthouse and Jail and New York State Capitol Building), or prominent commercial organizations (American Type Foundry and Marshall Field). Rugged, independent, and creative, they also displayed a delicate sensitivity in creating form that was both moving and poetic.

Ames Gate Lodge by H. H. Richardson, North Easton, Massachusetts, 1881. The millionaire's estate in North Easton, now Stonehill College, was noted for its "boulders of brute coarseness."

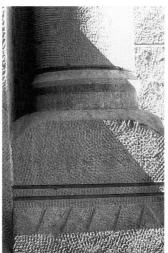

Column on H. H. Richardson's North Congregational Church, Springfield, Massachusetts, 1868

Goudy Handtooled repeats the forms of Richardson's arches at Trinity Church in its strong, carved curved strokes. This face, with its carved appearance, was designed by Morris Fuller Benton in the 1920s, who cut a line through Goudy Old Style and renamed it to evoke Goudy's handcrafting inclinations.

Both men historicized,[4] in the sense of visiting, sketching, and then copying forms from medieval and Renaissance architecture and books, imitating those older prototypes, and adapting them for American clients, who flooded them with commissions. A French-speaking native of New Orleans, Richardson studied architecture at the École des Beaux-Arts in Paris for six years, copying models of European architecture for which he became famous—the "Richardsonian Romanesque."[5] He also absorbed the earlier architectural ornamental style of Chicagoan Louis Sullivan.

New York State Capitol Building, Albany, New York. The most important building in the state was commissioned to Richardson and built between 1875 and 1886.

Mark designed by Goudy for the Village Press, which he owned and operated

Goudy's historicizing approach led him, also, to travel and copy from ancient carved letters. He surreptitiously made a rubbing from a marble tablet in the Louvre while his wife watched out for the guards, and with that antique model he designed the typeface Hadriano in 1910. He interpreted the inscription on the Trajan Column in Rome, which he saw in 1910, for use in America as "Forum" type.

In 1915 Goudy found inspiration in a letterform in a portrait thought to be by Hans Holbein. From it came Goudy Old Style, Bold, and Extra Bold. When he designed the italic for Goudy Old Style, he studied fifteenth- and sixteenth-century books to decide the amount of slant. Although a follower of old models, Goudy, like Richardson, was skilled in adapting them for practical use.[6] Imitating pen-drawn letters, he copied medieval diamond-shaped points, using them for the dot over the *i*, *j*, and exclamation point in Goudy Old Style.[7] Around 1918 Goudy designed a series of capital letters ornamented with the acanthus leaves of antiquity, revived by Sullivan and continued by Richardson in his buildings.

Tower of the Allegheny Courthouse and Jail (1883–88).
Here H. H. Richardson incorporated turrets and other historicizing elements, such as vertical slit windows and small openings originally meant for archers shooting arrows.

Goudy Handtooled, lower case letters *m, n, o, p*

Medieval diamond points

a b c d e f g
h i j k l m n
o p q r s t
u v w x y z
ff fi fl ffi ffl
1 2 3 4 5 6 7 8 9 0

Goudy Old Style

The visual landscape created by men such as Richardson and Goudy was the look of America of the late nineteenth century and early part of the twentieth century. To their intentions of re-creating historical models for America, they added imaginative genius and respect for craftsmanship, and, working easily with a brotherhood of powerful clients, ranged over the nation, creating its visual vocabulary. Most of all, there was beauty, strength, and usefulness in their created work. In addition to their contributions, there is the vast and unique heritage of Frank Lloyd Wright—including his early designs for churches (Unity Temple and Unitarian Meeting House), industry (Larkin Building and Johnson Wax Building), and residences (Ward Willits House and Robie House). It is remarkable that with such an existing tradition, the accepted version seems to be that only with "the importation of European Modernism" in the 1930s and 1940s did America learn how to design. An alternate story could be put forth: European refugees found an environment already hospitable to architecture, design, and originality, and did their best work here—true of Josef Albers, perhaps true of Walter Gropius and Mies van der Rohe.

Type Cloister Initial *A* with acanthus leaves

Detail of acanthus leaves on H. H. Richardson's New York State Capitol Building

NOTES

PREFACE: TYPOGRAPHY'S ROLE IN MODERNISM

1 Ulrich Conrads, *Programs and Manifestos on 20th Century Architecture* (Berlin: Ullstein, 1964), trans. Michael Bullock (Cambridge, Massachusetts: The MIT Press, 1970), p. 38.

2 Le Corbusier, *Towards a New Architecture* (New York: Praeger, 1960), trans. Frederick Etchells. English version of *Vers Une Architecture*, 1923. Quoted in Conrads, *Programs and Manifestos*, p. 60.

3 Alvin Lustig, "Designing, a Process of Teaching." Reprinted from the *Western Arts Association Bulletin*, (September 1952). In: Holland R. Melson, ed., *The Collected Writings of Alvin Lustig* (New Haven, Connecticut, 1958).

4 To use the phrase of Whitehead revived by N. Katherine Hayles in *The Cosmic Web* (Ithaca, NY: Cornell University Press, 1984), quoted by Dell E. Mook and Thomas Vargish in *Inside Modernism: Relativity Theory, Cubism, Narrative* (New Haven, CT: Yale University Press, 1999), p. 5.

5 Debora L. Silverman, *Art Nouveau in Fin-de-Siècle France* (Berkeley, CA: University of California Press, 1989).

6 Kenneth Frampton, *Modern Architecture: A Critical History* (New York: Thames & Hudson, 1992), p. 99.

7 Philip Johnson and Mark Wigley. *Deconstructivist Architecture*, published in connection with the exhibition "Deconstructivist Architecture," June 23–August 30, 1988 (New York: The Museum of Modern Art, 1988), p. 11.

CHAPTER ONE: EARLY EUROPEAN MODERNISM

1 Adolf Loos, "Ornament and Crime," 1908, in: Conrads, p. 19.

2 Bruno Taut, "Daybreak," p. 63. Taut, an architect and theorist, worked in Berlin with the November group of revolutionary German artists after the war. Taut's "Programme for architecture" saw all spiritual forces combine "in the symbol of the building."

3 Ibid., p. xviii.

4 Jan Tschichold, *The New Typography: A Handbook for Modern Designers*, trans. Ruari McLean (Berkeley: University of California Press, 1995). Facsimile of *Die neue Typographie: Ein Handbuch für Zeitgemass Schaffende*. (Berlin: Brinkmann & Bose, 1987). Original published in Berlin in 1928.

5 Tschichold cited *Die Form* and *110* as German journals of the time that met his criteria. He also alluded to the work being done for the City of Frankfurt under the direction of architect Ernst May.

6 Ibid., p. xv.

7 Ibid., p. 64.

8 Ibid., p xxvi.

9 Ibid., p. 66.

10 Ibid., p. 11.

11 Le Corbusier, *Vers Une Architecture* (Paris: Les Éditions D. Crès, 1923), p. 102.

12 Christopher Burke, *Paul Renner: The Art of Typography* (New York: Princeton Architectural Press, 1998), pp. 86–88.

13 Tschichold, *The New Typography*, p. xv.

14 Burke, *Paul Renner*, p. 65

15 Tracy, *Letters of Credit*, p. 158.

16 John. D. Berry, "New From ITC. ITC Johnston." *U&lc*, (Summer 1999), pp. 25–26.

17 Eric Gill, *An Essay on Typography* (London: Sheed & Ward). Republished, 1988. Introduction by Christopher Skelton, p. 6. Original 1931.

18 Le Corbusier, "Three Reminders to Architects," 1923, trans. Frederick Etchells and rep. in *The Essential Le Corbusier: L'Esprit Nouveau Articles* (Auckland: Reed Educational and Professional Publishing Ltd., 1998), p. 29.

19 Jacques Guiton, *The Ideas of Le Corbusier* (New York: George Braziller, Inc., with Fondation Le Corbusier, Paris, 1981).

20 Ulrich Conrads, *Programs and Manifestos on 20th Century Architecture* (Cambridge, Massachusetts: The MIT Press, 1970), p.74

21 Ibid., p. 58.

CHAPTER TWO: THE BAUHAUS

1 Walter Gropius, *The New Architecture and the Bauhaus*, 1937. Translated from German by Morton Shand (Cambridge, Massachusetts: The MIT Press, 1965), p. 92, paperback version.

2 Gropius, *Scope of Total Architecture* (New York: Harper & Brothers, 1955).

3 Ibid.

4 Elaine S. Hochman, *Bauhaus, Crucible of Modernism* (New York: Fromm International, 1997), p. 23.

5 Gropius, "Idee und Aufbau des Staatlichen Bauhauses, (The Conception and Realization of the Bauhaus)," 1923, quoted in *The New Architecture and the Bauhaus*, 1937, p. 57.

6 Gropius, "Is There a Science of Design?" *Scope of Total Architecture*." originally "Design Topics" in *Magazine of Art*, (December 1947).

7 Frampton, *Modern Architecture*, p. 96.

8 *Wellesley College News*, April 11, 1929, Wellesley College Archives, Massachusetts.

9 Magdalena Droste, *Bauhaus, 1919–1933* (Berlin: Taschen and Taschen Benedikt, Bauhaus-Archiv, 1990), p. 24.

10 Ibid., p. 54 ff.

11 Herbert Bayer, Walter Gropius, and Ise Gropius, eds. *Bauhaus 1919–1938* (New York: The Museum of Modern Art, 1938), p. 36.

12 Droste, *Bauhaus, 1919–1933*, p 54.

13 Bayer et al., *Bauhaus 1919–1938*, p. 78.

14 Ibid., p. 36.

15 "The Bauhaus at Dessau," Department of Art Scrapbook, 1928–32. Wellesley College Archives, Massachusetts.

16 Bayer et al., *Bauhaus 1919–1938*, p. 149.

17 Ibid., p. 78.

18 Ibid.

19 Droste, *Bauhaus, 1919–1933*, p. 252.

20 Gropius, *The Conception and Realization of the Bauhaus*, p. 82.

21 Ibid., p. 82.

22 Droste, *Bauhaus, 1919–1933*, p. 40.

23 Anja Baumhoff, *The Gendered World of the Bauhaus: The Politics of Power at the Weimar Republic's Premier Art Institute* (Frankfurt am Main: Peter Lang, 2001). A fresh look at the Bauhaus in 1919–32 with special emphasis on gender discrimination appears in this study based on records from women students, Gunta Stölzl in particular.

24 Internal Bauhaus document of March 15, 1921, quoted in Baumhoff, p. 60.

25 Baumhoff, *The Gendered World of the Bauhaus*, p. 84.

26 Droste, *Experiment Bauhaus* (Berlin: Bauhaus-Archiv, 1988).

CHAPTER THREE: DUELING MODERNISMS

1 Le Corbusier, *L'Art Décoratif d'Aujourd'hui* (Paris: Les Editions D. Crès et Cie, 1925), p. 84.

2 Bevis Hillier, *Art Deco of the 20s and 30s* (London: Studio Vista, 1968), p. 82.

3 Ibid., p. 14.

4 Hillier, *The Style of the Century, 1900–1980,* 2nd ed. (New York: Watson-Guptill, 1998), p. 75 ff.

5 Hillier, *Art Deco,* pp. 46–47.

6 "Rapport Général, Section Artistique et Technique i Livre." in *Exposition Internationale des Arts Décoratifs et Industriels Modernes,* Paris, 1925 (Paris: Larousse, 1925), p. 31.

7 Jérômne Peignot, *Petit Traité de la Vignette* (Paris: Imprimerie Nationale, 2000), p. 66 ff.

8 Deberny & Peignot Prospectus, 1926, courtesy Columbia University Libraries, Rare Book Collection.

9 W. Pincus Jaspert, with W. Turner Berry and A. F. Johnson, *The Encyclopedia of Type Faces* (London: Blanford Press, 1970), p. 254.

10 Henri Mouron, *A. M. Cassandre,* trans. Michael Taylor (New York: Rizzoli, 1985), p. 46.

11 Jaspert et. al., *The Encyclopedia of Type Faces,* p. 319.

12 Translated collection of *Journal de l'Esprit Nouveau* (New York: Da Capo Press, 1968), p. 100.

13 Ibid., p. 102.

14 *Journal de l'Esprit Nouveau,* #11–12 (Paris: *Revue Internationale d'Esthetique,* 1920–25), pp. 1245–156. (Author's translation from original issues in The Museum of Modern Art Library collection.)

15 See "Rapport Général," above.

16 *Journal de l'Esprit Nouveau,* #11–12, p. 1249.

17 Ibid., p. 1256.

18 Virginia Smith, "Robert Mallet-Stevens: Cul-de Sacs and Film Sets," in *DOCOMOMO,* (Winter 2003/4), p. 8.

19 Jacques Sbriglio, *Le Corbusier: La Villa Savoye* (Paris: Fondation Le Corbusier, 1999).

20 Found in many places, but in the original form in Conrads, *Programs and Manifestoes,* p. TK.

21 Charlotte Perriand, *Un Art de Vivre* (Paris: Flammarion, 1985), p. 13. (Published in connection with the exposition of her work at the Musée des Arts Décoratifs, Paris, in 1985).

22 Ibid., p. 21.

23 Richard Martin, Cubism and Fashion. Published in connection with the exhibition "Cubism and Fashion, 1998–99." (New York: The Metropolitan Museum of Art and Harry N. Abrams, 1998), p. 49.

CHAPTER FOUR: NATIVE AND IMPORTED FORMS

1 Alfred C. Bossom, *Building to the Skies: The Romance of the Skyscraper* (London: The Studio Limited, 1934), p.14.

2 Quoted in Hillier, *The Style of the Century,* pp. 36–37.

3 Ibid.

4 Ibid., p. 99.

5 Cervin Robinson and Rosemarie Haag Bletter, *Skyscraper Style: Art Deco, New York* (New York: Oxford University Press, 1975).

6 Louis H. Sullivan, "The Tall Office Building Artistically Considered," *Lippincott's Magazine,* (March 1896).

7 Mac McGrew, *American Metal Typefaces of the Twentieth Century,* 2nd rev. edition (New Castle, Delaware: Oak Knoll Books, 1993).

8 Ibid., p. 51.

9 Ibid., p. 55.

10 Ibid., p 33.

11 Frederic Ehrlich, *The New Typography & Modern Layouts* (New York: Frederick A. Stokes Company, 1934), p. 27 ff.

12 Ibid., pp. 41–42.

13 McGrew, p. 183.

CHAPTER FIVE: MID-CENTURY MODERN

1 Henri Focillon, *Vie des Formes* (Paris: Presses Universitaires de France; and New Haven: Yale University Press, 1942), p. 7. 1948 edition, George Wittenborn, Inc.

2 Brigid Keenan, *Dior in Vogue* (New York: Harmony Books, Crown Publishers, 1981), p. 60.

3 McGrew, *American Metal Typefaces,* p. 53.

4 Warren, Chappell, *A Short History of the Printed Word.* New York: Alfred A. Knopf, 1970), p. 85.

5 McGrew, p. 101.

6 Ibid.

7 Sebastian Carter, *Twentieth Century Type Designers* (New York and London: W.W. Norton, 1995), pp. 131–32.

8 Original typeface specimen sheets of Mistral, Banco, Diane, and Choc from Fonderie Olive through the Imprimerie Nationale, Paris.

9 Eliot F. Noyes, *Organic Design in Home Furnishings* (New York: The Museum of Modern Art, 1941).

10 Ibid., p. 6.

11 Peter Blake, "S. and E," *Interior Design,* (July 1994), pp. 29–30.

12 R. Roger Remington and Barbara J. Hodik, *Nine Pioneers in American Graphic Design* (Cambridge, Massachusetts: The MIT Press, 1989).

13 Bradbury Thompson, *The Art of Graphic Design* (New Haven, Connecticut: Yale University Press, 1988).

14 Martin Spector and Hodik, "Type Talks: Bradbury Thompson's Simplified Alphabet," 1958, quoted in Remington, *Nine*

Pioneers in American Graphic Design.

15 Stephen Bayley, Philippe Garner, and Deyan Sudjic, *Twentieth- Century Style & Design* (New York: Van Nostrand Reinhold, 1986).

16 William Curtis, *Le Corbusier: Ideas and Forms* (London: Phaidon Press, 1995), p. 175 ff.

17 *Monotype Newsletter* 92, 1972.

18 Richard Hollis, *A Concise History of Graphic Design* (London, Thames and Hudson, 1994), p. 130.

19 Emil Ruder, "Typography of Order," *Graphis*, Vol. 15, (September 1959), pp. 404–13.

20 Henry-Russel Hitchcock and Philip Johnson, *The International Style*, 1966, later edition of the original *The International Style: Architecture Since 1922 exh. cat.* (New York: W.W. Norton, 1932).

21 Ibid., p. 131.

CHAPTER 6: THE END OF THE MODERN MOVEMENT

1 Robert Venturi, *Complexity and Contradiction in Architecture: The Museum of Modern Art Papers on Architecture*, Into. Vincent Scully (New York: The Museum of Modern Art, 1966), p. 22.

2 Hubert-Jan Henket and Hilde Hennen, eds., *Back from Utopia: The Challenge of the Modern Movement* (Rotterdam: 010 Publishers, 2002), p. 12.

3 Diane Ghirado, *Architecture After Modernism* (New York: Thames and Hudson, 1996), p. 10.

4 Nikolaus Pevsner, "The Return to Historicism," 1961, *Studies in Art, Architecture and Design, Vol. 2* (New York: Walker & Company, 1968), pp. 243–59.

5 Author's interview with Ed Benguiat, September 23, 1999.

6 Stanley Trachtenberg, ed., *The Post Modern Moment* (Westport, Connecticut: Greenwood Press, 1985).

7 Noreen O'Leary, "Wolfgang Weingart," *Communication Arts*, (May–June 1998), pp. 74–81.

8 Wolfgang. Weingart, "My Typography Instruction at the Basle School of Design 1968–1985," *Design Quarterly*, No. 130, (1985).

9 Neville Brody and Jon Wozencroft, *The Graphic Language of Neville Brody*, Vol. 1 (London: Thames & Hudson, 1988); Vol. 2, 1994.

10 Warren Berger, "The Wunderkind of Graphic Design: David Carson," *Graphis*, Vol. 5, (January 1995), pp. 18–33.

11 David Carson and Lewis Blackwell, *The End of Print: The Graphic Design of David Carson* (San Francisco: Chronicle Books, 1995).

12 David Carson, *David Carson: 2nd Sight* (New York: Universe, 1997).

13 Philip Johnson and Mark Wigley, *Deconstructivist Architecture*, exh. cat. (New York: The Museum of Modern Art, 1988), p. 68. The seven featured architects and firms were Frank Gehry, Daniel Libeskind, Rem Koolhaas, Peter Eisenman, Zaha Hadid, Coop Himmelblau, and Bernard Tschumi.

14 Mark Wigley, "Deconstructivist Architecture," in Philip Johnson and Mark Wigley, *Deconstructivist Architecture*, pp. 10–20.

15 In the well-known phrase of British type authority Beatrice Warde, proposing that *type* was only a container for its content: "It did not intrude."

16 Matthew Carter, "Theories of Letterform Construction. Part I," *Printing History: The Journal of the American Printing History Association*, Vol. XIII, No. 2, (1991). and Vol. XIV, No. 1, (1992), pp. 3–16.

17 Moira Cullen, "The Space Between the Letters," *Eye: The International Review of Graphic Design*, Vol. 5, No. 19, pp. 70–77.

18 Robert Venturi, Denise Scott Brown, and Steven Izenour, *Learning from Las Vegas: The Forgotten Symbolism of Architectural Form* (Cambridge, Massachusetts: The MIT Press, 1972).

19 Ibid., p. 49.

20 Tom Wolfe, *From Bauhaus to Our House* (New York: Farrar Straus & Giroux, Inc., 1981).

21 The word *folly* is used in architecture to designate a small building erected in a park for ornamental purposes, historically by landed aristocrats.

22 Mary McLeod, "Architecture and Politics in the Reagan Era: From Postmodernism to Deconstructivism," *Assemblage 8*, (1989), p. 44.

23 Johnson credited the term to Aaron Betsky, from the title of an exhibition conceived by Paul Florian and Stephen Wierzbowski for the University of Illinois, Chicago.

24 Johnson and Wigley, *Deconstructivist Architecture*, p. 7.

25 Email from Chester to the author.

26 Glenn O'Brien, "Reality Bites Back," *Harpers Bazaar* (July 1996), p. 134.

27 Julie Turner, "From Trashcan Straight to Seventh Avenue," *Business Week*, March 22, 1993, p. 39.

28 Richard Martin, *Our New Clothes. Acquisitions of the 1990s* (New York: The Metropolitan Museum of Art and Harry N. Abrams, 1999), p. 63.

29 Lella Vignelli, *Artograph #4*, Virginia Smith, et. al., (Baruch College, 1984).

30 Steven Heller and Julie Lasky, *Borrowed Design: Use and Abuse of Historical Form* (New York: Van Nostrand Reinhold, 1993).

31 Jerry Kelly, "Adobe Garamond: A New Adaptation of a Sixteenth-Century Type," *Printing History: The Journal of the American Printing History Association*, Vol. XIII, No. 2, (1991) and Vol. XIV, No. 1, (1992), pp. 101–6.

32 Ibid.

33 Mark Argetsinge, "Adobe Garamond: A Review," *Printing History: The Journal of the American Printing History Association*, one issue combining Vol. XIII, No. 2, (1991) and Vol. XIV, No. 1, (1992), pp. 69–86.

34 Carter, *Twentieth Century Type Designers* , p. 127.

AFTERWORD: AMERICAN HEROIC

1 Peter Beilenson, *The Story of Frederic W. Goudy* (Mt. Vernon, New York: Peter Pauper Press, 1965), p. 41.

2 Margaret Henderson Floyd, *Henry Hobson Richardson: a Genius for Architecture*. Photographs by Paul Rocheleau. (New York: the Monacelli Press, 1997), pp. 110–113.

3 Ibid., p. 121.

4 Ibid.

5 James F. O'Gorman, *Three American Architects: Richardson, Sullivan, and Wright, 1865–1915* (Chicago and London: University of Chicago Press, 1992), p. 21.

6 D. J. R Bruckner, *Frederic Goudy. Documents of American Design* (New York: Harry N. Abrams, 1990), p. 15.

7 Frederic Goudy, *Goudy's Type Designs Complete: His Story and His Specimens* (New Rochelle, New York: The Myriade Press, 1978). Facsimile of 1946 *Typophiles Chapbook*.

BIBLIOGRAPHY

American Type Founders Company. *A Pamphlet Supplementing the Specimen Book of 1923, Showing Important Additions to the Goudy Family.* New York: Baruch College Trove, 1927.

Argetsinger, Mark. "Adobe Garamond." *The Journal of the American Printing History Association.* Vol. XIII, No. 2 (1991); Vol. XIV, No. 1 (1992), 69–86.

Bain, Peter and Paul Shaw, eds. "Type and National Identity: Blackletter." *Printing History: The Journal of the American Printing History Association.* Vol. XIX, No. 2, Vol. XX, No. 1 (1999), 4.

Barr, Alfred H. Jr. "The Bauhaus at Dessau." *Department of Art Scrapbook.* Wellesley, Massachusetts: Wellesley College Archives, 1928–32.

Baumhoff, Anja. *The Gendered World of the Bauhaus: The Politics of Power at the Weimar Republic's Premier Art Institute.* Frankfurt am Main: Peter Lang, 2001.

Bayer, Herbert, Walter Gropius and Ise Gropius, eds. *Bauhaus 1919–1938* Exh. cat. New York: The Museum of Modern Art, 1938.

Bayley, Stephen, Philippe Garner, and Deyan Sudjic. *Twentieth-Century Style & Design.* New York: Van Nostrand Reinhold, 1986.

Beilenson, Peter. *The Story of Frederic W. Goudy.* Mt. Vernon, New York: Peter Pauper Press, 1965.

Beissert, Gunter. *Jakob Erbar and the Sans Serif.* Translated by F. J. Maclean. Frankfurt: 1936.

Berger, Warren. "The Wunderkind of Graphic Design: David Carson." *Graphis,* Vol. 5 (January 1995), 18–33.

Bossom, Alfred C. *Building to the Skies: The Romance of the Skyscraper.* London: The Studio Limited, 1934.

Brody, Neville, and Jon Wozencroft. *The Graphic Language of Neville Brody,* Vol. 1. London: Thames & Hudson, 1988; Vol. 2, 1994.

Bruckner, D. J. R. *Frederic Goudy. Documents of American Design.* New York: Abrams, 1990.

Brunhammer, Yvonne. *Arts Décoratifs des années 20.* Paris: Editions du Seuil et Regard, 1991.

———. *The Nineteen Twenties Style.* London: Paul Hamlyn, 1969.

Bryson, Norman, ed. *Visual Culture, Images, and Interpretations.* Hanover, New Hampshire: University Press of New England, 1994.

Bryson, Norman, ed., with Michael Ann Holly, and Keith Moxey. *Visual Theory: Painting and Interpretation.* New York: Icon Editions, 1991.

The Bulletin of The Museum of Modern Art. Ed. John McAndrew (December 6, 1938).

Burke, Christopher. *Paul Renner: The Art of Typography.* New York: Princeton Architectural Press, 1998.

Cameron, Ian Alexander. *The Book of Film Noir.* New York: Continuum, 1992.

Carson, David. *David Carson: 2ndsight.* New York: Universe Publishing, 1997.

Carson, David, and Lewis Blackwell. *The End of Print: The Graphic Design of David Carson.* San Francisco: Chronicle Books, 1995.

Carter, Matthew. "Theories of Letterform Construction. Part I." *Printing History: The Journal of the American Printing History Association.* Vol. III, No. 2 (1991); Vol. XIV, No. 1 (1992), 3–16.

Carter, Rob, with Ben Day and Philip Meggs. *Typographic Design: Form and Communication,* 2nd ed. New York: Van Nostrand Reinhold, 1993.

Carter, Sebastian. *Twentieth-Century Type Designers.* New York and London: W.W. Norton, 1995.

Chappell, Warren. *A Short History of the Printed Word.* New York: Alfred A. Knopf, 1970.

Charles-Roux, Edmonde, et al. *Chanel and Her World.* Paris: Hachette-Vendome, 1981.

Cohen, Arthur A. *Herbert Bayer: The Complete Work.* Cambridge, Massachusetts: The MIT Press, 1984.

Conrads, Ulrich. *Programs and Manifestos on 20th Century Architecture.* Berlin: Ullstein, 1964. Translated by Michael Bullock. Cambridge, Massachusetts: The MIT Press, 1970.

Cullen, Moira. "The Space Between the Letters." *Eye: The International Review of Graphic Design.* Vol. 5, No. 19, 70–77.

Curtis, William. *Le Corbusier: Ideas and Forms.* London: Phaidon Press, 1995.

Deberny & Peignot Prospectus. New York: Columbia University Libraries, Rare Book Collection, 1926.

Deshouliéres, Dominique, et al. *Robert Mallet-Stevens, Architecte.* Bruxelles: Archives d'Architecture Moderne, 1980.

Droste, Magdalena. *Bauhaus 1919–1933.* Berlin: Benedikt Taschen and Bauhaus Archiv, 1990.

———. *Experiment Bauhaus.* Berlin: Bauhaus-Archiv, 1988.

Ehrlich, Frederic. *The New Typography & Modern Layouts.* New York: Frederick A. Stokes Company, 1934.

Feyrabend, Henriette, et al. *Quand l'Affiche Faisait de la Réclame!* Paris: Editions de la Réunion des Musées Nationaux, 1992.

Floyd, Margaret Henderson. *Henry Hobson Richardson: A Genius for Architecture.* Photographs by Paul Rocheleau. New York: The Monacelli Press, 1997.

Focillon, Henri. *The Life of Forms in Art.* Second English edition, enlarged. New York: George Wittenborn, Inc., 1948. First published in French as *Vie des Formes,* Librairie Ernest Leroux, Paris, 1934.

Frampton, Kenneth. *Modern Architecture: A Critical History.* New York: Thames & Hudson, 1992.

Gay, Peter. *Weimar Culture: The Outsider as Insider.* New York: Harper & Row Publishers, 1968.

Gerstner, Karl, and Markus Kutter. *The New Graphic Art.* Teufen, Switzerland: Arthur Niggli AG, 1959. English version by Dennis Stephenson. Distributed in the United States by Hastings House.

Ghirado, Diane. *Architecture After Modernism.* New York: Thames & Hudson, 1996.

Gill, Eric. *An Essay on Typography.* London: Sheed & Ward, 1931. Republished by David R. Godine, Boston: 1988.

Goudy, Frederic. *Goudy's Type Designs Complete: His Story and His Specimens.* New Rochelle, New York: The Myriade Press, 1978. Facsimilie of 1946 *Typophiles Chapbook.*

Gravagnuolo, Benedetto. *Adolf Loos: Theory and Works.* Preface by Aldo Rossi. New York: Rizzoli, 1982.

Graves, Michael. *Michael Graves, Buildings and Projects 1966–1981.* New York: Rizzoli, 1982.

Gropius, Walter. *The Conception and Realization of the Bauhaus,* 1923. Translated as *The New Architecture and the Bauhaus,* 1937. Reissued by The MIT Press, Cambridge, Massachusett, 1965. Translated from German by Morton Shand.

———. *Scope of Total Architecture.* New York: Harper & Brothers, 1955. Originally "My Conception of the Bauhaus Idea," 1937.

Guiton, Jacques. *The Ideas of Le Corbusier.* New York: George Braziller, Inc., with Fondation Le Corbusier, Paris, 1981.

Heller, Steven, and Anne Fink. *Faces on the Edge: Type in the Digital Age.* New York: Van Nostrand Reinhold, 1997.

Heller, Steven, and Gail Anderson. *American Typeplay.* Glen Cove, New York: PBC International Publishers, 1994.

Heller, Steven, and Julie Lasky. *Borrowed Design: Use and Abuse of Historical Form.* New York: Van Nostrand Reinhold, 1993.

Henket, Hubert-Jan, and Hilde Hennen, eds. *Back from Utopia: The Challenge of the Modern Movement.* Rotterdam: 010 Publishers, 2002.

Hillier, Bevis. *Art Deco of the 20s and 30s.* London: Studio Vista, 1968.

———. *The Style of the Century, 1900–1980.* 2nd ed. New York: Watson-Guptill, 1998.

Hillier, Bevis, and Stephen Escritt. *Art Deco Style.* London: Phaidon Press, 1997.

Hitchcock, Henry-Russell, and Philip Johnson. *The International Style.* New York: W.W. Norton, 1966 ed. of *The International Style: Architecture Since 1922.* Exh. Cat. New York: W.W. Norton, 1932.

Hofmann, Armin. *Graphic Design Manual: Principles and Practice.* New York: Van Nostrand Reinhold, 1965.

Jaffe, Hans L.C., et al. *De Stijl, 1917–1931: Visions of Utopia.* Catalogue of an exhibition organized by the Walker Art Center. Oxford: Phaidon, 1982.

Jaspert, W. Pincus, with W. Turner Berry and A. F. Johnson. *The Encyclopedia of Type Faces.* 4th ed. London: Blanford Press, 1970.

Johnson, Philip, and Mark Wigley. *Deconstructivist Architecture.* Exh. cat. New York: The Museum of Modern Art, 1988.

Kelly, Jerry. "Adobe Garamond: A New Adaptation of a Sixteenth-Century Type." *Printing History: The Journal of the American Printing History Association.* Vol. XIII, No. 2 (1991); Vol. XIV, No. 1 (1992), 101–6.

Kubler, George. *The Shape of Time. Remarks on the History of Things.* New Haven & London: Yale University Press, 1962.

Le Corbusier. *L'Art Décoratif d'Aujourd'hui.* Paris: Les Éditions D. Crès et Cie, 1925.

———. *Vers Une Architecture.* Paris: Les Éditions G. Crès, 1923. Translated by Frederick Etchells as *Towards a New Architecture.* New York: Warren & Putnam, 1927; and New York: Praeger, 1960.

———. "Three Reminders to Architects," 1923. Translated by Frederick Etchells and reprinted in *The Essential Le Corbusier: L'Esprit Nouveau Articles.* Auckland: Reed Educational and Professional Publishing Ltd., 1998.

Lustig, Alvin. *The Collected Writings of Alvin Lustig,* Ed. Holland R. Melson, Jr. New Haven, Connecticut: Holland R. Melson, Jr., 1958.

Martin, Richard. *Cubism and Fashion.* Published in connection with the exhibition "Cubism and Fashion." New York: The Metropolitan Museum of Art and Harry N. Abrams, 1998.

———. *Our New Clothes. Acquisitions of the 1990s.* New York: The Metropolitan Museum of Art and Harry N. Abrams, 1999.

McGrew, Mac. *American Metal Typefaces of the Twentieth Century.* 2nd rev. ed. New Castle, Delaware: Oak Knoll Books, 1993.

McLean, Ruari. *Jan Tschichold, Typographer.* London: Lund Humphries, Publishers Limited, 1975.

McLeod, Mary. "Architecture and Politics in the Reagan Era: From Postmodernism to Deconstructivism." *Assemblage* 8 (1989).

McQuiston, Liz. *Graphic Agitation. Social and Political Graphics Since the Sixties.* London: Phaidon Press, 1993.

"Modernism in the US After World War II." DOCOMOMO #31. (September 2004).

Morrison, Stanley. "First Principles of Typography." *The Fleuron* #7 (1930).

Mouron, Henri. *A. M. Cassandre.* Translated by Michael Taylor. New York: Rizzoli, 1985.

Müller-Brockmann, J. *The Graphic Artist and His Design Problems.* 3rd ed. New York: Hastings House Publishers, 1968.

Noyes, Eliot F. *Organic Design in Home Furnishings.* Exh. cat. New York: The Museum of Modern Art, 1941.

O'Gorman, James F. *Three American Architects: Richardson, Sullivan, and Wright, 1865–1915.* Chicago and London: University of Chicago Press, 1992.

O'Leary, Noreen. "Wolfgang Weingart." *Communication Arts* (May–June 1998.\).

Overy, Paul. *De Stijl.* London and New York: Studio Vista/Dutton Paperback, 1969.

Peignot, Jérôme. *Petit Traité de la Vignette.* Paris: Imprimerie Nationale Éditions, 2000.

———. *Typoésie.* Paris: Imprimerie Nationale Éditions, 1993.

Perriand, Charlotte. *Un Art de Vivre.* Paris: Flammarion, 1985.

Pevsner, Nikolaus. "The Return of Historicism," *Studies in Art, Architecture and Design, Vol. 2, 1961.* New York: Walker & Company, 1968.

———. *Pioneers of Modern Design from William Morris to Walter Gropius.* New York: Penguin Books, 1960. Originally published in 1936 by Faber & Faber, London.

———. *The Sources of Modern Architecture and Design.* London: Thames & Hudson, 1968.

Poynor, Rick. "Type and Deconstruction in the Digital Era." *Typography Now: The Next Wave.* London: Booth-Clibborn Editions, 1998.

Poynor, Rick, ed. *Typography Now Two. Implosion.* London: Booth-Clibborn Editions, 1996.

Rand, Paul. *Thoughts on Design.* New York: Van Nostrand

Reinhold, 1947, 1970.

Rapport Général, Section Artistique et Technique: Livre. Exposition Internationale des Arts Décoratifs et Industrials Modernes. Paris: Larousse, 1925.

Remington, R. Roger, and Barbara J. Hodik. *Nine Pioneers in American Graphic Design.* Cambridge, Massachusetts: The MIT Press, 1989.

Robinson, Cervin, and Rosemarie Haag Bletter. *Skyscraper Style: Art Deco, New York.* New York: Oxford University Press, 1975.

Ruder, Emil. "Typography of Order." *Graphis*, Vol. 15 (September 1959).

———. *Typography: A Manual of Design.* New York: Hastings House, 1967.

Ruegg, Ruedi, and Godi Frohlich. *Basic Typography: Handbook of Technique and Design.* Zurich: ABC Verlag, 1972.

Sbriglio, Jacques. *Le Corbusier: La Villa Savoye.* Paris: Fondation Le Corbusier, 1999.

Schwitters, Kurt. *Die neue Gestaultung in der Typographie.* Translated by Prof. Heinz Klinkon. Hannover, Germany: 1930.

Silver, Alain, and James Ursini. *The Film Noir Reader.* New York: Limelight, 1998.

Silverman, Debora L. *Art Nouveau in Fin-de-Siècle France.* Berkeley: University of California Press, 1989.

Smith, Virginia, et al. *Artograph #4. Massimo Vignelli.* New York: Baruch College, 1984.

———. *Artogaph #6. Paul Rand.* New York: Baruch College, 1988.

Spencer, Herbert. *Pioneers of Modern Typography.* Cambridge, Massachusetts: The MIT Press, 2004 edition of 1969 publication.

Sullivan, Louis H. "The Tall Office Building Artistically Considered," *Lippincott's Magazine* (March 1896).

Szasz, Thomas. *Karl Kraus and the Soul-Doctors.* Baton Rouge: Louisiana State University Press, 1976.

Tafuri, Manfredo. *Architecture and Utopia. Design and Capitalist Development.* Cambridge, Massachusetts: The MIT Press, 1979.

Thompson, Bradbury. *The Art of Graphic Design.* New Haven, Connecticut: Yale University Press, 1988.

Tolmer, A. *Mise en Page. The Theory and Practice of Lay-Out.* London: The Studio Ltd, 1931.

Trachtenberg, Stanley, ed. *The Post Modern Moment.* Westport, Connecticut: Greenwood Press, 1985.

Tracy, Walter. *Letters of Credit: A View of Type Design.* Boston: David R. Godine, 1986.

Troy, Nancy. *The De Stijl Environment.* Cambridge, Massachusetts: The MIT Press, 1983.

Tschichold, Jan. *Asymmetric Typography.* Translated by Ruari McLean. New York: Reinhold Publishing; Toronto: Cooper & Beatty Ltd., 1967. Translation of *Typographische Gestaltung*, Basel, 1935.

———. *The New Typography: A Handbook for Modern Designers.* Translated by Ruari McLean. Berkeley: University of California Press, 1995. Facsimile of *Die neue Typographie: Ein Handbuch für Zeitgemass Schaffende.* Berlin: Brinkmann & Bose, 1987. Original published in Berlin, 1928.

Tschumi, Bernard, and Irene Cheng, eds. *The State of Architecture at the Beginning of the 21st Century.* New York: The Monacelli Press, 2003.

Updike, Daniel Berkeley. *Printing Types: Their History, Forms, and Use. A Study in Survivals.* Cambridge, Massachusetts: The Belknap Press of Harvard University Press, 1966. Second printing of the third edition of the original of 1922.

Van Bruggen, Coosje. *Frank O. Gehry: Guggenheim Museum Bilbao.* New York: Guggenheim Museum Publications, 1997.

Vattimo, Gianni. *The End of Modernity.* Baltimore: Polity Press, 1988. First published in Italian as *La Fine Della Modernita,* Garzanti Editore, Milan: 1985.

Venturi, Robert. *Complexity and Contradiction in Architecture: The Museum of Modern Art Papers on Architecture.* Introduction by Vincent Scully. New York: The Museum of Modern Art, 1966.

Venturi, Robert, Denise Scott Brown, and Steven Izenour. *Learning from Las Vegas: The Forgotten Symbolism of Architectural Form.* Cambridge, Massachusetts: The MIT Press, 1972.

Warde, Beatrice (Beaujon, Paul). "The 'Garamond' Types: Sixteenth- and Seventeenth-Century Sources Reconsidered." *The Fleuron #5* (1926), 131–79.

Weingart, Wolfgang. "My Typography Instruction at the Basle School of Design 1968–1985." *Design Quarterly*, No. 130 (1985).

Whitford, Frank. *Bauhaus.* London: Thames & Hudson, 1984.

Wolfe, Tom. *From Bauhaus to Our House.* New York: Farrar, Straus & Giroux, Inc., 1981.

Woodham, Jonathan. *Twentieth-Century Ornament.* London: Studio Vista, 1990.

INDEX

CREDITS

Photograph and Reproduction Credits and Copyrights:

Archive Photos: pp. 95, 111 (right); ©2004 Artists Rights Society (ARS), New York/VG Bild-Kunst, Bonn: pp. 18, 38 (left and top right), 40 (top); Art Resource/©Erich Lessing, photo: pp. 12, 14 (left), 28; Bauhaus-Archiv, Berlin: pp. ii, 32 (bottom), 33 (left and bottom right), 35 (top right and bottom), 38 (bottom right and far right), 39, 41 (left), 43 (bottom), 48 (top), 49 (left), 50 (left), 51 (top); Bernard Tschumi Architects: p. 131 (top and bottom); Cary Graphic Arts Collection, RIT, Rochester, N.Y., Courtesy of: p. 15 (middle); Chicago Architectural Photo Co.: p. 80 (bottom); ©Christina Condak, photo: p. 14 (bottom); CORBIS/©Lynn Goldsmith, photo: p. 135 (left); ©Elaine Lustig Cohen: pp. 105 (all), 106 (right), 107 (left and right); ESTO/©Ezra Stoller: pp. 93, 112 (top and right), 119, 120–121; ©Fondation Le Corbusier: pp. 25 (all), 27, 65 (all), 67, 70 (left), 71; Foto Marburg/Art Resource Art, NY: pp. 31, 44 (bottom), 111 (left); Fritz Hansen A/S, Denmark: p. 103 (all); Josef and Anni Albers Foundation, Courtesy of: p. 42 (top); Isamu Noguchi Foundation, Inc., Courtesy of/Kevin Noble, photo: p. 108 (bottom); Knoll, Courtesy of: pp. 107 (middle), 108 (top); ©Gehry Partners LLP: pp. 124, 143; Les Arts Dècoratifs—Musée des Arts Decoratifs/Fonds Albert Levy-Musée des Arts décoratifs, Paris: pp. 55, 56 (all), 57, 58 (all), 59, 60 (all), 61 (all); ©Loretta Lorance, photo: p. 146 (left); ©May Phan, photo: p. 113 (bottom); ©Museum of the City of New York/Alan Rosenberg, photo: p. 112 (bottom); ©Museum of the City of New York/Philip Trager, photo: p. 113 (top); ©Museum of the City of New York/The Gottscho-Schleisner Collection: p. 117; ©Museum of the City of New York/Sherril V. Schell, photo: pp. 72, 78 (left); ©Museum of the City of New York/Wurts Brothers, photo: p. 79; ©Museum of the City of New York/Underhill Collection: pp. 81, 84; ©Museum of Modern Art, New York, photo: pp. 42 (bottom left), 46 (middle right and bottom left), 87 (right), 88; Palazzetti, Inc.,: p. 138 (left); Paul Rand, Courtesy of: p. 106 (far left, middle top and bottom); ©Paul Rocheleau, photo: pp. 144 (all), 147 (left), 148 (top left); P22 Type Foundry, P.O. Box 770, Buffalo, NY 14213: pp. 40 (bottom), 42 (bottom right); ©Steve Rosenthal, photo: p. 145 (top and left); ©Virginia Smith, photo: pp. 43 (top left), 37 (bottom), 68 (all), 80 (top and left), 131 (middle), 146 (right), 149 (left)

Artist Copyright:
©2005 The Isamu Noguchi Foundation and Garden Museum, New York / Artists Rights Society (ARS), New York: p. 108 (bottom)